Georgia O'Keeffe's Wartime Texas Letters

American Wests
Sponsored by West Texas A&M University
Bonney MacDonald, General Editor

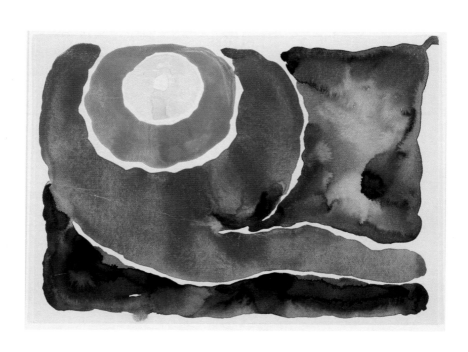

Georgia O'Keeffe's
Wartime
Texas
Letters

AMY VON LINTEL

Foreword by Bonney MacDonald

Texas A&M University Press • College Station

This paper meets the requirements
of ANSI/NISO Z39.48-1992 (Permanence of Paper).
Binding materials have been chosen for durability.
Manufactured in the United States of America

Library of Congress Cataloging-in-Publication Data

Names: O'Keeffe, Georgia, 1887–1986, author. | Von Lintel, Amy, 1978– editor,
 writer of introduction.
Title: Georgia O'Keeffe's wartime Texas letters / [selected, annotated, and
 edited by] Amy Von Lintel.
Other titles: Correspondence | American Wests.
Description: First edition. | College Station : Texas A&M University Press,
 [2020] | Series: American Wests | Includes bibliographical references and
 index.
Identifiers: LCCN 2019035580| ISBN 9781623498498 (cloth) | ISBN 9781623498504
 (ebook)
Subjects: LCSH: O'Keeffe, Georgia, 1887–1986—Travel—Texas. | O'Keeffe,
 Georgia, 1887-1986—Correspondence. | Artists—United
 States—Correspondence. | World War, 1914-1918—Personal narratives,
 American. | Texas—Description and travel—Sources.
Classification: LCC N6537.O39 A3 2020 | DDC 759.13 [B] —dc23 LC record available at
 https://urldefense.proofpoint.com/v2/url?u=https-3A__lccn.loc.gov_2019035580&d=D
 wIFAg&c=u6LDEWzohnDQ01ySGnxMzg&r=Vb_cq2f6gpCkUTLwv_VJN_5pQZyZ_AzWd-
 jHt3-hValk&m=GxEqZNlW1KrOHBS3O-_2TgIrvUcxfvszADMaz5OpQ_c&s=ugyQMk-
 2bDhlKbq3dimbiVC7QAXu4wLNINxDP4JILxE&e=

FRONT Cover: Georgia O'Keeffe, Series I – From the Plains, 1919, Georgia O'Keeffe
Museum, Gift of The Burnett Foundation. © Georgia O'Keeffe Museum.

BACK COVER: Sunrise and Little Clouds No. I, 1916, private collection. © Georgia
O'Keeffe Museum.

Watercolor on page ii: Georgia O'Keeffe, *Evening Star No. V*, 1917, McNay Art Museum,
Bequest of Helen Miller Jones © Georgia O'Keeffe Museum. Image © McNay Art
Museum / Art Resource, New York.

To my adopted daughters,
Mo and Shay,
who have the same
spunk and gumption as Georgia,
who fought for their survival at too young an age,
and who, again like Georgia, cannot help
but be loved by everyone who knows them.

Contents

Illustrations

Foreword

In this "American Wests" series, sponsored by West Texas A&M University, Amy Von Lintel offers an original and fresh take on Georgia O'Keeffe's formative years. The letters, primarily to Alfred Stieglitz, were written during O'Keeffe's time in West Texas; from 1912–14 she taught in Amarillo, from 1916–18 she taught at West Texas Normal School (now West Texas A&M University), and in 1918, she followed these stays with a brief trip to San Antonio— after which, she left for New York City, Stieglitz, and a life that would not again include Texas landscapes and cultures. As Von Lintel elegantly demonstrates, these years on the High Plains stayed with the artist in the decades to come and shaped the modernist aesthetic that she helped to create.

The letters, along with Von Lintel's thoughtful commentary and well-researched interpretation, show us an emerging, young, female voice keen to describe—even dramatize—the ups and downs of creativity and young womanhood. They also give us a window onto an American West in the Texas Panhandle; a power-ful and haunting account of the experience of war from the Texas Plains; and the on-again, off-again struggles of a young female art-ist seeking to engage and learn from her mentor and lover. We see in O'Keeffe the early phases of a young artist whose shapes, col-ors, and attitudes would shape modernist in the years to come.

O'Keeffe's relationship with and attitudes towards Amarillo and Canyon, Texas remain complicated and even contradictory. The letters show us her love-interests in young men like Ted, a ranch-kid for whom she shows whimsical and even serious fond-ness as she takes in his seemingly simple ways and with whom she spends many hours and days—entertaining, as she reports to Stieglitz at least, the idea of marrying him. Elsewhere in the letters, she returns from a day in town, full of anecdotes about local friendships and old-fashioned fun. And, at every turn, she is

full of glowing descriptions of her students' promise and remains appreciative of the understanding from college president, Robert Cousins—despite her many "jolts" to local culture delivered in her public addresses. Nonetheless, often in the same letters, she feels it necessary to distance herself from local, homespun provincialism, stating that some are "too stupid to speak to." And, certainly, this mixed response becomes more pronounced in her impressions of war. While at times naïve and declaratory, as when she just wishes she could enlist to see what real war was like, she also feels deeply and intensely the loss of life and "livingness," as she witnesses vibrant and promising Texas men head off to the front lines. And while, as Von Lintel notes, there are emotional and psychological ups and downs to O'Keeffe's life at the time, the war— with its loss, uncertainty, and brokenness—magnifies this memorably. From these small Texas towns, the young woman who would soon shape a modern era gives voice to the fears and terrors that haunted everyday lives on the Plains.

Finally these are, after all, letters from a young artist in the midst of trying to see, define, and describe herself—letters written to a mentor, lover, and, later, husband who was already a towering presence in modernism. They are letters from an unmarried woman written to a married man and, as such, have the flirtatious, occasionally manipulative and devil-may-care tone which, ones sees, is put out there to pull Stieglitz further into her life. She reports her romantic entanglements and escapades with local men as well as her involvement with Stieglitz's friend, Paul Strand; playfully reports the nudity of her paintings and warm Texas nights; and declares—echoing perhaps the New Woman of her era—her fiercely guarded independence. She tries out new ideas on form and color, offers lyrical and unforgettable accounts of Plains scenery and weather, and—through it all—gives voice to the geography that would forge her later shapes and colors. Finally, the fluctuations between portrayed innocence (the many references to feeling like a "little girl") on the one hand and, on the other hand, the stark insistence on individuality (her resistance to school dress codes and local custom) show us a complicated figure. O'Keeffe reveals herself as a young woman and artist in the making, trying to speak

herself into being during the formative years before she became a foundational figure in modern art.

Amy Von Lintel has given us a new look at an era in O'Keeffe's life that helps us see the artist's later years with a fresh perspective. Her volume of O'Keeffe's letters opens a window on American Wests, giving us a picture of West Texas through the eyes of an emerging artist—an artist whose roots remained tied to West Texas, even as her future unfolded in New York and New Mexico. It is a pleasure to see the growth of a career; and Von Lintel's book, with its emphasis on local culture and the broader experience of the war, gives us an immensely valuable view of O'Keeffe's formative years on the West Texas Plains.

—Bonney MacDonald, General Editor

Preface

An editor has many choices when converting handwritten letters into a typescript book. I share some of my editorial choices with the reader here. Georgia O'Keeffe rarely used traditional punctuation in her letters. Most often, she paused between thoughts as she wrote, inscribing a kind of squiggle or tilde mark between phrases and only occasionally inserting a full stop period. I have used the em dash to show these pauses, following the model of Sarah Greenough in her volume of the correspondence of O'Keeffe and Alfred Stieglitz, *My Faraway One: Selected Letters of Georgia O'Keeffe and Alfred Stieglitz, vol. 1, 1915–1933*. I have employed bracketed three-dot ellipses throughout all the letters whenever I have removed a section, rather than distinguishing between removing part or all of a sentence. I believe this aids the flow of reading O'Keeffe's modernist stream-of-consciousness style of writing. Likewise, I have tended to omit sections focused on O'Keeffe's romantic feelings toward Stieglitz, and her discussions with him about the New York art scene, as Greenough presents these aspects so vividly in *My Faraway One*. The present book, in contrast, aims to highlight O'Keeffe's responses to the American West as a place and space and its identity as the home front during the war. Therefore, my editorial excerpting does not reflect any judgment on my part of a lack of importance for O'Keeffe's life, but rather a lack of relevance for the particular focus of my book.

Moreover, I elected not to repeat the publication of some of the letters from Texas that have been in print most often. For those, I refer you to Jack Cowart and Juan Hamilton, *Georgia O'Keeffe: Art and Letters*; Anita Pollitzer, *A Woman on Paper: Georgia O'Keeffe*; Clive Giboire, ed., *Lovingly, Georgia: The Complete Correspondence of Georgia O'Keeffe and Anita Pollitzer*; and Jennifer Sinor, *Letters like the Day: On Reading Georgia O'Keeffe*, in addition to

Greenough's *My Faraway One*. The letters designated in my book with a "postmarked" date instead of a date of authorship are letters from the Alfred Stieglitz/Georgia O'Keeffe Archive at the Beinecke Rare Book and Manuscript Library at Yale University (abbreviated in the text as ASGOA), which have not yet been published in other letter volumes. I chose to use the date given by the archive based on the envelope in which the letter was sent by O'Keeffe rather than to try, like Greenough, to determine the authorship date. This serves one main purpose: it allows the reader to know which letters are unique to this volume, being published for the first time, but in a way that is not distracting from the readability of the letters as a collection.

O'Keeffe's writing has irregular and idiosyncratic spelling patterns. For instance, she variously wrote "Leah" and "Lea" for Leah Harris and "Watkins" and "Watson" for Kindred Marion Watkins. I have for clarity employed the common English spellings of words and what I have determined to be the correct spelling of a person's name based on historical records, again following the model of Greenough. However, to show O'Keeffe's own use of underscoring within her letters as her means of emphasis, I have retained that style as it appeared in the original letters.

Finally, I have chosen to use a distinct style of font, namely italic, to designate sections of O'Keeffe's letters that deal directly with WWI. This choice aims to maintain the fluidity between O'Keeffe's discussion of the war and her writing about myriad other topics, while at the same time demonstrating just how often the war emerges in her letters after April 1917. It bubbles up, often unexpectedly, and just as suddenly drifts back out of her mind. And so, I wanted to draw the reader's attention to these moments of O'Keeffe's consideration of the war without distracting too much from the holistic integrity of each letter or the chronology of her letters as a body of writing.

Regarding references in her letters to extant works of art, I most often point the reader to the plates in my volume *Georgia O'Keeffe: Watercolors, 1916–1918* (abbreviated in the text as GOKW). This is because of the highly precise color matching and quality printing that David Chickey at Radius Press in Santa Fe accomplished with

this volume, where O'Keeffe's watercolors completed in Texas—
which are so fragile and light-sensitive that they can only rarely
be exhibited—are beautifully reproduced in color at full size in an
ideal format for study. The volume also includes reproductions of
her Texas oil paintings, some drawings, and documentary photo-
graphs from O'Keeffe's time in Canyon. Also, when helpful, I refer-
ence O'Keeffe's works as reproduced and researched in Barbara
Buhler Lynes's *Georgia O'Keeffe: Catalogue Raisonné* (abbreviated
in the text as CR). These notations are to assist readers in appreci-
ating just how interconnected O'Keeffe's writings and works of art
were during her early career.

Acknowledgments

This book, and my broader work on Georgia O'Keeffe in Texas, would not have been possible without the kindness and assistance of many, many people. I won't belabor mentioning all the ways these contributors have helped my project, because that would make another book in itself, but rather I will name them in alphabetical order to reflect the equality of their various efforts and my appreciation for them all. These people have truly been a joy to work with and have made my O'Keeffe research the project of a lifetime: Amy Andersen, Dalinda Andrade, Melissa Barton, Shannon Bay, John T. "Jack" Becker, Samantha Biffle, Valerie Bluthardt, Susan Burke, Leesa Calvi, David Chickey, Stephen Crandall, Shelby Crews, Cindy Cross, Richard DeVoe, Kristina Drumheller, Elizabeth Ehrnst, Kirstin Ellsworth, Shirley Fancher, Sherri Felty, Gene Fowler, Linda Grasso, Michael Grauer, Alex Gregory, Randall Griffin, Robert Hansen, Cody Hartley, Joyce Herring, David Horsley, Alex Hunt, Brian Ingrassia, Sidnye Johnson, Carolyn Kastner, Mickey and Jeanne Klein, Robert Krett, Dale Kronkright, Marty Kuhlman, Thom Lemmons, Emily Liggett, Darcy Lively, Carol Lovelady, Barbara Buhler Lynes, Bonney MacDonald, Kim Mahan, Jessica Mallard, Laura Marshall, Thomas Mauter, Anne Medlock, Marcus Melton, Rachel Middleman, Chelsea Minton, Jan Minton, Larry Mobley, Megan Mulry, Bess Murphy, John Olson, Carolyn Ottoson, Brandy Pacheco, Dorothy and Don Patterson, H. Daniel Peck, Phillip Periman, Liza Raiser, Buster Ratliff, Jon Revett, Bonnie Roos, Wade Shaffer, Joe Bill Sherrod, Jennifer Sinor, Jeff Sone, Warren Stricker, Eumie Imm Stroukoff, Jean Stuntz, Dawn Tripp, Sharyn Udall, Ann Underwood, Millie Vanover, Beth Vizzini, Cindy Wallace, René West, the late David Willard, Pam Wilson, Sarah Beth Wilson, Traci Winter, Shawna Witthar, Helene Woodhams, and Sandra Zalman. I also thank the institutions of West Texas A&M University, the Georgia

O'Keeffe Museum and Research Center, the Panhandle-Plains Historical Museum, and Texas A&M University Press for their support and belief in me as a younger O'Keeffe scholar, as someone who really only "discovered" O'Keeffe after moving to West Texas for a teaching job myself (unknowingly following in Georgia's footsteps a century later). Finally, I must thank my entire Welch-Von Lintel-Rupp family for their patience and support in my workaholic obsession with this project.

Georgia
O'Keeffe's
Wartime
Texas
Letters

Introduction

A HOME ON THE HOME FRONT

In her ninety-eight years of life, Georgia O'Keeffe (1887–1986) spent less than four of them living in the state of Texas. From 1912 to 1918—for a total of forty months when she was between the ages of twenty-four and thirty years old—O'Keeffe resided in areas around Amarillo and San Antonio. Nor did she stay exclusively in Texas during that time; she was mobile and nomadic in her young life, moving back and forth between Texas and Virginia, where her family resided, or Texas and New York, where she went to school to train as an art educator. And yet her time in Texas was her first experience in the American West, which was revelatory for her, as she realized that America was bigger and more inspiring than she expected. Throughout her life, she wrote and said that she found a kind of "real America" out in Texas.[1]

In the 1910s, and particularly her years spent teaching at West Texas State Normal College (now West Texas A&M University) in Canyon, twenty miles south of Amarillo, O'Keeffe was incredibly productive in her artistic responses to her Texas experiences. My book *Georgia O'Keeffe: Watercolors, 1916–1918* focuses on this period of her art and argues that it was in Texas that O'Keeffe first became the experimental and determined abstractionist we now know her to be.[2] However, her creative production in these years was not limited to visual art; she also wrote prolifically, albeit privately, from Texas, producing close to two hundred letters, the majority to her future husband, Alfred Stieglitz.[3] Sarah Greenough's *My Faraway One* explores the letter-based love between O'Keeffe and Stieglitz, with a key section dedicated to O'Keeffe's Texas years.[4] In addition to Stieglitz, O'Keeffe also wrote to other correspondents from Texas, including her fellow New York art student Anita Pollitzer and her artistic colleague (and brief romantic love interest) Paul Strand. The letters she authored during her Texas years offer a font

of information not only about O'Keeffe as a developing artist and as the future wife and muse of Stieglitz, but also about O'Keeffe as a young, unmarried woman discovering the freedom and independence that the American West afforded her. In this study, I explore the artist as a verbal creator—as a painter with words as well as with brushes—and a profound interpreter of western American modernity. At the same time, when O'Keeffe's voice is allowed to resonate alone, without the dialogue that Greenough so carefully and beautifully re-created in her volume, the poetic expression of O'Keeffe's writing comes through in a new way. O'Keeffe has a style all her own. In such phrases as "I feel like shaking all the world off my fingers this afternoon like water"; "the nakedest thing I know of is an angleworm"; "What's the use in pretending to have flat feet and pop eyes and a Sunday school disposition when you haven't got them?"; "I'm not trying to do Art—I'm digging stars"; and "In the wind my black close hat brim is like a flickering shadow between me and the gold of the plains that stretches seemingly to never," we discover an author who is as creatively precise and lovely with words as with colors and shapes on paper or canvas.[5]

O'Keeffe's time in Texas was shaped by three distinct periods: first, her Amarillo years from August 1912 to May 1914, when she taught for the brand-new Amarillo City Public School system; second, her years living in Canyon, when she taught at West Texas State Normal from August 1916 to February 1918; and third, her months in the San Antonio area between February 1918 and the beginning of June 1918, when she was recuperating from an unidentified severe respiratory illness that forced her to leave her position in Canyon.[6] Regarding her Amarillo years, we have few extant letters or works of art by O'Keeffe from that time, so our understanding of her life and work in Amarillo is quite thin. Most perspectives on this period come from the artist remembering things later in her life, or from friends such as Pollitzer who recalled O'Keeffe sharing memories after she left Amarillo.[7]

In her 1976 autobiography, for instance, O'Keeffe reminisced about how she was already enamored with the myths of the Wild West and Texas before she arrived in the state in 1912: "Texas had

always been a sort of far-away dream. When we were children my mother read to us every evening and on Sunday afternoons [. . .] I had listened for many hours to boys' stories [. . .] of the Wild West, of Texas, Kit Carson, and Billy the Kid. It had always seemed to me that the West must be wonderful—there was no place I knew of that I would rather go—so when I had a chance to teach there—off I went to Texas—not knowing much about teaching."[8] She had been named "supervisor of drawing and penmanship" for the Amarillo public schools, where she was offered more money than was possible for her back East—never mind that her credentials were somewhat misrepresented.[9] She showed up in the fall of 1912 at one of the three modern train stations in Amarillo expecting to find a pioneer town of those Wild West novels, but instead she found a rapidly growing western city that had already become a major railroad crossroads and cattle shipping hub of Middle America.[10] She discovered streetcars, newly paved streets, an opera house, and neoclassical mansions being constructed down the street from her lodgings. Living in the Magnolia Hotel instead of the boardinghouses where other unwed teachers resided, O'Keeffe apparently came in contact with some rough-and-tumble cowboys right off the range, supposedly witnessed a shootout on the street in front of the hotel, and even caught a glimpse of the then-famous John Beal Sneed on his way to commit his second murder.[11] Welcome to Texas, Georgia! Where you are more likely to go to the pen for stealing a cow than for killing a person![12]

When O'Keeffe left Amarillo in May 1914 for Virginia to teach art for the summer at the University of Virginia, she still intended to return to Texas for the fall session. She had asked for a raise, but the Amarillo city school board denied her request.[13] Likely because of this denial, she never returned to her Amarillo teaching position but instead remained in the East in the fall of 1914 and enrolled in further classes at Columbia Teachers College in New York to advance her studies in art education. Being a professional educator was how O'Keeffe made an independent living at the time; her family was no longer supporting her.[14] Rather, she was helping to support her family, especially after her mother's death in May

1916. By late fall of that year, for instance, she began taking care of her sister Claudia, who followed O'Keeffe to Texas and enrolled at West Texas State Normal as a student.[15]

When an opportunity arose to teach again in the remote northwestern part of Texas in early 1916, O'Keeffe jumped at the chance. In January of that year, she received notice from West Texas State Normal President Robert Cousins that the college wanted to hire her as head of the art department.[16] In letters to Pollitzer, O'Keeffe expressed, after a period of intense negotiations with Cousins, her excitement to return to Texas: "Kick up your heels in the air! I'm elected to go to Texas [. . .] I just had a telegram from [Cousins] this morning telling me my election is certain [. . .] Isn't it exciting!"[17] She remembered what she had loved about living and teaching in Amarillo, and by September 1916, when she arrived back on the Texas High Plains, O'Keeffe wrote about the huge skies in the region and how she liked the glaring light of the atmosphere: "The country is almost all sky—and such wonderful sky—and the wind blows— blows hard—and the sun is hot—the glare almost blinding—but I don't care—I like it."[18] This letter holds one of O'Keeffe's many such exclamations about the raw beauty she discovered in West Texas.

By the time she began her position at West Texas State Normal, O'Keeffe had started writing lengthy letters, including almost daily ones to Alfred Stieglitz. Because of this extensive correspondence, her time living in Canyon offers a rich perspective on O'Keeffe's early days in the West, and on the western United States in the 1910s. As a result, we have a collection of highly detailed, almost moment-to-moment verbal accounts dating from fall 1916 to spring 1918 that feature her views on what she did, where she went, what she saw and felt, and with whom she spent time with. While she was residing in Texas, O'Keeffe's first solo art show opened in New York City in April 1917.[19] At that time, Stieglitz promoted her as one of the most authentic American artists he represented; she was uniquely "of" the American West for him and his New York audiences. Not the East Coast. Not European trained. An example of true American creative grit. In the June 1917 issue of Stieglitz's art and photography magazine *Camera Work*, a copy of which he sent to O'Keeffe in Canyon, his written dedication refers to O'Keeffe

as "the little girl of the Texas Plains." She was sending her art to Stieglitz with the return address of her current home in Texas: "My address will be Canyon, Texas, from now on."[20] But perhaps more than a simple geographic location is embedded in this phrase.

O'Keeffe did not see herself as a New York artist yet. At that time, she was making a home in Texas and wrote things in her letters like "I'd rather live here than any place I know if I could get to New York sometimes."[21] She also loved teaching her Texas students and equally enjoyed an active social life in the Panhandle. Describing her mentoring role, she wrote: "You know I get such a ridiculous lot out of living myself—and these boys and girls from the plains—get a lot out of it too [. . .] but I believe I can help them to get more—to get something they don't get now—I like them like the country [. . .] and it's absurd the way I like it—like to work in it."[22] She had even fallen in love with a Texas cowboy, Ted Reid, whom she considered marrying. As Reid explained in an interview in 1978, with loaded simplicity, "Well, I got quite well acquainted with Georgia."[23] In October 1917, O'Keeffe stated that she was indeed ready to marry Reid: if he asked her to "get right up and go with him," she wrote, "it doesn't seem that it would even be necessary to get my hat."[24] Meanwhile, she was flirting with and dating numerous other men as well, including Don Willard Austin, Kindred Marion Watkins, and Thomas Reeves, all of them married at the time. And, finally, she had not yet discovered her deep love of New Mexico; indeed, she saw the state for the first time only in August 1917, when she vacationed in Colorado during her time off from teaching at West Texas State Normal, and her train took a detour through the New Mexico landscape because of a washed-out railroad bridge.[25]

Part of what we retrieve through her early writings from Texas is O'Keeffe's young adulthood. Our retrospective knowledge of the outcome of her life—the knowledge that she became a world-renowned artist—often blinds us to the moments when she was, like any young professional, both contented and unsatisfied; was still developing her social identity and discovering whom she liked and who annoyed her; was finding her first expressions of her sexuality as a mature woman; was riding alone in cars with men,

"ridiculously fast" and without "any fear of speed"; was kissing these men and enjoying it; was lonely and extremely sick, without a parent or family member to care for her; and was deeply afraid of dying from tuberculosis as her mother had done so recently.[26]

We also retrieve a valuable perspective on what it was like living in the developing US West in the early 1900s, especially for a woman. The West, particularly West Texas, represented a conservative, Christian patriarchy with strict prescriptions about social behavior. Female students at West Texas State Normal, for example, were prohibited, according to the college student handbook, from riding in motorcars with men, a prohibition that O'Keeffe never followed, either because she was faculty and not a student, or because she simply didn't care to follow such rules.[27] O'Keeffe faced other prescriptive regulations as well: she regretted that she could not "go barefooted" around town if she wanted to and that she might lose her job if she decided to cut her hair short; and she found herself in an argument with her landlord over bringing a man upstairs to her rented room. "The little fat woman and I fell out," she wrote. "It was a most amusing talk—And that funny stupid man was here again—it was about his coming that we fell out—Imagine anyone telling me they objected to anyone coming to see me—I'm not really over the surprise yet—She is too funny for words."[28] In another instance, Reid described how one day, outside the boardinghouse where she took her meals, O'Keeffe broke the rules and did go barefoot: she "just sat down there on the front step and pulled her shoes off to rest her feet before she went on in the house." He continued: "I remember that. I was sitting out there and talking to her. We were visiting and talking, and two members of faculty came by and I noticed that they didn't know whether we should be reprimanded or seized!"[29] Here we see O'Keeffe willing to break the rules, but also the faculty and townspeople noticing with judgment her lack of scruples.

Despite the stringent controls she felt prescribed to her in Texas, O'Keeffe—along with other young women described in O'Keeffe's letters, including her sister, her women colleagues, and her friends, such as Leah Harris—discovered a new sense of unbounded freedom there. She wrote about how women would go on walks alone,

even at night, because "there was nothing there";[30] how they could arrange picnics together in the nearby Palo Duro Canyon unaccompanied by a male chaperone;[31] how they would hitchhike around the area, catching rides between Canyon and the city spaces of Amarillo;[32] how they would drive their own cars and motorcycles;[33] how they would shoot guns, play sports, and ride horses astride rather than sidesaddle;[34] in short, how they would manage their own time and leisure activities in the more rural West in ways totally disallowed in larger urban centers. O'Keeffe even questioned herself for permitting her sister to do so many daring things but reasoned that it did not matter so much out in Texas, where adventures and risk were a part of daily life: "I'm afraid she will shoot herself but guess it isn't any more likely than someone will shoot her through the wall."[35] At one point, after leaving Canyon for San Antonio to recuperate from her respiratory illness, O'Keeffe decided that she and Harris were going to run a farm in nearby Waring, Texas: "Half in fun but as we both had to come down here and quit work—why not in reality [. . .] I am beginning to think there isn't anything else I'd rather do right now." When Harris was asked by a male friend what business O'Keeffe had working on a farm, Harris "laughed and told him [Georgia] didn't know anything—didn't need to when she [Leah] knew enough for two."[36]

O'Keeffe's younger years were filled with networks and support systems of women that appeared to drop out of her life in her older years, as she later actively constructed her identity in ways that made her seem isolated and alone in her achievements, beyond a dependency on other women.[37] Her Texas letters, however, are filled with details about women friends and colleagues who provided social support for O'Keeffe. Linda Grasso's *Equal under the Sky: Georgia O'Keeffe and Twentieth Century Feminism* examines how O'Keeffe represented the New Woman: "Her physical mobility, irreverent ambition, and perception of herself as a 'damnably independent—self-sufficient young woman' and as a sexual magnet were characteristics of other women who shared her creed."[38] Grasso also connects O'Keeffe's embrace of "ennobled individualism, self-expression, and professional achievement as ultimate forms of liberty" to the "cherished American values" of freedom and

democracy.[39] What O'Keeffe's Texas letters reveal more specifically is how the New Woman and her "American" values took shape in particular ways in Middle America and the US West, in predominantly rural regions dotted with burgeoning urban centers such as Amarillo and San Antonio. In these spaces—and O'Keeffe specifically mentions the freedom in having lots of open space and air in Texas—women found different kinds of independence than in the eastern United States, reflecting regional nuances in the history of gender and feminism that deserve the recognition that O'Keeffe's Texas writings can offer.[40] For instance, O'Keeffe wrote that she wanted to "be a man" so she could go "hunting for that big loneness—away from folks."[41] She repeated often in her letters that the open plains offered her this desired isolation, but here she also connected that independence to masculinity. Only men could hunt for such self-sufficiency, she asserted, and as a woman she did not "have the courage to go as far as [she wanted] to alone."[42] But at the same time, she was actively finding independence and adventure for herself on her own terms. When someone asked her why she was in Canyon, considering that there was "nothing" there, she responded, "that was why [I] liked it."[43] In another letter, she described how she never wanted to depend on the men in her family: "You see—I can't help feeling independent—wanting to be free from everyone. [My family has] always objected to all the things I did—and I've done them anyway—I wouldn't ask the men of my family for anything to save their lives—I wouldn't even suggest that I wanted anything."[44] Here we see the New Woman identity playing out in her letters, but within the particular context of the West. This region gave her monetary independence because her faculty job was there, but also freedom from oppressive family judgment, and a sense of escape out in the "nothingness" of the still largely rural and undeveloped Texas High Plains.

Moreover, O'Keeffe's Texas letters also provide meaningful and fresh insights into the era of World War I. O'Keeffe was living and working in Texas in 1917 and 1918, when America joined the Allied forces in Europe. Indeed, the United States declared war on Germany in April 1917, the same month that O'Keeffe's first solo show opened at 291 in New York.[45] Suddenly everything changed

for America's citizens, and we can see this change as it inflects O'Keeffe's life and art. For instance, in large part because of the war, O'Keeffe's solo show was the last exhibition in that famous space of Stieglitz's 291.[46] The gallery closed permanently in early July. O'Keeffe only barely got to see her own show before 291 came to an abrupt end; when she showed up at the gallery in New York on May 24, having taken the train from Canyon without sending Stieglitz any warning of her arrival, he had just removed all her works from the walls.[47] He quickly rehung the show for her, and she saw, perhaps for the first time, her potential to be a nationally recognized professional artist. And yet it must have seemed as much like an end as a beginning. She read Stieglitz's words from June 1, 1917, where he imagines "the world without 291 [. . .] with the tears just rolling down [his] cheeks."[48] The issue of *Camera Work* that Stieglitz sent to O'Keeffe with his dedication to "the little girl of the Texas Plains" was also the last issue of this pivotal publication of modernism.

The modern art world that Stieglitz had been constructing in New York and that was starting to welcome O'Keeffe fell into hiatus. But O'Keeffe did not stop producing work after the United States declared war and 291 closed. Rather, she wrote to Paul Strand that "Art never seemed so worthwhile." She continued, "I have a million things to do—Must paint too—Must write too—I'm on the war path at such mad speed."[49] O'Keeffe realized that making art was the way she made sense of her world, and that her world in Texas was shaped by the war. She compared her own pace and passion for art making to being on a "war path." In other words, the war gave her new metaphors for productivity, and a new inspiration to make work. While living in Canyon, Texas, she produced more than one hundred watercolors, oil paintings, and drawings, keeping a pace that surely lived up to her artistic call to arms.

O'Keeffe's experiences in the context of the First World War have, to date, never been explored in their nuances. Scholars on the artist have often noted her tendency toward pacifism, and how she followed Stieglitz's strong antiwar sentiments developed within his New York milieu.[50] In contrast to Stieglitz, an East Coaster past the age of fifty, O'Keeffe experienced the war as a young professional

woman on the US home front, in the rural heartland, at the age where her peers were called up to fight.[51] O'Keeffe's letters offer a voice of careful observation and reflective passion about her time in Texas, but also of deep anxiety about war as part of her lived experience.

The war gives us a new way to understand the artist's biography, while it also reframes her role as an early twentieth-century modernist. O'Keeffe was among the first Americans to embrace artistic abstraction and was arguably the first to bring abstract painting to Texas.[52] Especially with her responses to the war, O'Keeffe also connected herself to broader global movements of modernism. O'Keeffe scholars have long noted her interest in Wassily Kandinsky's work, recognizing that by 1915 she was reading his book *The Art of Spiritual Harmony*.[53] However, Kandinsky's abstractions that specifically focused on war—including, most famously, *Improvisation #30 (Cannons)* (fig. 1)—have yet to be linked to O'Keeffe's work in light of the war era.

In a letter to Arthur Jerome Eddy, who purchased *Improvisation #30* in 1913, Kandinsky observed that "the presence of the cannons in the picture could probably be explained by the constant war talk that has been going on throughout the year."[54] Many of Kandinsky's works in that period offered no such references to objective realities and instead embraced nonobjectivity or total abstraction, making the approaches of O'Keeffe in America and Kandinsky in Europe seem divergent. Nevertheless, both artists clearly responded to the context of the war in their art and letters. O'Keeffe's need to produce creative work, which she compared to a "war path," resonates with Kandinsky's cannon imagery and the artist's explanation to the collector Eddy; both O'Keeffe and Kandinsky felt the pressure of the inescapable atmosphere of war in those years and used their art to make sense of that oppressive wartime culture.

O'Keeffe's "war path" metaphor also connects to the rhetoric of the Italian Futurists and the British Vorticists. F. T. Marinetti penned the first of his Futurist manifestos in 1909, which likened art to war and war to beauty, while Wyndham Lewis founded the journal

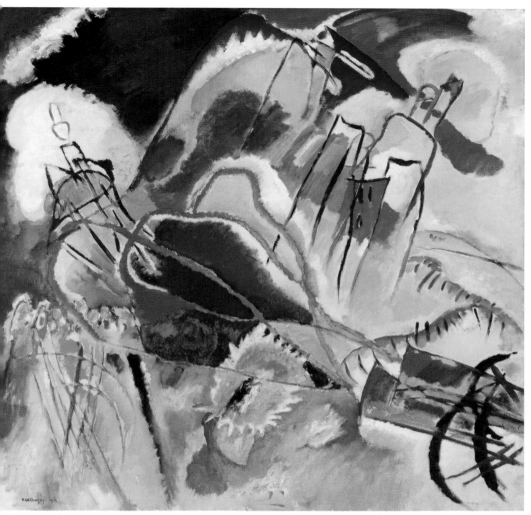

Figure 1. Wassily Kandinsky, *Improvisation #30 (Cannons)*, 1913, oil on canvas, 43 11/16 × 43 13/16 in., Art Institute of Chicago, Arthur Jerome Eddy Memorial Collection, 1931.511 © 2018 Artists Rights Society (ARS), New York / ADAGP, Paris. Photo credit: The Art Institute of Chicago / Art Resource, New York.

Blast in 1914 as a manifesto of the interdisciplinary movement of Vorticism, with its shocking pink cover and title printed at a dramatic downward diagonal meant to "blast" the eyes and minds of the reader with the radicality of the movement (fig. 2).[55] O'Keeffe embraced a similar bright pink color in several of her Texas paintings. For instance, a Panhandle snowstorm inspired her to label her sketch of a snow-covered roof with the word "pink" in decisive script. The final watercolor based on this sketch then became an eye-searing pink made with brazilwood pigments resembling the bold shade of Lewis's *Blast* cover (fig. 3). O'Keeffe also used that

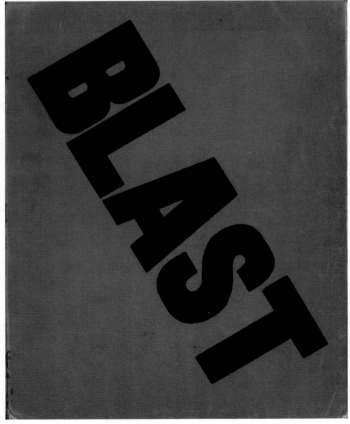

Figure 2. Cover of *Blast*, 1914. Image courtesy of Cushing Memorial Library & Archives, Texas A&M University.

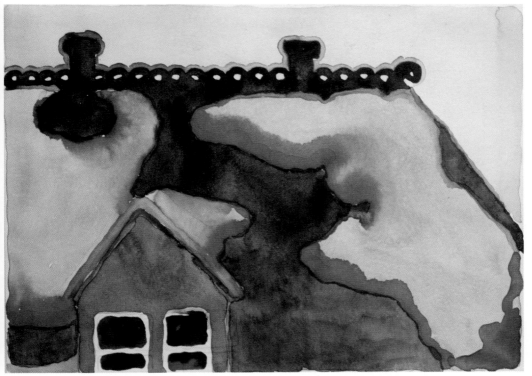

Figure 3. Georgia O'Keeffe, *Roof with Snow*, 1917, watercolor on paper, 8 7/8 × 11 7/8 in., Amarillo Museum of Art, purchased with funds from NEA, AAF, AAA, Fannie Weymouth, SFI, Mary Fain. © Amarillo Museum of Art.

same pink paint to render her own nude body in a way that recalls the Futurists' attempts to represent spatial movement and dynamism on a two-dimensional surface (fig. 4).[56] The artist's arms and leg double in form as if being reexposed on a photographic negative—not unlike the Futurist photograph *Typist* (1911) by Anton Giulio Bragaglia, where he left his camera shutter open to register the fluid ghost image of hands that rapidly tapped away on a typewriter. Alongside Bragaglia's experiments in the depiction of dynamic motion, O'Keeffe's *Nude* produced one of the most radically modernist images of the war years. Both in its screaming pink

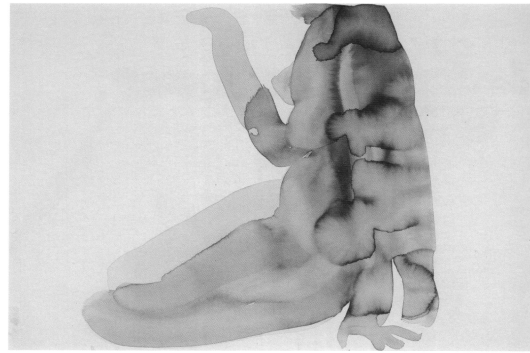

Figure 4. Georgia O'Keeffe, *Nude Series XII*, 1917, watercolor on paper, 12 × 17 7/8 in., Georgia O'Keeffe Museum, Gift of The Burnett Foundation and The Georgia O'Keeffe Foundation. © Georgia O'Keeffe Museum.

hue and in its layered, shifting forms, this nude figure—painted in July 1917 according to O'Keeffe's letters—seems to embody the very seismic shifts of the war era that deconstructed all traditional stabilities and lurched global humanity into a new age of uncertainty.[57] What these pink-based works show, but what has not been addressed by O'Keeffe scholars thus far, is how they are in clear dialogue with an international set of aesthetics—both visual and verbal—connected to the First World War. Even if O'Keeffe wasn't directly aware of or studying the European modernists, she nonetheless explored similar themes and ideas in this pivotal era.

In these war years, O'Keeffe wrote of "attacking" her art and teaching with the fervor of fighting, and she often saw her

public lectures at West Texas State Normal in terms again of "war paths," but also "explosions" and violent confrontations with the forms of traditional art and education she felt were destructive for America's youth.[58] At one point, she wrote: "I just knocked everybody's head against the wall and made hash."[59] She wrote to Stieglitz several times about risking her job because of her bold statements, wondering if she would be fired.[60]

Though she didn't speak of annihilating libraries, museums, or universities in the same way as the Futurists, she matched their passionate desire to "wage war" on the people and policies holding back a progressive future. Marinetti called on Futurists to "glorify war—the only true hygiene of the world—militarism, patriotism, the destructive gesture of the anarchist, the beautiful Ideas which kill."[61] O'Keeffe was never so unequivocal in celebrating war. But this restraint on her part is understandable given that the Futurists expressed their war fervor before the realities of trench warfare had set in, and before the attrition of millions of lives per year had become a pattern seemingly without end.[62] O'Keeffe, in contrast, was responding to the war in 1917 and 1918, when the steady death machine had been operating at full force for three years. By that time, several Futurists, including Umberto Boccioni and Antonio Sant'Elia, had been wounded or killed on the battlefield, making their earlier celebratory rhetoric on war ring hollow.[63] Still, O'Keeffe's fierce commitment to making and teaching art fits an international spirit of modernism that needs to be recognized.[64] She would have agreed with Marinetti when he wrote, "Beauty exists only in struggle," and a "masterpiece" emerges only from "an aggressive character," or with Lewis in his statement that artists are "Primitive Mercenaries in the Modern world" and that humor could be used "like a bomb" to liberate people from the retrogressive legacies of the past.[65] As isolated as she might have felt out in the Texas Panhandle, she shared a war experience based in aesthetics with artists and others across the globe. And like the modernists of her time, she saw creative expression as a social and political necessity, rather than an "art for art's sake" luxury.

Even while her Texas years connected her to artistic and political movements that transcended any one national context,

her time in Texas also provides a rich case study for a specifically
US identity during World War I, and one that spanned both rural
and urban contexts and reached across the US continent. What
was actually happening to students and young professionals in
the vast American landscape in those years? And how were they
feeling about it? O'Keeffe's writings give us a window into this
youth consciousness during the war. She was one of those people
on the home front in Texas, a woman who could not directly partic-
ipate in the battle effort by serving as a soldier, but who fought for
the US cause nonetheless. She taught at a college where her male
students were leaving for war, where her female students were
taking classes on canning and other ways women could contribute
to the war, and where patriotism among the college community
and the town of Canyon was strong and unyielding.[66] Her own
brother Alexis was in training as an officer in 1917, having signed
his registration card on June 5, 1917, the first day of the American
draft (fig. 5).[67] That day, millions of young men stood in line at their
local draft office for hours waiting to register.[68]

While she lived in Texas, war was often on her mind. It distracted
her from work and life: "What's the use. As usual—the things you
said about the War today were almost exactly what I had been think-
ing—This morning almost forgot to finish lacing my shoe [. . .] sitting
here pulling on the strings—thinking about the War."[69] Daily tasks
as simple as tying her shoes suddenly became difficult and seemed
unnecessary or silly when compared to the heaviness of war. She
also felt conflicted about the duty of young men as soldiers: "War
is killing the individual in it unless he has learned livingness—if he
had it he wouldn't be a good soldier."[70] The role of the soldier was
not abstract and distant for her; it was personal and close, affecting
her own brother and the male students at West Texas State Normal
who were her friends. Was a "good soldier," she wondered, some-
one who stepped up without a second thought to fight for his coun-
try? Or was it, more realistically, a young person who had doubts
and fears and even tried to escape service or put it off until he fin-
ished school? O'Keeffe's letters from Texas discuss these conflict-
ing ideas in poignant detail.[71]

Figure 5. Military registration card for Alexis O'Keeffe, signed in Madison, Wisconsin, June 5, 1917. Photo courtesy of the National Archives, Atlanta.

Again, we can bring out new layers of interpretation in O'Keeffe's Texas artworks in light of the war. She completed images of West Texas ranchlands that seem to have little to do with fighting or the traumas of the war. For instance, she painted *Untitled (Windmill)* and *Untitled (Windmills)*, which feature the ubiquitous windmills,

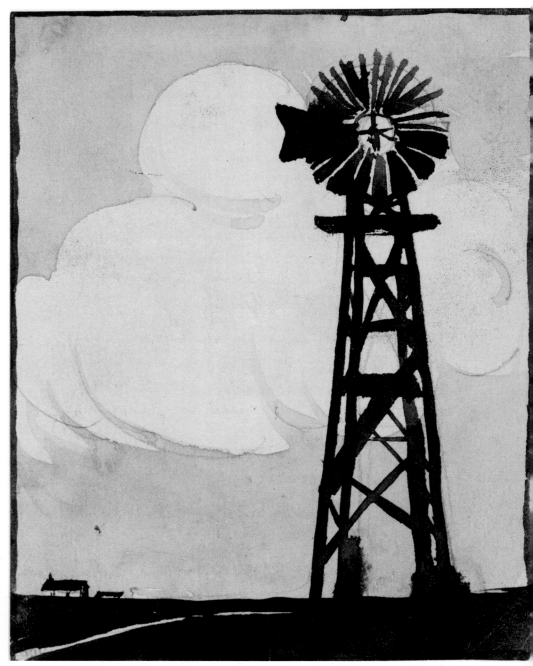

Figure 6. Georgia O'Keeffe, *Untitled (Windmill)*, 1916, watercolor and graphite on paper, 4 3/4 × 3 5/8 in., Georgia O'Keeffe Museum, Gift of The Burnett Foundation. © Private Collection.

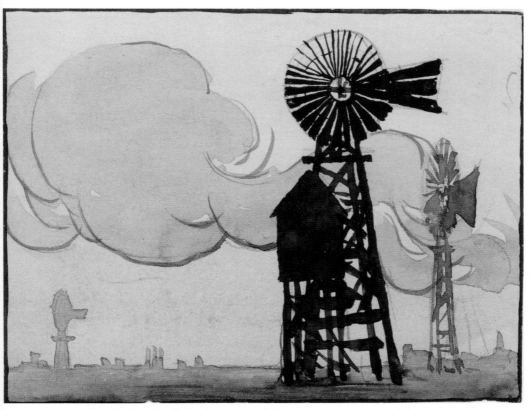

Figure 7. Georgia O'Keeffe, *Untitled (Windmills)*, 1916, watercolor and graphite on paper, 3 5/8 × 4 3/4 in., Georgia O'Keeffe Museum, Gift of The Burnett Foundation. © Private Collection.

water towers, and simple dwellings as the only forms that break up the big Texas sky and its perfectly flat horizon (figs. 6 and 7).[72] She also painted abstractions of sunsets with little bulbous forms set in the distance against that horizon, which could represent cattle grazing, such as *Sunrise and Little Clouds No. I* (fig. 8).

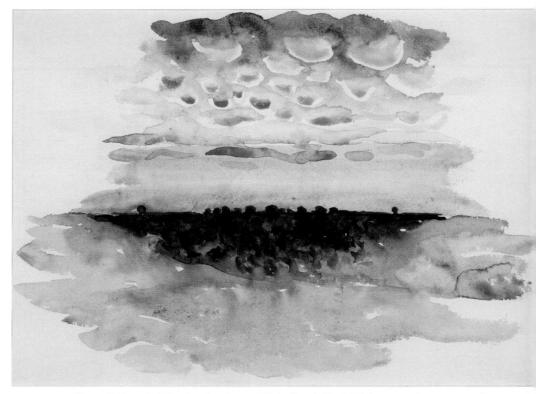

Figure 8. Georgia O'Keeffe, *Sunrise and Little Clouds No. I*, 1916, watercolor on paper, 9 × 12 in., private collection. © Georgia O'Keeffe Museum.

Though she never painted large-scale images of cattle that we know of, she did write about going to the county fair and finding the bodies of the cows beautiful, and about admiring Texas cowboys and cattle, while she described the unforgettable stench of the loading and holding pens in Canyon.[73] She was in the thick of cattle country and she knew it, even loved it.

However, these works and words also encapsulate aspects of the home front during the war. In her letters, we learn that she understood cattle ranching to be an alternative to war, and that war was seen as a distraction from the "real work" of raising animals that needed full-time care. O'Keeffe wrote about Reid, a man she cared

for deeply. In letters, she described Reid's hesitation to abandon his family's ranch: "Ted is a nice boy—No that's not the way to say it—I like him says it better—He is one kind of cowboy—Thinks he can't go to war right now because he has a lot of cattle down on the ranch that they have to keep through the summer."[74] This contrast between war abroad and agricultural labor at home was something that the US war administration recognized as well. Many men applied for and received exemption from service based on their contributions to the nation's agricultural needs. To be sure, raising cattle and wheat for the war effort was considered a patriotic duty alongside fighting as a soldier.[75] In a letter from a week later, O'Keeffe continued her description of Reid's choices: "Ted thinks maybe he will go down on the Rio Grande to be a River Guard—would rather do that than be just a straight run along soldier—Has a ranch and cattle down there."[76] Here, we see the struggles Reid was facing as a young man doubting he would make a good soldier, given his frontier independence perhaps, or his preference for work on the home front—indeed his responsibility to his family and animals— rather than in the European theater of war. And we see O'Keeffe empathizing with him, facing those decisions alongside someone she loved. According to O'Keeffe's letters, she and Reid often lay side by side underneath the Texas skies like the one she painted in *Sunrise and Little Clouds No. I.* While they shared a profound appreciation for the harsh and barren regional beauty, Reid and O'Keeffe were also talking about their futures. What could they look forward to? Fighting or ranching? Combat or marriage? Death or life? The date of these letters is also key—May 1917, one month after the war became very, very real for these young people in Texas.[77]

O'Keeffe's memories of Panhandle cattle also lingered with her after her Texas years, and she produced at least two abstractions based on these memories. As with her Canyon landscapes from the 1910s, these later works have yet to be read within the context of O'Keeffe's memories of war. In her 1976 autobiography, O'Keeffe specifically described her painting *Series I – From the Plains*, made after she returned to New York (fig. 9), in terms of the sound memories of lowing cattle.

She wrote that the forms in this work responded to the sounds

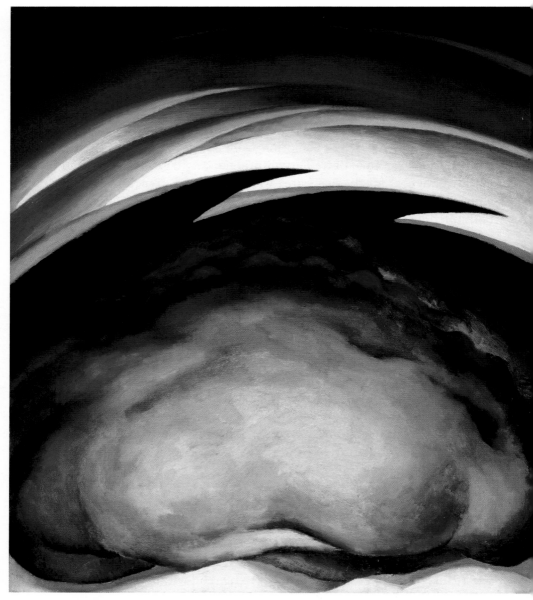

Figure 9. Georgia O'Keeffe, *Series I – From the Plains*, 1919, oil on canvas, 27 7/16 × 23 1/2 in., Georgia O'Keeffe Museum, Gift of The Burnett Foundation. © Georgia O'Keeffe Museum.

of Texas cattle, in particular the cows separated from their calves. She says that their lowing in the holding pens "always haunted" her.[78] Yet we might also see the sharp saw-blade edge and somber color palette that dominate this 1919 abstraction in reference to the soldiers O'Keeffe had known who were sent to war like cattle to market. Not only was the cattle industry an alternative to war and fighting, but it also gave O'Keeffe a metaphor for the "meat market" of the US military. She questioned why the older generation in Canyon sent their youth off to war "like sending the cattle to market," while they stayed behind with their "cars and their despicable selves—it's only the nice youngsters that go."[79] The lowing of the cattle may have resonated in her mind alongside the anguish of young men filled with trepidation as they waited in the Canyon train depot for their transport, and of their loved ones who had to say a tearful farewell: "More boys gone," she wrote, "mothers come to tell them goodbye."[80] O'Keeffe realized that the bodies of these soldiers were as owned and controlled as the bodies of the cattle in the holding pens. In her mind, older men with power and money had put them both there. The sound memory that O'Keeffe translated into a hard-edged and jagged form surrounded by what looks like storm clouds fat with raindrops suggests anxiety, trauma, and melancholy. O'Keeffe responded again to these memories in her later years too, in *From the Plains I* (fig. 10). The cool blues of her 1919 work became blistering oranges and yellows, as the intensity of her Texas memories exploded onto the canvas, with bright colors seemingly more searing than soft or inviting, more like the explosion of live ammunition than the somber sadness of a goodbye.

O'Keeffe's comparison of soldiers and cattle is decidedly fitting given her life in Texas. The cattle market was the primary source of power when she lived there—oil was discovered in the Panhandle only in 1926, so in the war years, cattle was the money-making industry.[81] And it would not have been the cattlemen or ranch owners who were shipped off to Europe. It was their sons, or their cowhands. While the ranch owners made money on their cattle and drove their newly purchased cars around the home front— this was an era when well-to-do Americans were first expected to

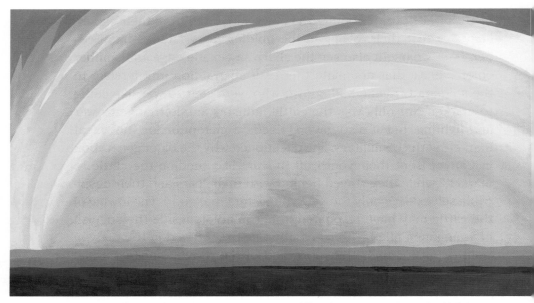

Figure 10. Georgia O'Keeffe, *From the Plains I*, 1953, oil on canvas, 47 11/16 × 83 5/8 in., McNay Art Museum, Gift of the Estate of Tom Slick, 1973.22. © Georgia O'Keeffe Museum. Image © McNay Art Museum / Art Resource, New York.

own cars—young people like Reid were being called on to fight for something far away and unknown.[82] O'Keeffe often wrote about this generational difference: "It's the older folks I cannot stand— The talk of men past thirty—The—women—Girls and boys and the ones who must fight are different."[83] She lamented how the "old dead ones hamper[ed] the young live ones," in words that sound strikingly familiar to Marinetti's Futurist advice to throw anyone over forty into "the waste paper basket like useless manuscripts."[84]

In these statements, we can tease out the nuances of O'Keeffe's opinions about her neighbors in Canyon. Scholars have tended to overstate her dislike of the townspeople without fully recognizing the precise wartime politics of her distaste.[85] O'Keeffe was commenting specifically on power structures, as someone who was interestingly caught between these two generations. She was just then thirty years old herself. She still identified with the West Texas

State Normal students: "I feel like one of them," she wrote.[86] They were the ones directly and bodily fighting for their country. However, she also felt herself holding some power equal to that of the older generations; she wasn't a student, but a professional educator and faculty member at the local college. Therefore, she felt she could and indeed had to speak out about her views on the ethics of war, to promote leadership for change in the educational and political systems in the United States, and to demonstrate increased empathy for the plight of young Americans. She wrote: "If I didn't like it here so much I wouldn't bother to jolt them—but I like it—and—I wonder why I like it—Isn't it queer that I like it here—like it so much."[87] She felt strongly that the structures of power and pedagogy needed to change, and she was dedicated to staying in Texas to change them. She gave students advice against blind patriotism, against being herd animals who simply followed their parents' guidance. She openly disagreed with the college policy of graduating male students early if they enlisted, not simply as a so-called pacifist, but because she saw this as an incentive that would lead to the tragic truncation of their futures, rather than to the successes in life that college promised them.[88] If we look again at letters from her Texas years through the lens of war, we begin to see that O'Keeffe was an inspiring mentor, educator, and public speaker who took her role seriously enough to stand up for her students and to "fight" alongside them for a better future.

O'Keeffe's writings connected to broad attitudes about the war. In his account of World War I and the rise of a modern consciousness, Modris Eksteins relates British, German, and French soldiers' frustrations with the civilian populations who could not understand the struggle of those fighting in the trenches. He explores how the older generations at home often became as much of an enemy for the soldiers as those fighting just across No Man's Land.[89] Eksteins quotes one French soldier, Charles Delvert, who wrote in his diary, "The best of France was at the front fighting the enemy and the worst was at home governing, if that is the word, the country."[90] Delvert's opinions about the young soldiers versus the institutions of power parallel O'Keeffe's. However, this principled gumption of the young O'Keeffe to "fight the good fight" during the war has

been somewhat lost in the artist's biographies, as accounts of her life and work often move quickly into the years after Texas when she became a full-time studio artist in New York through Stieglitz's support.[91] When she left San Antonio for New York permanently in the late spring of 1918, O'Keeffe never again worked as a full-time educator, and her early teaching persona still remains to be fully retrieved as part of her story. Significantly, this teaching identity emerged during the years surrounding the war and was therefore deeply inflected by this national and international crisis. Her letters from Texas give us a picture of her young years that should be recognized for her own story, but also for the light they can shed on the era of the war in America and beyond. As we are now celebrating the centennial of US involvement in the First World War, no time is better to look again at O'Keeffe's life in Texas.

O'Keeffe's letters offer a moving account of what daily life was like on the US home front. For instance, she described the struggle to continue everyday activities in the face of trauma. She wrote that even while she was having "lots of fun" dancing with friends and students, it was hard for young people to feel "exactly happy" because of the "turmoil" of war: "The dance was lots of fun [. . .] I don't know exactly why—but it was more fun than usual—It was great to see Ted—his face very red—outdoors all the time—seventy-five miles to get here—faces turn a wonderful color from sun and wind here—His eyes so shining—Not exactly happy—war—everything a turmoil—grabbed my hand right tight—dancing."[92] She described how Reid hesitated to be fully joyful, to celebrate without an edge of sadness, along with the people at a party. Dancing with him, O'Keeffe may have felt guilty that she, too, was enjoying herself even while knowing he might soon disappear into the fighting. And if he returned, he would be forever changed. After Reid had left for military training and then she saw him again, she felt that indeed he wasn't "himself anymore," that his "freedom" and "realness" had been dampened.[93] In another letter she wrote after she had left Canyon for San Antonio, she told of running into a West Texas State Normal student who had joined the army: "We went to the bank and while we stood in line I turned round and there was Frank Day—Lieutenant Day—one of our Canyon army boys—He

almost stood on his head—it was great to see how excited he was—and changed though still the same."[94] O'Keeffe was surprised to see Lt. Day again, but she also recognized that he was not the same boy she had remembered when he was a student in Canyon.

In still another letter, O'Keeffe explored the idea of giving her own life for the cause of war: "Everything [is] war and I can't get enough of it—and still it almost drives me crazy. I'm not at all certain that my feeble mind has been able yet to center on anything that would make me willingly offer my life if the excitement and adventure were taken out of it all."[95] She had trouble imagining herself giving her life for the cause of the war; but at the same time, as a woman on the home front, she seems somewhat envious of the excitement and adventure of war, something she can only contemplate from a distance while continuing to live her life as if everything were normal. In October 1917, she wished she could find another home without war, or at least join in the fight: "I wish there were another country to go to—I'd like to leave this one for a country where there isn't war—or else I'd like to go to Europe and see what it's really like—Still—it makes me sick—nauseates me just to talk about blood—and internals—I wonder what it would be like to see folks mutilated—only parts of folks—wonder if I'd get used to it—I'd like to try—You know—I feel as if I can't stand it here much longer [. . .] If I were a man I'd get up and go to war so fast you couldn't see me."[96] She was curious about how hard it would be to participate in the battles, wondered whether she could stomach it. She did not know whether to run away or to run toward the war, to flee or to fight; but then, as a woman, she knew she didn't really have that choice. She reveals her envy again in a letter written in November 1917: "I should think going to War would be a great relief from this everlasting reading about it—thinking about it—hearing talk about it—whether one believed in it or not—it is a state that exists and experiencing it in reality seems preferable to the way we are all being soaked with it second hand—it is everywhere—I don't know—I don't know anything."[97] She even admits that she could be a "murderer," that she "could kill" if she had to.[98] For O'Keeffe, the reality of the death and destruction of the warfront flooded her mind, surrounded her with anxiety but from afar, an obtuse pain rather than acute. She felt

denied that "relief" of jumping into the action, when thinking could stop and the comfort of automatism could take over.

In perhaps her most pithy letter about the war, she beautifully summarized how difficult it was to make sense of the conflict: "Everything war and I can't get enough of it [. . .] I wish that for a thing so tremendous and terrible as what is happening I might put my hand on some cause and desired result that I could feel definitely justifies it all—but I hunt all around—it is like chasing an almost invisible slippery nut—small—slippery—hard to crack—slippery—Everything contradicts the other."[99] War was slippery, contradictory, infuriating. Just as O'Keeffe throughout her life chased the perfect design to reflect her mind's visions of creation, "wrestling all day" with an idea, often to her own severe frustration in the face of her failed attempts, she likewise chased the meaning of war in Texas.[100] She wrote of working like a whirlwind or a tornado, metaphors from the plains, to get a picture right, just as we see her pouring that same determination into her thinking, writing, and public speaking about the war.

O'Keeffe often talked about the bursts of creativity she had in Canyon, as when she produced her *Evening Star* series (fig. 11). She wrote: "Painting in my spare time—it's big and it looks like Hell let loose with a fried egg in the middle of it—and I'm crazy about it anyway [. . .] I feel as though I've burst and done something I hadn't done before. The sister is liking it very much too— Oh it's great to feel full of work again—It's terribly red—and such fun."[101] O'Keeffe described how she had figuratively exploded with creativity to create this series of abstract forms that were filled with so much energy and passion. But we know that while she was "fighting" to produce these forms in March 1917, she was also thinking about war and fighting, even before the United States joined the war in Europe. That same month, she wrote to Stieglitz that she was reading the book *Why Men Fight* in her spare time.[102] She was already thinking about the reality of war coming to the nation's and her own doorstep. As much as we can see the dramatic beauty of the Texas evening sky in this image, we might also see tension, apprehension, and building anxiety. These

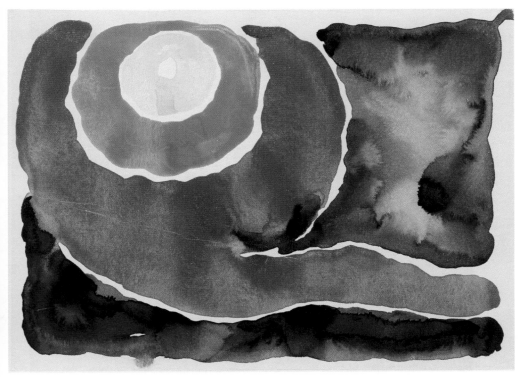

Figure 11. Georgia O'Keeffe, *Evening Star No. V*, 1917, watercolor on paper, 8 5/8 × 11 5/8 in., McNay Art Museum, Bequest of Helen Miller Jones © Georgia O'Keeffe Museum. Image © McNay Art Museum / Art Resource, New York.

sentiments pushed O'Keeffe to produce creatively—"never has art been so important as it is now."

We could also compare the burst of creativity she described with her *Evening Star* series to the explosion of color and light in the upper right of her *Red Landscape* (fig. 12). We do not know exactly when she completed this painting, whether it was before or after America's declaration of war.[103] What we do know is that the burst of light may reflect her own moment of enlightened inspiration, as well as the blazing light and bright colors she saw in the plains sunsets; but perhaps it also responded to her imaginings

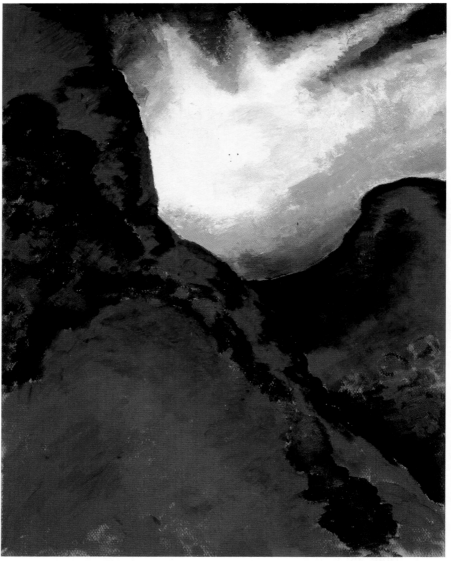

Figure 12. Georgia O'Keeffe, *Red Landscape*, 1917, oil on board, 24 × 19 in., Panhandle-Plains Historical Museum, Canyon, Texas, Gift of the Georgia O'Keeffe Foundation. © Panhandle-Plains Historical Museum.

of exploding bombs on the battlefront, visions conjured from a distance that made her feel quite helpless. Is this light hopeful or destructive? Like any great abstractionist, O'Keeffe doesn't give us the answers. She allows us to guess, surmise, and play with ideas in response to her art. *Red Landscape* can be all these things. Surely, it represents something bigger than ourselves, life as well as death, creation as well as destruction. Something both inspiring and terrifying, even the beauty of "what comes after living," words she used to describe the vast space of the open plains in Texas.[104] Such words and ideas take on a new resonance when we think about how she faced the reality of death in a more pressing way during the war.

That same painting, *Red Landscape*, highlights the red color that inspired O'Keeffe in Texas, along with the shocking pink of her *Roof with Snow* and her *Nude* (figs. 3 and 4). She wrote about the red of the cliff walls of Palo Duro Canyon, and about the red-bloodedness she found herself loving in certain people that she met in Texas.[105] This redness should not be taken too literally because the walls of Palo Duro Canyon are more orange or terra cotta; but O'Keeffe's red derived from a subjective, inner redness that she discovered in the Texas canyonlands and the rugged lifestyles required of inhabitants there. When she painted her own nude body, she used a variety of reddish-pink hues and described them as resembling the area landscape and her painting of it: "I painted them all red—It has a curiously funny quality—A feeling of bigness like the red landscape."[106] When she became frustrated with the people in Canyon, she described them as lacking "any red at all": "I hate it here—It's a lifeless bloodless sort of life to live—No one I can think of here seems to have anything but white blood—no red at all."[107] And she watched as some of the young people who loved "living" and still had some red in their blood were forced to risk that "livingness" and "redness" by fighting in the war. So perhaps the loss of life and red blood is equally embedded within the bloody red of O'Keeffe's *Red Landscape*. Its lumpy, craggy texture stems in part from her lack of dexterity with oil paint at the time, when she was more focused on watercolor as her primary medium, while it also beautifully suggests the rough textures of western canyon walls and the

"livingness of life." However, it can simultaneously read as wounds or scars or burns, threatened human flesh in a time of war, or even as the rough walls of the earthen trenches and blown-out shell holes on the Western Front.

In certain letters and in certain situations in Canyon, O'Keeffe was highly critical of extremist wartime patriotism. However, she consistently remained an American patriot. She viewed the war through a skeptical lens that reflected an independence of thought particularly remarkable for a young woman in the 1910s. As Reid witnessed, O'Keeffe "just had a different turn. She just looked at the whole situation differently."[108] For instance, she went back and forth about her response to "the flag" and its symbolism. At one point, she wondered how she could support the war effort when she felt she could not simply or blindly "clap and wave a flag." She wrote this in response to a discussion with Stieglitz about wartime parades in New York and across America, but in the same section of her letter she mentioned the writings of Nietzsche, revealing her serious contemplation of America's opponent Germany and the German cultural contributions to the modern age. She talked about how she and Leah Harris were fighting over a volume of Nietzsche's writings in Canyon, as both wanted to read it and felt connected to it.[109] But O'Keeffe clearly found reprehensible the blind patriotism of the older generations in Canyon and connected such militaristic "flag waving" directly to German culture. Her letter to Stieglitz revealed this. She was surely aware of the rise of German militarism between 1871, when Prussia united the nation, and 1914, when Germany had become the leading military power of Europe, if not the world. She had lived through much of that shift in the global balance of power. Nevertheless, her opinions on Germany were complicated. At one point, she openly criticized a Canyon drugstore owner for selling Christmas cards with what she saw as an unnecessary warmongering message that America should "Wipe Germany Off the Map," something she could not coordinate with a holiday spirit.[110] She wrote several letters about the drugstore incident, describing how it yielded a response on campus and in the community, labeling her as anti-American. In another instance, O'Keeffe appears to sympathize with the many

German American citizens of Canyon who became "nervous" after the declaration of war in light of local anti-immigration and anti-German sentiments. O'Keeffe wrote on April 29, 1917, describing her visit with an immigrant couple: "I didn't want to stay but I am sorry for them—He is a Rumanian—she a German—Been here seventeen and twenty-two years—Foreign—and some way folks do not understand—It was bad—I didn't enjoy it a bit—He very quiet—she nervous and excitable—It is terrible."[111] In other words, O'Keeffe struggled with notions of patriotism and militarism, coming both from enemy nations and from civilians on the home front. Her stance on the war was indeed a "slippery" nut that was "hard to crack."

In the same letter in which she said she couldn't just clap and wave a flag, she also asked, "What's the use of Art—if there is war," a doubt she also expressed in April 1917, just after the United States officially entered the conflict.[112] But after she had visited her brother Alexis, who was in officer training at Camp MacArthur in Waco, Texas, around Thanksgiving 1917, she seemed to reverse her attitude about the flag and patriotism: "The soldier mind is a revelation to me. It seems as though I never felt a real honest need of Art before—it never seemed necessary before—It seems as though I feel more on my own two good feet than I ever have in my life before—I hope they don't dampen me completely the minute I get off the train in Canyon [. . .] I didn't want to come home—but I feel as though I have lots to do—lots—and one thing to paint—It's the flag as I see it floating."[113] Her sentiment likely corresponds to her watercolor painting *The Flag* (fig. 13).

By the time she painted this flag, she had received news of her brother being shipped off for Europe in January 1918, when she was gravely ill and unable to cover her teaching schedule at West Texas State Normal. And then she learned that his ship had sunk off the coast of Ireland that February, right before she left Canyon for the San Antonio area to recuperate in a milder climate than that of the Texas Panhandle.[114] Though Alexis did not perish in this shipwreck, news traveled slowly, and for a time O'Keeffe faced the potential of her brother's death. After a brief recuperation in Ireland, Alexis fought in the trenches of France, was the victim of

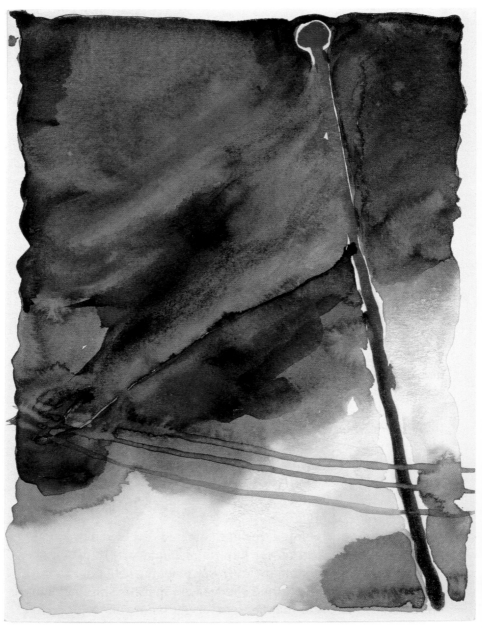

Figure 13. Georgia O'Keeffe, *The Flag*, 1918, watercolor on paper,
11 15/16 × 8 13/16 in., Milwaukee Art Museum, Gift of Mrs. Harry Lynde Bradley,
M1977.132. © Georgia O'Keeffe Museum / Artists Rights Society (ARS), New York.
Photographer credit: Larry Sanders.

gas attacks, and fell ill with the Spanish flu; he died in 1930 at the age of thirty-eight, his life shortened by the damage to his heart and lungs during the war.[115]

When O'Keeffe completed her flag painting in 1918, she rendered an image that does not exactly depict America's flag; its surface patterning is obscured. But the colors of the work are clearly red, white, and blue, evoking patriotism for America's cause in the war even while holding on to that "slipperiness" she observed, and the pain she felt in learning of her brother's close calls in Europe. The amorphousness of this flag, and its lack of being a clear or single universal response to war, are precisely what makes the work such a powerful statement of US wartime identity. Its fabric appears torn or distressed, as if used in battle: "A dark red flag trembling in the wind like my lips when I'm about to cry."[116] But the flagpole's linearity anchors that quivering: "There is a strong firm line in it too—teeth set—under the lips."[117] And yet, the crimson imperfections along the linear pole shine like coats of wet blood on the wood. It offers a statement of resolve and patriotism but also asks, at what cost?

The subject matter of the flag in paintings made during the war raises the comparison of O'Keeffe's work to Childe Hassam's images of New York's Fifth Avenue draped with flags, which he completed between 1917 and 1918 (fig. 14).[118] Hassam's use of abstraction as an American Impressionist, in which he played with the patterns of light and color formed by the numerous flags moving in the soft breeze, still shows each individual flag with relative clarity. Hassam's paintings are not always simplistically celebratory and often have a sense of melancholy embedded within them, comparable to O'Keeffe's, especially the ones in the rain where the flags melt into the thick, wet atmosphere. But Hassam's images also offer a clear contrast to O'Keeffe's single flag painting with its intangibility and fragility, as well as its bold geometry of dominant diagonals that compose a sharp central triangle drawing more on the abstraction of Cubism than Impressionism.

The ripped and frayed edges of O'Keeffe's flag moreover recall Frederic Edwin Church's *Our Banner in the Sky*, made in 1861 in

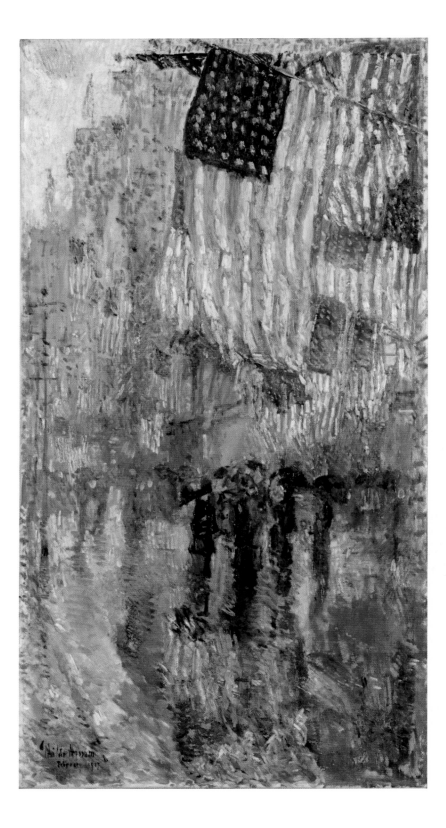

response to the Confederate attack on Fort Sumter as the first battle of the US Civil War (fig. 15).[119] Church produced the image as a color print that was widely circulated at the time, and its diagonal silhouetted tree with a sky at sunset forming the flag image behind the tree eerily mirrors O'Keeffe's flag image from more than fifty years later, especially in its diagonal pole form, the wispy clouds of the red and white stripes that look torn and distressed, and the red color glowing like freshly spilled blood.

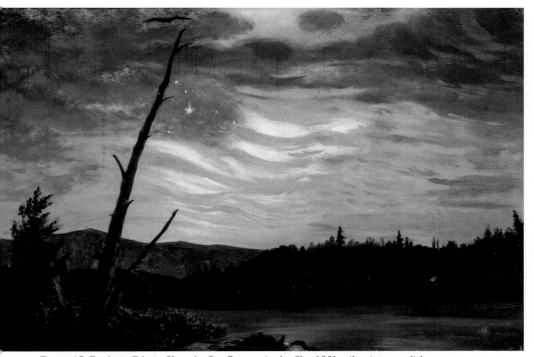

Figure 15. Frederic Edwin Church, *Our Banner in the Sky*, 1861, oil paint over lithograph on paper, laid down on cardboard, 7 1/2 × 11 3/8 in., Terra Foundation for American Art, Daniel J. Terra Collection, 1992.27 © Terra Foundation for American Art, Chicago.

(at left) Figure 14. Childe Hassam, *The Avenue in the Rain*, 1917, oil on canvas, 42 × 22 1/4 in. White House Collection / White House Historical Association, Gift of T. M. Evans, 963.422.1.

This comparison also reminds us that the closest total war in the memories of many US citizens living through World War I was the American Civil War, and therefore the complex blend of trauma and patriotism in both paintings is all the more resonant.[120]

The lines in the bottom third of O'Keeffe's painting add further abstraction to her work in contrast to the more mimetic representations of Hassam and Church. These lines could reflect telecommunication lines, such as telephone or telegraph lines, reminding us of the speed and technology so celebrated by the Futurists before the war began. However, they could also reflect railroad tracks. There are three lines, not two, but O'Keeffe used the same three clear lines to resemble railroad tracks in *Train Coming In, Canyon, TX* (fig. 16).

In the 1910s, the train for O'Keeffe offered the reality of mobility, the means to travel to Amarillo from Canyon for a day trip to shop, visit a friend, see her doctor, or view a film at the theater; it was the way she got back to New York in May 1917 to see her solo show on the walls at 291; and it was how she saw the mountains of Colorado and New Mexico during her summer vacation in August 1917.[121] But the train was also a machine of war in 1917. Trains took her student-soldiers away from Canyon to their stateside training stations, just as they transported soldiers throughout the European front. She wrote: "Boys leaving school and going to war—the best ones it seems [. . .] I don't know—it's bad—a few new ones getting the fever every day—leaving on one train or another."[122] The Italian Futurists had also painted trains as war machines (fig. 17). The warm pastel colors of these two train paintings are comparable, while for both works produced in the context of World War I, the reality of trains as tools of war cannot be ignored.

In O'Keeffe's paintings of flags and trains, the artist seems to claim that being patriotic, just like being an American during the war, was layered, complex, and challenging. The Great War was a time when the United States arguably first asserted itself as a leading nation on the international stage. General John J. Pershing refused to let his troops be commanded by French or English officers once the nation entered the war; rather, he held to his stance

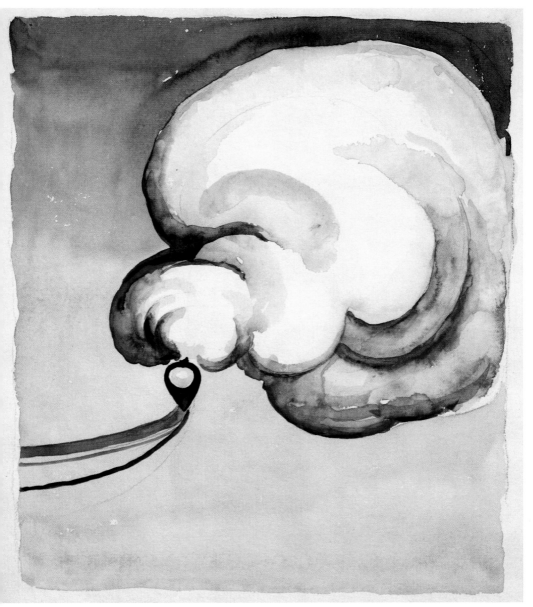

Figure 16. Georgia O'Keeffe, *Train Coming In, Canyon, TX*, 1917, watercolor on paper, 11 7/8 × 8 7/8 in., Amarillo Museum of Art, purchased with funds from NEA, AAF, AAA, Fannie Weymouth, SFI, Mary Fain. © Amarillo Museum of Art.

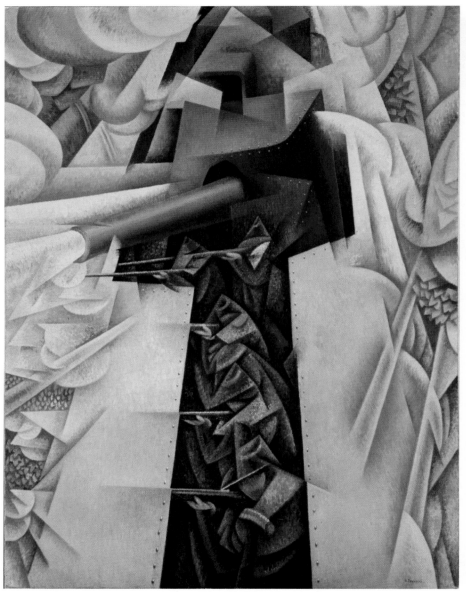

Figure 17. Gino Severini, *Armored Train in Action*, 1915, oil on canvas, 45 5/8 × 34 7/8 in., Museum of Modern Art, gift of Richard S. Zeisler © Artists Rights Society (ARS), New York. Digital Image © The Museum of Modern Art / Licensed by SCALA / Art Resource, New York.

that America was a sovereign nation and that he would command his own troops, a policy he would never waver from.[123] It was a time when Americans struggled—on the battle front and on the home front—with exactly how to be patriotic, and when a unified national identity was severely challenged by racial and ethnic differences in the population, a struggle that O'Keeffe's art and letters reflect.

Her palette of red, white, and blue continued beyond her 1918 flag painting. In at least one instance, she used these colors in a work that directly referenced her time in Texas. In an interview from later in her life, she described how her skull imagery in *Cow's Skull: Red, White, and Blue* (fig. 18) related to her discovery of the cattle industry when she lived in Texas, and how it represented the real "American scene" for her: "I had lived in the cattle country—Amarillo was the crossroads of cattle shipping, and you could see the cattle coming in across the range for days at a time. For goodness' sake, I thought, the people who talk about the American scene don't know anything about it. So, in a way, that cow's skull was my joke on the American scene, and it gave me pleasure to make it in red, white, and blue."[124]

Her reference to patriotism here was layered with irony and skepticism; she never took the "American" color palette to be something simple without recognizing the surface clichés embedded with deeper, even contradictory meaning. This painting also plays with gendered stereotypes of the American West, with O'Keeffe "masculinizing" her art by foregrounding this reference to the male-oriented cattle industry.[125] At the same time, she created a cruciform shape with the black vertical stripe behind the skull, where the horns form a crossbar. The background in blue and white has folds as if made of fabric, perhaps pointing back to her flag painting of 1918. And in the context of a crucifix, the red vertical borders suggest the spilling of blood—in a Christian context as well as in the US fight abroad in World War I. So not only does this work play with notions of nationality and the American West; it also references the death, martyrdom, and sacrifice that connect O'Keeffe to her memories from Texas, including her memories of war.

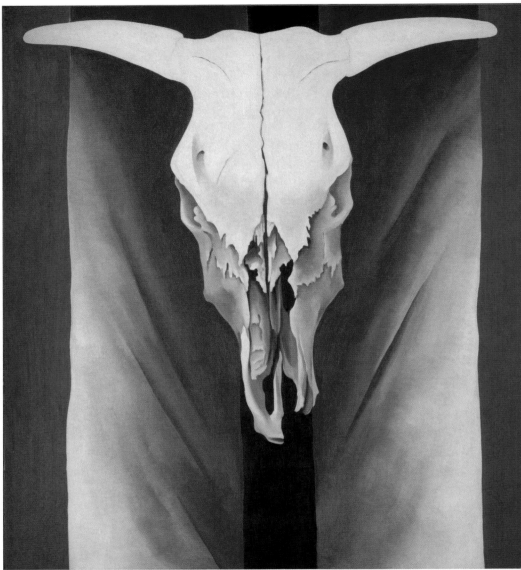

Figure 18. Georgia O'Keeffe, *Cow's Skull: Red, White, and Blue*, 1931, oil on canvas, 39 7/8 × 35 7/8 in., Metropolitan Museum of Art, Alfred Stieglitz Collection, 1952 (52.203) © Metropolitan Museum of Art, New York. Image © The Metropolitan Museum of Art. Image source: Art Resource, New York.

It is interesting to compare her Texas letters penned in 1916 to those written after the United States joined the war. For instance, whereas she raved in September 1916 about the wonderful great big sky, by November 1917—after the country had spent more than six months at war—she wrote: "The outdoors comes nearer bringing me to life—making me feel something [. . .] It seems the first life I've felt in ages [. . .] The plains are wonderful—mellow looking— dry grass—the quiet and the bigness of it—anything that makes you feel quiet and bigness like that is marvelous—wouldn't it be great in a person—why can't I make it into shapes—I wish I could want to try."[126] Things are still "wonderful," but now with a clear tinge of melancholy. "It's like walking around in a dream with your eyes open," she wrote on October 1, 1917, "a queer stupefied sort of existence."[127] In another letter from that month, she lamented, "It's as though the sky will never be clear again."[128] In her later Texas letters, O'Keeffe often expressed confusion and numbness, self-doubt and worthlessness. She began to write frequently of being unsure, disillusioned, and even of "not want[ing] to live."[129] On April 24, 1917, she wrote: "It's hurt everywhere these days— everywhere you turn something to tell you of it [. . .] There is a deadening sort of consciousness of it all."[130] Then, months later, in January 1918, she verbalized that she felt "like Nothing— Nowhere—Never." This feeling of "nothingness" and that "nothing mattered" became a recurring theme in her writings during the war.[131] O'Keeffe's letters from Texas remind us how even when we search for certainty and complete clarity about anything— war, patriotism, or what it means to be an American—we often search in vain. Those notions are so very complicated—but in that complication, O'Keeffe found inspiration, creativity, productivity, community, freedom, and independence. So we can surely learn about Texas and the West from the young O'Keeffe, but we can also learn some profound ideas about US identity, especially in times of war.

[1]

1916

FINDING THE "WONDERFUL PLAINS" OF TEXAS

O'Keeffe to Anita Pollitzer, January 14, 1916,
Columbia, South Carolina

Anita—I'd pack my trunk and leave for half a cent—I never was so disgusted with such a lot of people and their ways of doing—I halfway have a new job out in Texas—hope I get—I'll have a cat and a dog and a horse to ride if I want it—and the wind blows like mad—and there is nothing after the last house of town as far as you can see—there is something wonderful about the bigness and the loneliness and the windiness of it all [. . .] sometimes I've seen the most wonderful sunsets over what seemed to be the ocean—It is great—I would like to go today—Next to New York it is the finest thing I know—here I feel like I'm in a shoe that doesn't fit.[1] [. . .]

O'Keeffe to Pollitzer, February 1916,
Columbia, South Carolina

[. . .] I'm so tired that my ribs ache—I've just written four letters that make me want to knock my head off—blow my brains out—It's that darned Texas job—I'd rather not have it than haggle over it almost. If I get it—I'll have to give up so many things that I like that I almost hate to think about it. Goodnight—I'll write you more tomorrow—Nothing but rain.[2]

O'Keeffe to Pollitzer, February 1916,
Columbia, South Carolina

[. . .] I wanted to pack my trunk all day today and leave this darned place—I don't know about Texas yet for sure—we are haggling and tearing the air over it—I'll probably know soon—I don't know—I may not go—I really don't care like I ought to [. . .] I think if they decide that they want me in spite of my shortcomings—They asked me to apply for it you know—I think now it is very probable that I will not go till June if I go at all—and I am thinking I will just pick up and leave here—if I find I am going to the desert in June[3]—I don't know—I really have no plans beyond today [. . .]

O'Keeffe to Pollitzer, February 1916,
Columbia, South Carolina

[. . .] The [letter] last night was from Texas—we are still jawing at one another. It all riles me up till I feel that I simply must do something rash. Now he wants to know if I will go up and take Pa Dow's class in Methods next summer if I am elected to go to Texas in September.[4] Well—I told him I would go right now—so I may be up. I seem to be hunting madly for an excuse to leave here [. . .]

O'Keeffe to Pollitzer, February 1916,
Columbia, South Carolina

Dear Anita: Kick up your heels in the air! I'm elected to go to Texas and will probably be up next week. I am two hundred dollars short of what I need to finance me through the time I want to spend in New York but if I can't scratch around and chase it up from somewhere I'll go without it—because I'm going. I'm chasing it—hunting for it at a great rate—I just had a telegram from the man this morning telling me my election is certain but he wants me to go to T. C. for this term as I understand it[5]—He says letter will follow—I'll

probably get it Saturday—then things will be more definite—the place is certain—on condition as I understand it—and I like the condition better than the place [. . .] My head is about to pop open so guess I'll not write any more. Isn't it exciting! I can't believe it will come true—Can you?

O'Keeffe to Stieglitz, September 3, 1916, Canyon, Texas

[. . .] <u>I'll be damned</u> and I want to damn every other person in this little spot—like a musty petty little sore of some kind—on the wonderful plains. The plains—the wonderful great big sky—makes me want to breathe so deep that I'll break—There is so much of it—I want to get outside of it all—I would if I could—even if it killed me—I have been here less than twelve hours—slept eight of them—have talked to possibly ten people—mostly educators—<u>Think</u> quick for me—of a bad word to apply to them—the <u>little</u> things they forced on me—they are so just like folks get the depraved notion they ought to be—that I feel it's a pity to disfigure such wonderful country with people of any kind—I wonder if I am going to allow myself to be paid eighteen hundred dollars a year to get like that[6]—I never felt so much like kicking holes in the world in my life—Still there is something great about wading into this particular kind of slime that I've never tried before—alone—wondering—if I can keep my head up above these little houses [fig. 3] and know more of the plains and the big country than the little people[7]—Previous contacts make some of them not like my coming here [. . .]

I waked and heard the wind—the trees are mostly locust bushes twenty feet high or less—mostly less—and a prairie wind in the locust has a sound all its own—like your pines have a sound all their own—I opened my eyes and simply saw the wall-paper. It was so hideously ugly—I remembered where I was and shut my eyes right tight again so I couldn't see it—with my eyes shut I remembered the wind sounding just like this before—I didn't want to see the room—it's so ugly—it's awful and I didn't want to look out the window for fear of seeing ugly little frame houses [. . .] The sound of the wind is great—But the pink roses on my rugs! And the little squares with three pink roses in each one—dark-lined squares—I

have half a notion to count them so you will know how many are hitting me—Give me flies and mosquitoes and ticks—even fleas— every time in preference to three pink roses in a square with another rose on top of it—Then you mention me in purple—I'd be about as apt to be naked—don't worry—! Don't you hate pink roses—!

[. . .] Your letter makes me want to just shake all this place off—and go to you and the Lake[8]—but—there is really more exhilaration in the fight here than there could possibly be in leaving it before it's begun—like I want to.—After mailing my last letter to you I wanted to grab it out of the box and tell you more—I wanted to tell you of the way the outdoors just gets me—Some way I felt as if I hadn't told you at all—how big and fine and wonderful it all was—It seems so funny that a week ago it was the mountains I thought the most wonderful—and today it's the plains—I guess it's the feeling of bigness in both that just carries me away [. . .] When one lives one doesn't think about it I guess—I don't know— The Plains sends you greetings—Big as what comes after living—if there is anything it must be big—and these plains are the biggest thing I know [. . .] You are more the size of the plains than most folks [. . .]

O'Keeffe to Alfred Stieglitz, September 8, 1916, Canyon, Texas

I must write you tonight—I don't know why except that I seem to think I must tell you a little of what living here means to me. That mixture I sent last Sunday may be a bit deceiving [. . .] I don't know what I wrote last Sunday only I remember I was just snorting mad at the educators—Well—even if I was I'm glad I'm here—In fact—I like it so much that I wonder if it's true—The country is almost all sky—and such wonderful sky [figs. 6, 7, 8, and 10][9]— and the wind blows—blows hard—and the sun is hot—the glare almost blinding—but I don't care—I like it—The work? I like that too—rather—I am going to—I think—because—well—You know I get such a ridiculous lot out of living myself—and these boys and girls from the plains—get a lot out of it too—in a way—but I believe I can help them to get more—to get something they don't

get now—I like them like the country—I've lived out here before you know—twenty miles from here[10]—and it's absurd the way I like it—like to work in it—The building is all new—one just like it burned two years ago[11]—of course this one is better in many ways—but it seems so remarkable that this land of nothingness can get a building like this planted way out here at the end of the earth—The funniest thing to me is a swimming pool[12]—out here on the plains where it only rains twice a year sometimes—And it's as fine a swimming pool as they have at Columbia—Because I pawed up the earth last Sunday don't think I don't like it—I <u>do</u> like it—I'd rather live here than any place I know if I could get to New York sometimes—easier—I wonder how long I'll stay—

And yet—no particular friends—I don't want any—When I like them at all—I like them so much that it almost eats me up alive and I just want time to breathe—I feel almost smothered with the pulls of the past few weeks—maybe I should say months—I just want to get out where there is space and breath—and not like anybody and not be liked [. . .] Mostly I am glad that there are no more like me—I hope there are not—Living is wonderful till it becomes almost torture—or it is torture till it seems to be great—I can't help it—it's hell and I like it. Yes laugh!

O'Keeffe to Stieglitz, September 20, 1916, Canyon, Texas

[. . .] My regular routine (I hate doing things by the clock—have always hated to do things at any stated time) only takes twelve hours a week—but last week I seemed to fill up every minute of day and night with something—This morning—right now—I am hot from a walk to the train in the sun [fig. 16]—it is almost cold in the shade but the sun is hot—blinding—of course I go bare-headed—And what is on my mind is my small sister[13]—When I came out here I was sure I should bring her—others said no—a letter from her this morning makes me see that my premonition was right—Foolish of me not to insist then—it would have saved trouble.—She is—I start to say queer—but I won't—she is too much like me—So I wrote her by the next mail—to come—I don't know what I'll do with her but I'll do something—She will have to go to school

and I'm waiting with a broad grin to hear her remarks on the peo-
ple—It will be really fun—Still it makes me a bit uneasy—Will she
come—again—I don't know what to do with her—but guess I will
in time—Wish you could see the long stretches of white and sand-
colored and greenish-gray cliffs out there that mark the beginnings
of the Canyon[14]—they are a long way off—and I seem to feel lost
out there—even though I'm here—in spite of the cliffs—the skyline
is perfectly straight.[15]

Yesterday I rode out into that[16]—then off to the right—where
there is nothing—clouds making big dark shadows on the flat-
ness—I almost went to sleep—dreaming over nothing—I guess—
And I want to tell you about the big dark lumps of clouds—seem-
ing down close to the ground last night—and the moon—always
trying to get through—just a few stars in queer places—Last night
the moon was white—but the night before it was red—seeming like
something alive and breathing out there—as it came up [. . .] But—
when I work—even when it is to say something to someone—it is
to say it my way—and I don't care whether they understand—or
get anything out of it or not [. . .] The little fat woman who runs
the house saw [my work] on the wall one day and asked if it was
a sailboat[17]—a girl thought my last pet drawing was an ear about
two feet long—I try to keep them put away but sometimes forget—
I'm liking the drawing and hate to take it down [. . .]

I didn't tell you about going to the Panhandle State Fair at
Amarillo[18]—to see the cattle—Black Angus and white-faced Her-
efords—and the pigs and sheep and horses and mules—It may
seem a bit out of place to you to put a fat steer or pig in the same
class as music—but they are such nice shapes—I always want to
feel them. So much finer than lots of people seem to me. The sec-
retary is an old friend of mine—has been a miner in Alaska—is a
pillar in the Presbyterian Church and has been and done every-
thing in between[19]—Yes—this is a very funny country—but it's
great [. . .] But I'm so glad I have space—I seem to need it so much
now—It poured rain this afternoon—doesn't seem to soak into
the ground—just stands in ponds and runs down the road in riv-
ers—the ground just doesn't know how to treat rain it gets it so
seldom.[20]

I sat out in a funny little car with the most enormous brown-faced—blue-eyed old plainsman you can imagine[21]—a great shock of white hair—whites of his eyes very white because his skin is so dark—He is so big that he seems to fill a whole room when he gets in the house—He wasn't made for houses—He was made for big outdoors—We watched the sun set[22]—The whole sky was full of it—all round—the brightest reflection coming to us down the little river in the road—He is the most human thing I've found out here—We watch the sunset quite often—It's nice to watch it with him—but he is so big I'm afraid of him in the house—He is the husband of the little fat woman—They just got through with the last murder trial and another man was shot—today.[23]

O'Keeffe to Stieglitz, September 24, 1916, Canyon, Texas

Sunday night—Last night was a great night—I was reading *The Divine Comedy* for the first time—and the most terrific thunderstorm and the wildest wind and such pouring—rain—took me from it—out on the porch—in my kimono[24]—I watched the most wonderful lightning I ever saw—held tight to a post for fear of blowing away—The man I told you about—the great big old man—No—not so old either—came out and watched it with me—he is too strong and live-looking to call old even if his hair is white—it was a great storm—and a great book—they seem to be the same thing almost—I must tell you that—this big man—Mr. Ackerman—he is big inside as well as out—runs the town waterworks—and has the only house in this end of town that has steam heat—and walls one can stand to live with. He always wears a black sateen shirt and a tight-fitting cap with a shiny black visor—a nice human man [. . .]

O'Keeffe to Stieglitz, October 9, 1916, Canyon, Texas

[. . .] But this has been such a great day—a queer day—I've been so amused with myself—I must tell you—Yesterday was sunny and fine and I went to the Canyon again—about twenty miles east—climbed and scrambled about till I was—well I had enough—I was out of breath many times over—and felt very little—such a tiny

little part of what I could see had worn me out—Yes—I was very small and very puny and helpless—and all around was so big and impossible—It seemed as if the steep places—the far away parts—the ragged little cedars and uncertain stones all laughed at me for attempting to get over any of it—Then at night I walked for a couple of hours in the moonlight on the plains—everything light but our shadows—The girl with me was one of the Training School teachers[25]—a girl who has always lived out here—

So I slept—hard—I ought to hoe corn or ride cattle or do something really hard every day to get tired the right way—Then—when we were almost home there was one flash of lightning in the clear stillness—She said it meant a northern—and this morning it was here—a tearing wind from the north and cold[26]—I had intended going out with Ralph to the place we went to last Monday but working outdoors would have been impossible[27]—and I was glad—I had a thing I had been twisting around in my mind and on paper for a long time—I told you about making something I like some few weeks ago—But I wasn't through—It has hung here in front of me and I've liked it all this time—I've been doing it again—and for some reason—I don't know why—I wanted to work on it today and have—all day—It's absurd—I don't know what it is—I don't know why I'm doing it—I do know what I want it to do—that is—I know when it looks right and when it looks wrong—But what amuses me is—that—I think there is a right and wrong about it and—still I don't know what I'm making—that is—I can't say it in words—I haven't any words for it—What is it? I wonder if you could tell me—

Why should a person want to put down marks like that—Some way or other it doesn't fit into any kind of reasoning I know of—It sounds so unreasonable that I wouldn't try to say it to anyone else I guess—They wouldn't understand how something I can't explain could be so very definite to me—I can't understand—I don't care either—and still I do care—I've had a great time all day—working—cloudy out—and the tearing wind—thinking I knew what I wanted to make—what I wanted it to look like—but not having any idea what it is—It is ugly—dirty-looking[28]—and the one I made this time—yesterday morning and today—knocks the one I've

been liking right off the wall—They are both hanging there—The one I liked doesn't mean anything anymore—and it would give me great pleasure to cut a big hole in the other—I hate it and like it too—I have sort of a grudge against it for spoiling the other one and want to make another to spoil this one.—I've been stiff all day from climbing—wanted to be out in the wind—there was something fine about its coolness—but no—I must make this thing—and I don't know what it is—Now wouldn't you laugh at yourself if you were such a fool—and I'm perfectly sure I'll have to make it again—This one isn't quite right yet—But it's so much fun to be that sort of a fool—I can't help wanting to say why?—Now you laugh—Can there be any sense in what I'm making when I don't know what it is enough to say it—and still it seems alive to me—Not exactly alive—altogether—but parts of it—and when my eye is on one part—I jump right quick to another because I think something is happening over there—When there are so many things in the world to do it seems as if a woman ought not feel exactly right about spending a whole day like I've spent today—and still—it did seem right—that's what gets me—It must be done—and if anyone asked me—what it is—I cannot even tell myself.

Tonight I've been to a faculty meeting—They are more fun than anything that happens here—Really—they are great—and they all look at me as though they think I'm crazy when I say I like them—But—they are so much fun I just have to say it—Goodnight—Tomorrow I'm going up to Amarillo with the History man[29]—I almost hate to go—I don't want to see people I know—no particular reason—except—I don't—The air just makes you feel free—free from everything—and some way—I don't seem to be wanting people—just space has been so fine—I haven't had enough of it yet—Again—goodnight—It's a windy—gray night—the moon pale when you see it at all—still it's light.

O'Keeffe to Stieglitz, postmarked October 16, 1916,
Canyon, Texas

[...] I feel in a pen—and I wonder why I don't just get up and wander out into that big dark—and when the day would come—it would be

the big day—free from the littleness where folks live [. . .] Teaching school is awful—for instance—I can't go barefooted tomorrow if I want to—I might lose my job if I cut off my hair—They pay you to be such a fool sort of pattern. Still I haven't the nerve to quit in the morning—Anything else is just as bad—I just want to go out and be wild for a while [. . .] Think of how great it would be to be out in the canyon tonight—I don't even want a house. No use to say anymore—words tangle it. It made me turn from listening to the wind—and looking at the dark. I want so very much to go with it. Music. I would like to hear music tonight because it would hurt me so—the kind I want would hurt terribly and I want to hear it alone. You see one reason I want to be a man is so I could go hunting for that big loneness—away from folks—I don't think I'll have the courage to go as far as I want to alone—being a woman—I wonder—is it much different—or do I just blame my lack of courage to my sex. It's damnable—one poor little life to live and doing it in a pen. [. . .]

O'Keeffe to Stieglitz, October 22, 1916, Canyon, Texas

Sunday night—This morning—just to be contrary I guess—I said to myself at seven o'clock—I <u>will not get up</u>—I wasn't sleepy—I just objected to having to eat at 7:30—I'd rather not eat sometimes than have to do it at a certain place and at a certain time [. . .] The word "humbug" coming to my mind right now makes me want to swear—It isn't just in New York that you can use it—I don't know any better place to use it than in a little town on Sunday—I don't see how anyone with a grain of sense in their head can go through the nonsense they do and call it religion—I mustn't think of it—it makes me—too furious—and really—if they enjoy it—I see no reason why I should object—One reason why they didn't want my small sister to be with me is because I do not go to church—and the amusing thing is that the ones who object—never go themselves—She isn't an idiot—very funny—What makes me so furious is talk about—SIN—Why talk about it—if it is so awful—No—I'm not going to write you a sermon—but something ought to be done to some of the folks who are talking to young folks on Sunday [. . .]

I've been in the Canyon all afternoon—I didn't climb—I sat on

the top all alone—the first time alone—I didn't want to climb—so
wore high-heeled slippers—knowing it would keep me from it.—
That was the only way to keep me from it—and I had to laugh at
myself sitting there in those shoes—and I had to laugh too—think-
ing how feeble-minded I must be to have to hobble myself before
I left home to make myself behave—It was a wonderful warm
quiet day—The color—I would like it better if I had never seen
things people have painted from places like it—The very far away
side of it—lavender and pink and red and blue[30]—made dirty in
places by millions of little scrubby cedars—never more than ten
or twelve feet high—but sometimes having trunks two feet thick—
gnarled and twisted—sometimes half uprooted—scrubby little old
things but still alive and bravely green [fig. 12]—when all the grass
around that we think of as being younger is dead and brown—
Shadows very blue—I almost cooked—half-asleep in the sun—but
the shadows of the little scrubby trees were cold—I guess I liked
being really hot—I'm usually cold after the middle of August until
the next July—Anyway—I had a great time by myself—The sunset
was a long warm glow—it seems to hate to leave this country—
Goodnight—It is a very still night—it is still early—not nine—but I
am going to sleep—

O'Keeffe to Stieglitz, October 26, 1916, Canyon, Texas

Thursday—Just fifteen minutes—This morning when I waked—
the first thing I thought was—I'll not go to chapel today—it is
twenty minutes in the middle of the morning—It's the first time
I've missed—going is part of my job you know[31]—But as I sat—just
thinking for that twenty minutes—among other things it seemed—
I guess I smiled at the letter I had just mailed you [. . .] I usually
work on Sunday if I'm not outdoors—I've been going to a Sunday
School class at the Methodist Church—here—sometimes—The
President of the Normal has it and I like to hear him talk[32]—I went
the first time because I want to know as much as I can of what he
is like—I still go for that reason—and will probably continue to
as long as I can make myself—or until I know all I want to about
him—I like him. I guess I didn't go to chapel today because I knew

he was away and didn't see any use in listening to or watching the old fat tub who takes his place[33]—It is warm and sunny and a little windy this noon—I like my coat buttoned[34]—a very nice day—I wish I could give it to you—or that you would walk with me after the class I have in a few minutes—I'll probably go alone—the youngster plays tennis—*Faust* was on my table when I came from dinner—what you write in the front—I like—thank you[35] [. . .] Last night was a wonderful still starlight night[36]—I was out alone for a while—Just standing still—space all around—to look at it. It was cold but I put my hat in my pocket[37] [. . .]

Another few minutes—Friday noon. Yes I've been reading— After the class yesterday I walked—without knowing where or why—*Faust* under my arm—I didn't want to read it in the house— So I walked—The plains seemed like rich green and yellow gold—I walked toward the cliffs or sand hills—there was nothing but—the nice shapes of the ground in front of me—I never saw it look so like gold—The sun was getting low—that is—it was between three and four—nearer four—I didn't see the sky—my hat was down close on account of the glare—and I only seemed to see the ground— warm gold—almost impossible to believe it—then farther away to the right those cliffs—blue—pink—lavender—a curious quality— makes me want to rub my eyes and see if it's true—It's something very beautiful I want to touch—but—wouldn't if I could for fear I might find there is nothing to touch—Finally I saw a high pile of tumbleweeds lined up along a fence—so I got through the road fence and went far enough along the tumbleweed fence so that anyone who might go along the road wouldn't matter—I sat down in the little strip of shade made by the tumbleweeds—even then I looked for a while—It's great being alone out here. I read—till the sun was almost gone and I realized I was cold [. . .]

O'Keeffe to Stieglitz, October 31, 1916, Canyon, Texas

Tuesday night—It's a wonderful night—still and warm and moon- light—big quiet moonlight—As I walked home alone in it—I was tired—Sunday night I worked almost all night—Monday morning when the plains were still fresh and hazy in just waking up—your

letter came. The big fat long one—It's a wonderful letter—*Seven Arts* and the letter and a trip to Amarillo yesterday[38]—coming home in the midnight starlight—Such wonderful big starlight[39]—It was cold—the wind stung my face so that I wondered was it cold or hot—An old woman—sixty-five or more in Amarillo who is fond of me—the one who has lived with the plains country as it grew—went to see *The Melting Pot*[40]—Then home late in the starlight—Why last Saturday seems months ago—I've thought so many different kinds of things—even Sunday—quiet—out on the plains with Ralph—seems months ago—I've worked till two or three [most] nights—just wanted to—I don't know—I've felt like an alarm clock all wound up—ready to go off—hadn't worked since I painted this thing—the one I wrote you of on wrapping paper—and I guess I'm tired tonight—Still I want to do lots of things—can't possibly do them all [. . .]

I wish I were just a little girl—about ten—and that you'd hold me and let me go to sleep—but I'm not just ten—Of course I understand your letter—Well—the youngster stopped me here[41]—she has been restless—bobbing around—in and out—finally she said "Well, I never was so restless in my life. It's no use to study—I'm only using 4/10 of my brain."—Then a long talk—she thinks it queer and there is nothing queer about it—but—she tried every seat in the room—even the window sills—I tried to persuade her to stay out of school for a month and begin next quarter—but no—she won't. She has gained six pounds—has gone out to walk for a while—then to bed—no lessons tonight [. . .] I think the best way I can tell it to you is—that last night I loved the starlight—the dark—the wind and the miles and miles of the thin strip of dark that is land—It was wonderfully big—and dark and starlight and night moving[42]—It is—tremendously free—you would love it—I wish you had been by me—(she just came in for a thicker coat) [. . .] Feeling particularly feminine I suppose—I want to be spoiled—And instead I feel as if I've been out cracking hickory nuts the size of pumpkins. Goodnight. [. . .]

O'Keeffe to Stieglitz, November 4, 1916, Canyon, Texas

Tonight I'd like to paint the world with a broom—and I think I'd like great buckets of color like Hartley's to start at it with[43]—lots of red—vermillion—and I don't want to be careful of the floor—I just want to splash [. . .] And I worked all day after I went to school—that is four hours and at three we had Faculty Meeting—Well, I like Faculty Meetings—I always get so riled up—I want to scalp someone—Education is such a mess when it's bottled like they bottle it—I want to live about three hundred years and see what happens—I think it's terrible that I can't—And I came home in the moonlight—still bright—warm moonlight—not even a coat—just my green smock—it's absurd the way I love this garment [. . .]

And then I'm going to decide if it's worth the trouble to fight and try to do some things here my way—I'm not sure that it's worth the trouble—I get so terribly riled when I start to fight—it wears me all out—And is it worth it?—I don't know—They like things as they have it—Chemistry and Latin brought me home[44]—talking election—bumping over the rough places—not noticing where they went—Latin is fat and bald—Chemistry lean—with a shaky way of getting up—his head is big—Nice old boy I guess—but Latin is a "nut"—no Nut—I had a hard time to write that word—

I had a whole armful of chrysanthemums—red ones—I love them—I like the odor—better than any flower—and I like them in great big bunches—lots of them—I wish I had a whole acre of them tonight—School is very bad—I get so terribly excited over it—I wish I could just make up my mind to do one thing instead of wanting to do dozens.—To do school right would take all my time—to do anything right would—I guess—but I'm so damnably fond of reading what I want to instead of what I ought to—Making fool drawings when I ought to be doing the other thing—No—not ought—These other folks don't take time for outdoors—I do what I want to when the notion strikes me—I do my work—sixteen hours a week—it is really just a side issue—it isn't the important thing

in the day at all—And I think I do it rather well—but I can't give all of me to it—I could—but won't—! [. . .] Oh what is the world for anyway. I'm tired of it—and still I want to live three hundred years. My flowers are lovely—The watch and a train just pulling out—a sharp dog bark—train almost gone—cattle sound great here at night sometimes [. . .]

O'Keeffe to Stieglitz, November 12, 1916, Canyon, Texas

The day has been still—white—cold—sometimes a fine mist— maybe sleet—I don't know—so very fine—even when it touched my face—I didn't know—but I saw ice—on water—when I walked— so I guess it was cold—I noticed that faces were very red [. . .] One day I painted and it is forcibly impressed on me because the thing is so awful that I hate to think I made it—and still it amuses me—A woman who wonders what I'm driving at said this afternoon (I didn't want to show it but she saw the back turned out and wanted <u>really</u> to see—and I—being very mercenary thought— maybe I'll learn something—so showed it) "Someway it makes me think <u>woman</u>—but it doesn't look like one in shape—the head seems to be a very beautiful flower—but the tail of it is an animal." It made me laugh—It's very bad. I've been making it over—that is the fifth—The sister thinks it very ugly—

Other days I've been working on scenery for a couple of plays[45]—It was very interesting—results fairly good—but they provoked me—I don't know why—After it was over—even though I thought they worked out fairly well—I came home and felt like chewing nails. To be honest—I guess it was because I had been so intensely interested—and nobody got it.—But—I'm over it now— guess I'm glad of it—glad most of the fun was mine—The next one is already whirling in my mind—I'll just prepare to have the next party all by myself—There have been wonderful nights—coming home late—I wish you could see the night out here—You get to know people so differently working like that—such funny things happen. [. . .] It has been a crazy week—arguing—I must do something very different this next week—I read a fool book on Egyptian Decorative Art—among other things and those damned *Courses*

of Study[46]—This morning I hated it all so [. . .] All day—outdoors has looked as if something were going to happen—any minute— and all day nothing happened—unless the night happened— thin ice on everything—happened with it—and a quiet sort of wind—like someone crying—softly—the short dry grass looked quite white and shiny—the sky very big—and dark—and soft—I loved it—wanted to go into it—but not alone—it's slippery [. . .]

O'Keeffe to Stieglitz, November 13, 1916, Canyon, Texas

[. . .] My mother began dying to me the Christmas after I was six- teen—She didn't believe a simple statement I made about not waking up one morning—Probably things like that hurt more than her really being gone—only I always hoped that some way I'd find her—and now—of course—I won't—and I don't like to think of her being out there like that—They thought they wanted me around but I always found it to be irritation all round so I stayed away. The small sister is the same[47]—She irritates the rest of them—queer— I don't know—probably a lot of just plain <u>Devil</u> in me. There is a younger brother[48]—big—fresh and free—the kind that fills a room to bursting—I've always been very fond of him—I am yet—But we are out too—We used to stay out almost all night—just walking and talking—often—I could get him to do anything I wanted to— but finally told him he could stand upon his own backbone and be decent or go to the devil—I was tired of holding the string round him—That was three years ago—I haven't seen him—won't know what has happened till I do—According to other folks—I guess he is a fair success—but that doesn't mean he will be to me—It's all a queer mixture. We are all very funny—No one appreciates how funny like the younger brother—he can see if he wants to—It's probably much better that my little one is just a piece of paper—I have a great fear for a live man like that younger brother—such a damnable daring—but the conscience is very fine—so strong physically and so big—the very liveness of that bigness—makes the fineness inside get lost at times—Still I got tired of keeping my hand on him—He was the only one who understood when the oth- ers didn't—And what's the difference [. . .]

I'm the little girl who needs someone—Probably to most folks—
a damnably independent—self-sufficient young woman—No—I'm
not sick—haven't been—it's curious the way this past week didn't
seem like me—I don't know what was the matter—except work
that took all of me—and every night I was very tired—but I like to
be tired like that. I feel great out here—doubt if there is room for
improvement—and the sister—Wish you could have seen the red
face—snappy black eyes—smooth shiny hair—very dark brown—
above the soft blackish green coat—She thinks the day is great [. .
.] I'm glad too that I'm not in New York—I don't want to be there—
There is more out here [. . .]

You see—I can't help feeling independent—wanting to be free
from everyone. They have always objected to all the things I did—
and I've done them anyway—I wouldn't ask the men of my fam-
ily for anything to save their lives—I wouldn't even suggest that I
wanted anything—They amuse me so—I am in debt and they know
it—Still—if the sister lives with me—I have to take care of her—
Really—it's great—I enjoy it—They don't approve of my borrow-
ing—but I do—when I want to—All this is nothing—of course—but
maybe it will make you see a bit more of why I am like I am—Why I
dare to put on paper anything I choose—Why I dare to be frank—I
have nothing to lose—no one's opinion to consider—maybe some-
thing to gain—I don't know—Nothing to do but live—and it amuses
me that I can do it pretty much as I please in spite of them—and
that the sister can too—It amuses me to think how furious they
would be if they could see me writing all this to you—really it's a
good joke on them [. . .]

It's night—Monday night—I was in such a storm over my family
this morning that I forgot everything else—I guess the truth of the
matter is that I can do pretty much as I please with any of them—
but it's such darned hard work—I just decided I'd let them rock
along as they please—Why should I try to fit them to what I want—
I hate it all—Let's forget it—I've been working again on that darned
thing that I ought to be ashamed to own—but if it's in me I sup-
pose it's a good thing to get it out—It makes me want to go back
to my old question that almost drives Anita mad—What Is Art?—
I'm beginning to think that maybe I'm exceedingly vulgar—and the

funny thing about it is—I don't understand—I get the shapes in my
head—can never make them exactly like I want to—but there is a
fascination about trying—And then too—there is a delicious prob-
ability that I don't know anything about what Art is—So it's fun
to make the stuff—ART—It can't be anything like that in front of
me.—It's repulsive—I'd hate to touch it—and then at times it has
a curious kind of beauty—and what is it? I never made anything
such a funny color—I dreamed the other night that the sister was
very sick—and her face that color—the little sister—It was ter-
rible—Then on another wall it simply howls—in blue with a little
green—it makes such a noise it makes me laugh—It all leaves a
very bad taste in my mouth [. . .]

This morning—windier—colder—clear cold—definite cutting
ice and snow in the air—just a little—a little snow on the ground—
blowing—many bare places because of the ice underneath—such
nice sounding wind—Really a wonderful day—I wish I could give it
to you—At breakfast I gave the letter of last night to a girl to mail for
me.—You see the big man always brings my mail and would take it
too—but I don't choose to have his fat little wife keep track of who
I write to—It's hard to get over certain obstacles in living [. . .]

There is a Faculty Circle—sort of experiment—and we are all
going to have to give talks on whatever the committee assigns
us—They have given me "The Cubist in Art"—and I'd like to scalp
that fat old Latin creature if he had any hair on his scalp to make
a respectable showing—I think he has a notion that all modern
art is cubist—I've got to get enough definite information in my
head to talk for half an hour at least—the condensed kind that
you can get over to folks that have no ideas about it at all—or
very funny ones—Some of the men have good brains—the kind
that tussle—think around things—not easy to satisfy—I want to
say a lot in a little while—Just at present—I don't know a cubist
from much of anything else—definitely enough to get it to anyone
else—I haven't cared exactly—about what a cubist is—It's a ridicu-
lous thing to try to do—but—they have such queer notions about
what I'm supposed to teach—I try to teach what I think is of use to
everyone—I'm aiming to give the Fatty the jolt of his life—he can't
think much—but there is another who can think—three or four

that I want to interest enough to make them ask questions—the President—History—English and Chemistry[49]—I have till January to think about it—If you help me—thank you.—I'm glad you like Wilson—I've been afraid to ask for fear it might be Hughes [. . .][50]

My hands? They often make people say funny things—One of the boys who was helping me with that scenery[51]—asked me to hold one up—I did—and remarked that it was very dirty—put it down to go on with my work—When I held it up the fourth time at his request—he was a little behind me—I turned around to see if he were crazy—and asked—Why—He said—"Well—it's a great hand—that's why I like you." I laughed—and he added quickly— "My girl has a hand like that"—she's at some school in South Texas. I never think of the looks of them—it's always wanting to use them—touch with them—feel with them—Oh—I must go to bed—I've written you enough for one day—. Goodnight—It is such a wonderful night—nine above zero—doing pretty well—walking at sunset was great—still—ground fairly white—ice still on every-thing—sky all warm—Oh it's really great out here—So cold—so big—so warm—and you feel so alive—Stars now [. . .]

O'Keeffe to Stieglitz, November 30, 1916, Canyon, Texas

Thanksgiving—Nearly night [. . .] The sister had a cold and I insisted on her staying in bed—You know—it is so queer to have someone around to think about—I've always been alone—Twice last night I got up and went over and looked at her—bothered about her—She is better today but took lots of time—Has been tinkering with clocks most of the afternoon—She has three going now—They had all been given up—She gets so much fun out of it that it's funny [. . .] This morning I got up while it was starlight and walked over to the cattle pens—Saw the cattle come in yes-terday—about five hundred two-year-old white-faced Herefords— The noise they were making was great—I climbed up on top of the fence—it's very high as fences go—watched them a long time—and the coming morning—They were afraid of me—open plains all round—town off on one side—daylight coming on the

other—When I got off the fence only two stars were left—I walked northeast—A train was coming way off—just a light with a trail of smoke (fig. 16)—white—I walked toward it—The sun and the train got to me at the same time—It's great to see that terrifically alive black thing coming at you in the big frosty stillness—and such wonderful smoke—When I turned—there was the sun—just a little streak—blazing in a moment—all blazing [. . .][52]

O'Keeffe to Stieglitz, December 10, 1916, Canyon, Texas

Sunday—Sunset. I'd like to write you with letters about two feet high—But maybe that would be a bit high—This morning—in a tearing northern and snow—blistering cold I started for the Canyon—I just got home—my hands a bit swollen from the cold but it was great! In the Canyon I climbed. It was all rough—but it was great. Wish you could see the tumbleweeds blow—they are round and just tear across the plains like mad—big ones and little ones— far ones and near ones—where there are fences—sometimes they hang singly—sometimes they just pile up—It is the tumbleweeds that mark the fences here—A stretch of fourteen miles of nothing after the last house till you come to the Canyon—a slit in the ground—sometimes three miles across—sometimes five or six [fig. 12]—but it is great—and that darned wind—and the cold—It's all so big—such big washes—big hills—long drops—thick trunked scrubby cedars—hardy—old—strong—often broken or the soil all washed from several feet of the roots—but they don't mind—they are still green—Wonderful distances—colors—all kinds—Isn't it funny—when I was climbing out—sat down all out of breath— looking back at it—in the fine—wild-driven snow—I love it—wish I could be with it now—I want it all—The reality of it makes me almost crazy—Isn't it funny—folks get color very like that on canvas or paper—but the darned things don't get me going at all [. . .] I feel rough like the wind tonight—I'd like to take hold of you and handle you rather roughly—because I like you—We rode miles in the Canyon besides climbing—it was all rough—and it was great[53]—

O'Keeffe to Stieglitz, postmarked December 12, 1916, Canyon, Texas

Good morning—Your letter was great this Sunday morning—It's a very windy morning but the wind is warm. I'd like to walk in it but the dust blows so bad today. I can't remember anything I made with red in the sky—except—Thanksgiving morning—and I know you haven't seen that—It's awful red[54] [. . .] I usually worked in the evening—between supper and dark—on a west porch—no chair even—always on the floor—I never seem to get on with water color except on the floor—never have enough room any other place—Monday—1:30—Really a wonderful day—interruptions yesterday—it is more like summer—Last night we walked from sunset till—long after dark—walked straight south—The ground here seems level because it is so empty—the sky-line at sunset and sunrise is marvelous—the quality of it—seeming perfectly straight all round till you look a long time[55]—Then there was the moon— and the starlight—I guess I didn't look up at it—didn't think to— what I seem to remember is the line of the horizon—just the sister and I—not on the road—no path—just out into it [. . .]

All morning I've been at the doctor's with the sister—Had her tonsils removed—one of the Normal boys was there for the same purpose—great big husky thing—just in from riding cattle—wasn't in school last quarter—of course he made about twenty times as much fuss about it as she did—and between the two of them I almost died—it's so very still here now—got a breath of wind—I want to go out there where I can't see anything but land and sky— and lie down and be still but must stay near the youngster—I didn't know what to do with her—thought I'd try having her carved—he said she ought to—the doctor here and the doctor from Amarillo— so it's done now—the one from Amarillo did it—What can a person do—I'd rather have had myself done than her—You know how it makes me feel. [. . .]

The laundry man came—and I talked to him—a boy selling subscriptions to magazines—came too—told his family history— you see I'm just sitting here on the porch sort of doped with exis- tence—the fat little old woman came out and told about a girl who

died a couple of days ago from her tonsils—and about her precious boys having influenza—all so nice, you know—so good to hear this afternoon if I were anyone but myself—I'm not afraid—but I want to be a long way from it all [. . .] You know there is hardly anything I hate like fear—it often comes to me but seldom stops me—at present maybe it's fear of myself.—A drawing on my wall unfinished because I'm afraid of what I'm making—what I've made in the top—it startled me several times—the thing I was painting—I've stopped working on because of what it is—it's only the seventh of the same thing but—Oh, it's so bad—A lot of spots are wrong but I don't want to fix them—afraid to maybe—because I would not want to show you—Am I afraid to be honest [. . .] I feel like shaking all the world off my fingers this afternoon like water—shaking it right off the ends like we often do [. . .]

After that I came in to the sister—she was awake—read to her till sunset—then went out to see that. Went over and climbed the cattle pens again—empty—sat there for a long time watching the sunset—it was cloudy and—clouds make gorgeous sunsets here [fig. 8][56]—I sat there till some cowboys came up with a few cattle— while they were fussing around in the tangle of the fences I climbed down and came home—moonlight—but still red in the sky—then I went to the Drug Store and got a gargle—it seems to be a compensation for the loss of tonsils—and now my poor little sister—the pale little face—white like the pillow—only a little bluish—blue is worse than white—and she can't swallow—can't talk—has to write what she wants—no use to talk about it. I'd just about as soon go to a saloon as a drug store out here—In fact—the air simply reeks with a kind of filth that there are no words in my vocabulary for— Goodnight [. . .]

O'Keeffe to Stieglitz, postmarked December 19, 1916, Canyon, Texas

[. . .] I've been out watching the sunset again—I wish—where you see the wonderful sky-line—It's a tremendous line—Just earth and sky meeting—nothing in sight—absolutely nothing[57]—We walked into it a long time—then sat down—I lay down—flat on my

back—Stars coming out—turning my head a little I could see the
sky-line—still a little color in the west. The sky like a wonderful
jewel—darkest in the center—light around the edges. I've always
wanted to touch it—since I was a very little girl—and it always
seems more wonderful—I'm wanting it more. It makes me feel like
such a little girl. And I came home—looked at what I've been work-
ing at all day—and I felt like a still littler girl—what's the use in try-
ing to paint—I haven't the mentality to do what I want to do—It's
like reading *Faust*—A lot of it will get by me—My funny little thing
is in front of me on a chair—I'm not through—it's so funny [. . .]
It has been like wrestling all day and now there is that funny little
thing—it's screamingly funny—I've drawn it about fifteen times—
little—and twice—big—and this is the second attempt to paint it
[fig. 11][58]—it's great to be a fool—But it makes me feel so help-
less—like such a little girl—A kind of helplessness that's amusing
because—why—I wish it were daylight—I want to paint it all over
again—so sure I'll get it tomorrow—still knowing I never will—Isn't
it funny—There isn't anyone in Texas to talk to tonight—my head
would just about come to your knee if I were standing in front of
you—and it's great to be little—I like it [. . .] The wonderful stretch
of the bare line at sunset—the stars—a train that I watched like a
star on the horizon [fig. 16][59]—it's great to watch it moving such a
long time—it never came close enough to be anything but a little
line—the wrestle of the day—the emptiness of the night—and I like
it all so—nobody in Texas—it's funny what way I like it. [. . .]

O'Keeffe to Stieglitz, December 21, 1916, Canyon, Texas

The nakedest thing I know of is an angleworm—and I feel that I've
rather given myself that quality—to you—I hate angleworms so
tonight I'm not going to talk about myself—I must tell you of the
sister—Her latest adventure has been motorcycling—not trailing
on behind—running it herself—she has simply gone mad over
it—But last night it snowed—it's bitter cold—everyone's left yes-
terday for the holidays—she was a bit depressed—but hit on the
bright idea of going shooting—she got a gun and off she went
about five o'clock this afternoon—I followed about fifteen minutes

later—when I caught up with her she had shot a bird—a prairie owl—She said she hadn't shot for such a long time that it never occurred to her that she would kill it when she aimed at it. Thursday night.

GOSH! She has been out again this afternoon and come home with two jack-rabbits—shot two more but couldn't carry but two so is sending a boy for them in the morning. Some way it doesn't seem right to me—She says she hates to shoot them but it's so exciting to see if you can—She went skating this morning—her ankles are weak though and it makes them hurt so this afternoon went back to the gun. Folks look cross-eyed at me for letting her do things like that—but I don't see why not—if she wants to—She is so excited that she is limp.—At supper she would lift things— expecting them to be as heavy and they would go up—Every little while she tells me about another part that's tired and hurts—and if it isn't that it's some incident of the afternoon—Just now she told me about another bird she shot—It was a long way off and she didn't think she could hit it—then she was so sorry she stopped and buried it—She rode home on a load of baled hay—she was just so tired carrying those rabbits. She just now told me that I don't know what it is to be tired—Even her hands hurt from carrying the rabbits and the gun and the cold—I'm afraid she will shoot herself but guess it isn't any more likely than someone will shoot her through the wall—I don't know of anything to do with her but to let her do as she pleases—It's very funny. So much better than having her wildly excited about—oh lots of other things she might like.—

Funny I haven't wanted to go out—I've been at home two days now—Thursday was the first day of vacation—and I've just liked being alone—Have been working—Your letter today was great— the only remark I made to myself while reading it was when you said you wondered what the things I am doing now look like—I said emphatically—Like Hell—Then later at dinner—I was thinking about you and I said to myself—GOSH! but he is great—Then I thought to myself—I don't like that word but what am I going to say—I object to the coarseness of the word but I like its expressive feel—We need some new words—or is it my poor taste in putting

them together—it doesn't matter of course but I feel a deficiency in the English language when I want to say—no express—GOSH—it expresses what I mean but has a ring I don't like [. . .]

O'Keeffe to Stieglitz, postmarked December 26, 1916,
Canyon, Texas

[. . .] What have I done? Nothing much—a forty-two (that's a game played with dominoes by folks who don't believe in cards—and in places out here where the law doesn't allow cards—just a way of sliding round morals and the law) party—a dinner party—I hate things like that but here they are amusing in a way because the queer combinations of folks you find brought together because some queerly-made person must do things like that—makes them fun—such funny combinations of folks—they would be utterly impossible most any other place—but here there aren't enough of any one kind for them to make up a crowd—Oh it's very funny. They just have to mix [. . .]

I feel particularly sane—and wonder if I am—it's so funny. Afraid of nobody and nothing—it's great. Found a great girl today—daughter of the old fellow who teaches German—home for the holidays—They are very German—but look French—are part French[60]—very dark—wonderful eyes with a queer slant—hair just a little curly—very pale—just a little color well put on—so thin that one pound less would make her too thin.—It was great to find her—seems like the first real person I've found out here— She's great to look at—the frailness—and the fire—we are going to walk early in the morning. You know to look at her that she likes to walk—She likes Christmas—likes to give things to many folks. Teaches music in Dallas. [. . .]

Commentary

In this chapter, O'Keeffe negotiated her job contract for West Texas State Normal College and arrived in Texas for the start of the fall semester of 1916. In her careful words, she described both the frustrations and the inspirations she found on the High Plains—the

students she loved and the restrictions she hated, as well as the traditional forms of education she was willing to stay and "fight" to change. She wrote with clarity and poetic specificity about the countless forms of beauty she observed in the Panhandle landscape—starlit nights and blazing sunsets; stark horizon lines and endless skies; rough winds, blowing dust, "wild-driven snow," and tumbleweeds that "tear across the plains like mad"; trains that seem like "terrifically alive black thing[s] . . . in the big frosty stillness"; rainbows of color with an emphasis on red; rugged canyons with cliffs that called her to climb; and the bodies and sounds of herd animals in cattle country. She recognized her sense of escape, freedom, and independence connected to Texas, away from her family—other than her younger sister Claudia, whom she suddenly found herself responsible for. She loved it out in the "middle of nowhere," where there was "nothing" to hold her back from daring to do new things, including writing to her confidant, the married man Stieglitz, about everything she did and saw and felt. She neither held back nor hesitated much in expressing her feelings in these letters, such as when she declared frankly how she wanted to "take hold of [Stieglitz] and handle him rather roughly" because she liked him so. At the same time, she described her ongoing struggles to capture ideas in colors and shapes, especially when she was kept so very busy with her teaching job. We see her continually "wrestling" with her art to get it right, and her stubborn willingness to fail again and again and still never give up creating.

[2]
Winter to Spring, 1917

MOMENTS BEFORE THE WAR
AND "WHY MEN FIGHT"

O'Keeffe to Stieglitz, January 2, 1917, Canyon, Texas

Tuesday night.—I've been sitting here a long time wondering how
to tell you how amused I am. There is simply no way unless you just
get it. The little fat woman and I fell out[1]—It was a most amusing
talk—And that funny stupid man was here again[2]—it was about his
coming that we fell out—Imagine anyone telling me they objected
to anyone coming to see me—I'm not really over the surprise yet—
She is too funny for words—So instead of sitting in her old house
we rode for nearly three hours—Her objecting made his coming
interesting—And way out there in the Canyon draw I made him
get out and walk—He didn't like it but I did—It was really wonder-
ful out—only he spoiled its wonder—but in place of wonder and
star-gazing it was just ridiculous—I just want to yell when I think
about it—Can you imagine me shut up in the car—standing still
for—oh it seemed like ages—arguing and objecting to—beefsteak
with really nice hands—(well shaped—makes you think he ought
to play something) objecting to an arm round me and hands on
me—Why—I wonder that the car didn't laugh. It was so funny I
couldn't get mad—He is really nice inside—and because I laughed
so—he couldn't understand. After several attacks—that I paid no
attention to—I couldn't help shivering—and saying I hated to be
touched—Then—I thought of you—how funny it would seem if
you could see and hear—and laughed so hilariously I had to tell
him why—He got it wrong of course—and asked if I were going to
marry you—I told [him] goodness no—and that you were married
years ago—more arguing—I wonder if that car isn't laughing

somewhere out in the dark of the barn—I almost forgot to tell you that I found out since the first time that he is prosecuting attorney in the court here—whatever that is—brother is president of the bank I go to and father [of] one of the biggest ranchmen around here. I never ask questions so I didn't know—Folks are so funny— What makes them so funny [. . .] And the little fat woman—she would ship me in the morning—scandalized—It's too funny—or is there considerable irony in it. Goodnight. I feel as if the expression on my face would be idiocy if I'd look at myself—

Wednesday Morning [. . .] Seeing last night again—the wind is howling but it's warm—and sitting here listening I can see it all so clearly—It's nine A.M.—The car run up next [to] the fence at the side of the road—horses—runty western breed—strung along the flat space between us and those terribly bare hills—they were there because it was sheltered—a lavender kind of moonlit night—rather windy—I out for contrariness more than anything else. I had on three garments—all as thin as the law allows— besides my coat—It's amusing that you too like being cold—He couldn't imagine anyone liking to be cold—I too only like certain kinds of kisses—certain kinds of touches—I cannot understand the other kinds of kisses—I can the other kinds of touches—there is something pathetic about them—He only wanted to touch me because I was a woman—I distinctly did not want to be touched because he wasn't a particular man. And still wanted to put my arm round him and my hand on his cheek simply because he was so everlastingly man—and I was sorry—and he wouldn't under- stand—So it was funny—hilariously funny—You would have had a good time on the back seat—too bad you couldn't be there— And he wanted to send me wine and I had visions of the old lady sniffing at my key hole—He insisted even to the front door—think how her porch was polluted—Still—I knew the woman inside— overfed—not exercised enough. He doesn't know it so can't help it—I'm never going to eat any more and am going to walk miles every day [. . .] The little girl again after being the won- dering woman—Little girls are selfish—thoughtless—I'd like to be rocked to sleep close to somebody—Goodnight—Wednesday night—

O'Keeffe to Stieglitz, January 10?, 1917, Canyon, Texas

[. . .] I was so sick—excitement always makes me sick—and I gave that darned talk Monday night[3]—and I got so excited and they all got so excited that we kept at it right over all the time allotted to the man who was to come after me and over an hour past time to go home—It was very funny—and I've talked to individuals for hours at a time since—So funny—At the table—in the halls—in the offices—funny how interested they all were—Really amusing—maybe because I'm so interested—and I've hardly slept for three nights—drinking coffee without knowing I was drinking it—but trying to be still—not even to think—This morning my first class was at 11:35 so I didn't get up until nearly eleven—However—last night the sister was hunting for my paint brushes to clean her gun—put my pallet on the bed—then sat in it—So this morning got up extra early to take the dress to the washwoman—so she found your letter to me and waked me by throwing it at me in the dark—I wanted you but was too sick to get you out of the envelope till after nine o'clock—GOOF—

Yesterday there was other excitement too—that is—things to decide—It's Summer School[4]—I don't know why but I sort of feel that I'd be a backslider if I didn't stay here and dance to the music—even if I don't like it—Someone else would take my work and get it all mixed up—but I'll have to work twenty-four hours a week—I have sixteen now—it will be for nine weeks—and I don't see how any white woman can do it[5]—it doesn't seem to me to be worth it—Still if the others do it I hate to back down—I don't know exactly why but I want to see the whole year round—Isn't it funny—I seem to want to try it just to see how people do things like that—queer isn't it—then too—money—but I put that consideration last—I'll be out of debt by summer but won't have enough to live through the summer—so all round working seems best—When I think of not working I have to laugh [. . .] Why I never felt so lost and funny as I do when I imagine myself with three months and a half ahead to do as I please with—I wouldn't know how to behave—No place I want to go—No one I want to spend it with—I don't know—right this minute I think I'd like to spend it under

the tree—or working with you[6]—not saying a word—either of us—
Still—you some way telling me the story. I'd like to go up in the
mountains by myself and stay—but I'd be afraid—So what's the
use of it all—That nine weeks—twenty-four hours a week—makes
me feel still sicker—but it's so funny too—it makes me laugh—any-
way—I told old "Lanky" Allen—he teaches Mathematics and has
charge of the Summer School[7]—he walked home with me today—
it's fun to talk to him—he looks so—sober and overworked and
lean and lank—I always pat myself on the back when I've been able
to make him laugh—and today I made him laugh several times—I
told him I guessed I'd try worrying along with the rest of them—
Then when I came in—here was a letter from Virginia wanting me
to make out the material for their bulletin and wanting me to come
back[8]—funny I don't want to go—I must be crazy—the way I am
enjoying being away from people I know [. . .] It's almost like sum-
mer today—was yesterday too—I hate plans—so it aggravated me
to have to be thinking so much about summer—it's so far away—
maybe it will never get here—or will it—does it always come—It
does—doesn't it.

O'Keeffe to Stieglitz, February 4, 1917, Canyon, Texas

Sunday night 9:25—I've been in bed all day [. . .] This afternoon
I read some—Nietzsche—He's a wonder—I didn't read much—
watched the sun go down—just a plain yellow sunset and one star
came out—I wanted you when the yellow light came in and it was
all so quiet—the day had been very windy—just to be quiet by
you—while the sky turned from yellow to cold white moonlight—
you would have liked it too I think—The windows were very wide
open—I hadn't enough over me and didn't know it till I accidently
felt the coldness of my own skin—my face on my arm—I liked the
coldness so that I didn't cover up then till the sister came from
supper and shut the windows—She has been riding horseback
and is very stiff—can't cross one knee over the other—it's very
funny—Tomorrow—among the forty eleven other things I have to
do—we are going to move.[9] I tell her she is going to do it—and she
laughs—I'm curious to see how she will manage. I'm not even going

to pack my own things—I know it's a risk—I'll probably never find anything again but I guess it doesn't matter much. We will have to build fires [. . .]

(The sister just came in and announced that the next time I stayed in bed she was going to tag herself with a big red tag saying "My sister Georgia O'Keeffe is indisposed." So she won't have to answer so many questions—) She's in a very foolish humor [. . .] Monday was about the busiest day I ever spent—But it went fairly well—the play too and after that a party—a colonial party—very funny—and the blond man came down from Amarillo[10]—and stayed over yesterday—We rode miles—I was too tired to move—There was a picture show (I hate them—only go about three times a year)[11]—it was *King Lear*—and I almost died with all the other folks—The night was still and almost like day—He's just a comfortable sort of man—you just don't mind him much [. . .] Blondy says he will stay over till Saturday—or come down again then if I'll go up to Amarillo for the weekend but I think I'm not going—I've had enough—I feel bored to distraction with people and things—I'm ready for my own company again and lots of it too [. . .]

O'Keeffe to Stieglitz, postmarked
February 13, 1917, Canyon, Texas

[. . .] I'm so glad I'm here—and it's such a funny place to be glad to be. You see—there is nothing here. We are rooming together in a yellow room—mine isn't finished yet—it will be white[12]—Folks do so much as they please out here that carpenters and painters and the like only work when they want to so unless you just get up and do things yourself you have to wait till someone else gets good and ready to do it. [. . .]

O'Keeffe to Stieglitz, February 16, 1917, Canyon, Texas

[. . .] The *Courses of Study* we have been working on—I told them they were trying to make everybody alike—and they said they guessed they were[13]—it seemed the right thing to do—and I wondered—and then—I don't know—lately I've been thinking I'd go

and tell Mr. Cousins that I'm a bum cog in the wheel for turning out what they want to turn out—but he would think I am crazy—You see I feel like a hypocrite pretending to belong in that wheel at all— And just tonight—It's this way—Sunday I caught cold—and Monday I went to the Canyon and Tuesday after my first class I came home and went to bed—and almost died for a couple of days—sore throat—headache—couldn't breathe—ached all over—eyes—and the doctor was sick too—so—Anyway—It's the end of the quarter and this morning—no it was yesterday—it just seems the same day—I got up and went to school because I just had so much to do I had to—and after supper I just had so much to do that I wouldn't come home and do it—went [to] Hollands—that's the awful drugstore—There are always loafers—It's really absurd—And—why—I didn't know till I got home what funny things I had said—all students—but so foolish—I just said some things I wanted to—and it didn't sound like a cog in the wheel—and old red-headed Heyser almost turned handsprings out the door once[14]—and little Mattie B's eyes almost popped out[15]—And—I was thinking here when I couldn't sleep—What's the use in pretending to have flat feet and pop eyes and a Sunday school disposition when you haven't got them—And I could just see Mr. Cousins laugh at me if I went and told him he better get someone with fallen arches and nearsighted pop eyes in my place—The head of the training school is like that I know she will stay here till she dies.[16]—She fits—I feel like holding the lid on a boiling kettle—She would scold the boys outrageously—be horrified—says it better—if she heard the noise they made coming up the street with me—a crowd on their way to basketball practice. Clearing the streets because they had faculty with them. Gosh—I'd like to be a green balloon going up into the sky—blue sky—and—burst—!

Sunday morning [. . .] Mail wasn't open yet so we went to Hollands—Fred was there in all his shining glory[17]—and two others—quite as amusing. I think they are being especially nice to me because they want me to go to a dance they are having tomorrow night—It's hard to get faculty to go to dances—and still quite necessary[18]—One of them—Davis[19]—(Beverly says he has sixteen silk shirts and nothing to do but be good looking)[20]—insists that I go to

breakfast with them tomorrow morning—and he is coming around
after me—whether I go or not—but he hopes I'll go—We all went
for the mail—Fred's not talking much this morning—looking off—
thinking—But he insisted on looking very carefully at the letter that
pleased me so—your letter—That's the way things trail along—
Then I came home and read it. You know—besides the night I was
awake all night—I haven't had a minute to myself all week—except
about an hour yesterday—and that hour—I took a gun and a box
of bullets—and went out on the plains and threw tin cans into the
air and shot at them—The sister and I. She went on hunting after-
ward but I only had the little time—Last Sunday—after writing
you in the morning I think—I came in after supper and wanted to
write you again—but it seemed so foolish—and I lay on the bed by
the window—quiet—all alone—watching the sky turn from day-
light to night—many stars—just full of stars[21]—and I remembered
your star story—It's queer—the way I find myself—sometimes—
seeming to feel into space—for the little one I wanted—and there
was an element of wonder in the fact that I haven't it—I seem
hardly able to understand it—And all the week—so busy—still—
thinking—And—because of what I was thinking—wondering if I
ought not give up my job—Some way—I feel today—no. It's a great
place to work—No traditions—the whole thing—the whole insti-
tution—just beginning—started to build it seven years ago yes-
terday—Why I'd rather work here than anyplace I know of—and
maybe I'm not such a misfit as I sometimes feel—I've said some
scandalous (according to some folks) things in class this week—
way off from art—or maybe the very substance of it if it's life—I
don't know—I know the class was astonished—but they seemed
to enjoy it—Still I wondered—would the sober ones of the place
think me off my track—And it occurs to me that something besides
those sober ones may help the whole thing along. I don't know—
I'll stay another quarter anyway—

Sunday night. The wind has blown a gale all day—it started while
I was looking out the window after reading your letter—I guess I sat
there a long time with it in my hand—The dust blowing has made
the sky seem a little yellowish—it shakes the house. [. . .] Most of

the day I've watched the wind—and wondered [. . .] too windy to go walk—Wish you could hear the wind whistle [. . .]

O'Keeffe to Stieglitz, postmarked
February 28, 1917, Canyon, Texas

[. . .] I had on a black dress—white crepy silky stuff for sleeves and collar—had to laugh when I looked down and saw it—I looked as though I didn't know when you asked the question—Didn't you know—I always wear black—haven't had anything any other color except that green one last fall and the green smock and colored coats sometimes—and I hate the green things now—I've always been more comfortable in black and white than anything else.[22] [. . .] No my room isn't finished yet—but it is almost—This one has three windows facing north. Mine has three—one very wide and two small—facing east and a small one north and a small one south—all one end is window[23]—If I ever move in—Another coat of paint—then the floor—It's wonderfully white—I like it—It's wonderful when the sun rises—just plains to the sky.

My pink hyacinth is pinker and fatter and funnier than ever—it reminds me of the little fat man—Latin[24]—who lives across the street and comes out every morning just as I am getting up—and I know he is looking at me—has seen me in all stages of undress I guess—but I'm usually too sleepy to care or move from in front of the window—I told Claudie—he has seen it all now so it doesn't matter—He teaches Sunday School—ought not to look if it isn't all right.

I had a great time the night I went to Amarillo this week. The car was the loudest yellow thing you ever saw[25]—Gave the little town such a jolt—It was open—the wind blowing—sunset—we go mostly north—Such a wonderful sunset and we went so fast—the plains are turning just a little—I don't know—I was just in a humor to have a great time—everything looked great—such a wonderful color—such emptiness—it's tremendous—and I must say again that we went ridiculously fast—and I liked it—tried to scare me—but there simply wasn't any fear of speed in me—Oscar Seagle song[26]—we rode over town then out into the night again—Such

wonderful starlight—I was so very alive—seeing things I liked tre-mendously everywhere. Came down on the early morning train—Sunrise—great—Really had a great time but it was the humor I was in as much as anything. He unexpectedly went East the next day—They tried to get me to go out to the Country Club[27] again for the week-end tonight but I balked. Wanted me to go to Amarillo first and I wasn't sure I'd get away so I wouldn't go. I remembered myself at the wood-pile with a pan to get chips when it was still starlight in the morning—the sky in the east just turning warm—The cliffs are great against it—I looked a long time till I was really cold—then looked down and laughed—My kimono wasn't even fastened[28]—I got my chips—went in—made a fire in the fireplace—some was left—Then dressed and went out and looked at the world a while and no one else was up yet when I got back after a long walk and climb—It was funny—I want to go again—but guess I didn't want to enough today—No—really—I was afraid I'd have to spend too much time with some folks I don't like—I didn't feel like being nice like I might have to be. I'm not feeling polite—I'm just feeling human. [. . .] We have been having wonderful warm days—some-times a bit dusty—windy—but really wonderful. It's really spring-time—pretty hard to stay in the house—I haven't been in much except when at school. Goodnight. [. . .]

Saturday night—[. . .] the little freshman boy—really big—I haven't an idea of what his name is—came tearing out of the pressing shop as I was passing tonight and we walked a long way—It was so funny—I had never talked to him before—he talked right straight along—a blue streak—about what he wants to do—what he is doing—how unless he is just "dog tired" he can't sleep nights for thinking of what he wants to do—machin-ery—electricity—he has spring fever—such a nice big funny little boy—and I had never known him before from lots of others—It's all unexpected—It's fun—it puzzles—I don't know—I'm just liking living—It's the light that wakes me most every morning and I get up just about sunrise—again goodnight.

O'Keeffe to Stieglitz, postmarked February 28, 1917, Canyon, Texas, second letter from this date

[. . .] The yellow car won't come anymore—he is off for sure this time—and I'm glad—I've been wasting such a lot of time on such stupid folks. Feel as if I'd yell if I had to speak to any of them again—They have made me laugh and be foolish—I guess that was necessary. But—now—This darned book has made the things I've seen people do all day—seem so foolish—so insane[29]—that I believe I can laugh by myself awhile—Maybe it isn't laugh—as much as it is wonder at it all—The man [Nietzsche] is a wonder—I want to tear the picture of him out of the book and hang it up—stick it up somewhere so I can see it anytime—when I think back over the day—I want to jump on all the stupid folks I've seen and talked to—Not a single one I'd give the book too—I have too much respect for it—I want to jump on them with my heels—to hurt—Or maybe blow them around with a very hard wind that would knock them hard against the first upstanding thing—Goodnight—My pink hyacinth doesn't seem so funny tonight[30]—it's pinker on the top—dying—I don't know why—but it seems like a tall slender girl tonight—with an unnatural flush—and very shiny eyes—her dress is very pale pink—so pale it is almost white.

O'Keeffe to Stieglitz, March 11, 1917, Canyon, Texas

It's a very wobbly little girl writing you tonight—Sunday night. I've had a wonderful day—Last night I didn't tell you about my invitation to go to the Canyon because I wasn't sure—I only thought—sort of felt it. I go for the mail every morning—and frequently a big man—is going that way too at the same time—I knew who he was but had never met him—A nice young fellow—I knew he watched me—but I never looked at him—why should I care if he looked at me—and why look at him—he didn't interest me—His wife phoned me and asked me to go[31]—and the first thing she said

after she introduced me when I went out to get in the car was—
"He said he wanted to take you to the Canyon because he likes the
way you walk down the street with your hands in your pockets
and he thinks he likes you." Wasn't it funny—I knew he had done it
but it would have seemed so absurd to say if she hadn't said that.

The day couldn't have been finer—and they are great folks—
she is very pretty and blond—I walked and climbed—and climbed
and walked till I feel all shaky in the knees and limp all over—They
took another girl too—a great friend of Mrs. Reeves—We waded
in the stream[32]—icy cold—about ten feet—lay in the sand a long
time—Really big cedar trees—I took a long walk by myself—fol-
lowing cow trails through the cedars along the stream—We all
took our hair down—No, it was just Mrs. Reeves and I—but it was
great—just to feel free in the big outdoors—And the awful places
we climbed—Really—life wasn't worth living to me a few times—I
was so scared—It's all so tremendous—and we came home riding
into the sunset—Too wonderful to be true—I made a lot of draw-
ings—just little ones[33]—I'm almost too tired to wiggle but I wanted
to tell you about it [. . .]

Fred was by me when I got [my mail][34]—he had been telling me
about a blue hyacinth he was going to bring me—Agriculture is his
specialty and he has been growing some flowers—and when he
saw those three letters and the package—he said he wouldn't bring
me the blue hyacinth—and he hasn't brought it today—I had to
laugh—he'll bring it yet—The pink one froze—I cut the top off and
there are just a few blossoms way down among the leaves. I was
glad when it froze—Well—I must go to bed—it's after nine—and I
am to be ready to go out on a tramp at five o'clock in the morning
with some girls and boys—breakfast out somewhere—I don't know
where—You know—I'm just living—I just sort of plunge from one
thing into another—so often—so very much afraid—And you feel
like something that protects me—something I want to be very close
to—like I had to shrink back—so many times today—against the
wall of rock going straight up beside me—and in front—Gosh—a
misstep and I'd roll down forever—and the dirt and rocks crumpled
and rolled down and there was nothing to hold to—I dare not hold
anything—and I couldn't stand still by the wall of rock—or I'd never

get to the top—I must keep moving—and I guess—being so afraid
made it all the finer—It was that way many times—and another
awful place was a bare ridge—that went down seemingly forever
on both sides and we must climb up it—as it slanted up and ran
along the top when it was on the level—There is something so mer-
ciless about the Canyon—so tremendous—I love it—The big cedar
trees were very nice too—the grass is very short and brown—no
underbrush—such clean ground under the trees—clean ground
and rocks and trees and a very clean stream[35]—And we could see
for miles and miles and miles—and nobody—When we came out—
way off on the edge of the earth against the sunset were a lot of
cattle in a string—We could see daylight under them—Like a dark
embroidery edge—very fine—on the edge of the earth. Goodnight.

I think—if there is anything left of me after I've trailed off for
that moonlight breakfast I'll paint tomorrow—I thought a lot about
you down there today—It was so quiet and warm—Just a little girl
tonight—so tired—I wish you were somewhere around—When I
wonder how I ever got out of that place I want to be close to you—I
seem to hate to stop writing—My hands are filthy—scratched and
dirty—my face burns and my lips burn more—chapped. The air is
very dry. That letter I sent this morning was in my pocket and my
pen leaked on it—much ink and cedar gum on my hands too—Oh,
I've had a great day—So glad he likes my hands in my pockets—He's
a nice man—I like him—When I got out—when we came home—he
said "Now you must consider I've called on you and I expect you to
return it." Guess I'll have to because he has my hair-net and a comb
that I can't live without in his pocket. Goodnight again—

O'Keeffe to Stieglitz, postmarked
March 11, 1917, Canyon, Texas

[. . .] I feel as if the Devil has me by the ears and is about to pull
them off—if only he would let loose and just sit down and talk to me
for a little while I think I'd probably enjoy him. I wouldn't even mind
romping and rollicking around with him a bit like I've just been doing
with the youngsters downstairs[36]—but for goodness sake—why
won't he let loose of my ears.—There's a little boy five—and a little

girl—a little over a year I guess—I've forgotten—she can walk but she can't talk—pink and white—blue eyes—yellow hair—straight hair—so dainty and little—I just have to pick her up every time I see her—simply have to—She isn't fat—she is just lovely—too nice to be real—too nice to grow up. I've been playing with them for over an hour. [. . .] I finished Wright's book on Nietzsche[37]—I'm going to try one of the translations next—Only his ideas—theories—all of it seemed made for men—but I don't care—He makes me hate such a lot of folks—Myself included—principally because I can only laugh when I think of what havoc I'd raise around if I'd do as I pleased. Living is so funny. [. . .] Texas is just empty plains and sky tonight— have you ever been very hungry? Emptiness is excruciatingly painful—I've drawn a little this week—little pencil things—nothing more than four by five inches. The flower is two yellow jonquils in a pot—and I love them. [. . .] Wind and sand have blown all day— hard—We all wear knee dresses on days like this—but tonight—it's quiet—very still and warm—The sister is tennis-mad—a bit vacant in the upper story—Just plain crazy with living—I guess we are both a little cracked. Goodnight. Nietzsche would say everyone I know in Canyon is sick—Or I think he would—except one girl—She twisted and turned her still life study into a blue soda water glass with green straws in it—and fixed up a bottle—labeled poison—yellow on red—And had the queerest looking animal—sort of a spider only it had a grinning face—climbing up the glass[38]—I just wanted to yell—She had a wonderful time doing it—The class was some-what horrified that I had such a good time out of it—She's as strong as an ox—would knock anybody down for half a cent if they didn't please her—just to get them out of the way so she could go on— Then again—she has the sweetest little feminine smile—She came since Christmas—just came to me this quarter—a little head—little eyes—but such snap—

O'Keeffe to Stieglitz, postmarked
March 14, 1917, Canyon, Texas

Monday night—This morning seems years ago and yesterday almost never was—I couldn't sleep last night—so got up and read till three—then slept till five and got up. Dark yet—but

moonlight—Started to cook breakfast way out there when the first little streak of morning began to show—It was great—watching the day come[39]—and I like the youngsters too—had a great time.—I rode back with the wildest-looking old farmer you ever saw [. . .] Tried to sleep again after dinner but couldn't—Couldn't get up and work either—it's like a high fence between me and work and I can't get over it and can't kick it down—Several ideas but I can't see them clearly—I can only see them in parts.—

The trouble really is Lester, I guess[40]—and it's so absurd—he whirled around my fool head all afternoon—Now I've seen him again I have to laugh—It's so absurd. You would die laughing if you could see him—I hate him almost—Only he is so darned healthy to look at—still it's well-fed health—not the kind you get from vigorous exercise—and in a way he is amusing because you have to work so hard to get anything out of that expressionless face—It's immovable—so making it move is great sport—it can move— Someway I don't think he'll bother me any more—trail round in my brain when I want to do other things—and I don't know why I suddenly feel through [. . .] Lester has taken more time and thought than he is worth—simply because I'm almost an empty space—An empty space will fill up with something. I'm getting mixed up. [. . .]

This afternoon I started to the lumber yard to get some stuff to paint on[41]—I've grown to be such a loafer that it took me nearly two hours and a half to go the eight or ten blocks and get what I wanted and get home—There seemed to be so many folks to talk to and I just couldn't get away—I was in a good humor—enjoyed talking and Paul Bell finally nailed me to a telephone pole and I guess I'd be there yet if I hadn't just brought him along home with me. He was a carpenter—came here to work on the school when they were building it—and when it was finished decided he would quit carpentering and go to school—Queer sort of fellow. Anyway he carried my stuff home when we did get away from the telephone pole and I carried his books—He is stupid but he likes to talk to me so I talk to him—Warm sunshine—great for loafing—I came home and worked awhile till supper—and after that walked into the sunset till it was gone—about three miles I guess—then back in the dark—with a queer tall girl that I like [. . .]

O'Keeffe to Stieglitz, postmarked March 15, 1917,
Canyon, Texas, first letter from this date

Wednesday night—I've worked—today—even painting in my spare time—it's big and it looks like Hell let loose with a fried egg in the middle of it [fig. 11][42]—and I'm crazy about it—I can see where it's bum too but that doesn't matter—I'm crazy about it anyway—I believe it pays not to work for a long time—I feel as though I've burst and done something I hadn't done before. The sister is liking it very much too—Oh it's great to feel full of work again—It's terribly red—and such fun—And I walked into the sunset again till it was dark with the tall dark girl[43]—she is just human. Then back in the starlight—I must tell you that I made an awful blunder. As I came out of the drug-store that yellow chariot rolled up and I grabbed the girl and made a dash for it from habit—forgetting that Austin couldn't be in it[44]—And the man who was in it nearly died laughing when he saw my look of surprise—I didn't know him at all—it was funny. Greetings to you from the night—it's weird—feeling and dark—a little wind—the noisy whirl of a windmill out in the blackness [figs. 6 and 7]—Goodnight.

O'Keeffe to Stieglitz, postmarked March 15, 1917,
Canyon, Texas, second letter from this date

It's cold as the devil—snowing almost all day—I just came in from supper and can't make the fire burn fast so I'll write you while I wait for it—I'm quite as uncomfortable cold as anyone who doesn't like me might wish—I don't mind shivering over a little scrap of fire out in the open—wet wood and all—but this kind—in a stove—that you can't see—isn't much—I can hear it—burning on the southwest side—and don't dare look at it—because if I do—every time I look and poke it—it goes out—I've wanted to write you ever since the last time but—You see—I've been wasting lots of time on folks—and it's hard to quit—even when you are ready—They come along and jolly you with your last piece of foolishness—and before you know it you are off again—and a whole evening is gone or a whole afternoon—

Yesterday afternoon I came home—and got *Faust*[45]—I'd been wanting to read it for almost a week but someone or something always kept me from it—And I fled from the house and the phone— to get away from them all—I went to a little stream[46]—not much more than twelve feet across—you can't see it till you are right by it—the water is low—and has left something—lime, I supposed— on the ground and grass where it has gone down—that looks just like frost—I don't remember sitting down—or lying down—but I was looking at the water—almost upside down for a long time before I knew it. Then I sat up and looked at *Faust* and laughed at myself for carrying it way out here and not reading—just dream- ing—and I wondered—did I have it along just because I like to have it by me—I spread out my handkerchief—I should say one of my handkerchiefs—now that I have pockets I can carry lots of things—and put *Faust* on it—so it wouldn't get scratched—Then I lay down again and went to dreaming again—The sun was warm in the little hollow where the wind didn't strike.—You would have liked it—I wondered what you would say and feel out here where there is nothing but ground and sky—It must be that you would like it. [. . .]

The day—the paper said Germany was giving Texas to Mexico— The smiles—the war talk [. . .] *Isn't it queer—the way it fits some moods and not others—and every night I got out Wright's Nietzsche book too*[47]—*and looked at the chapter on the Anti-Christ and put it away—That's as far as I have read—I want to read the rest of it but can't get the humor so far* [. . .]

I just came in—Sunday night—it's 10:30 [. . .] After supper one of the teachers—Assistant in History—light hair—27 or 8—and I were walking—we passed Lester—the lawyer[48]—and in a little while he came along in the car—and asked us if we didn't want to ride—we rode—into the sunset—a long time—then back—left her at her house—then he and I rode into the sunset again till it was all gone—moonlight back—He said his mother and father and brother were away—didn't I want to go to his house—nobody there—comfortable—no fire in the sitting-room here—It would be trouble to come here—no trouble there—I said—let's get someone else to go too—He laughed and asked if I were afraid—I said—no—I

<u>wasn't</u>—so we went—I don't know—I had a good time—There was
a Victrola—we played a little—and we talked—and we talked some
more—and we kept still awhile—Finally we got off on that lavender
night—and we talked some more—and someway he made me con-
trary—and in the car on the way home I got more contrary—The
hands so persistently on the wheel I wanted—and when I unex-
pectedly felt it round mine—I didn't want it—and when it was on
the wheel I wanted it—I told him—and he laughed.

When I finished your letter this morning—I banged it down
on my desk in the office—I had been sitting there between the
windows—my tilty business-looking chair tilted back against the
radiator—my feet propped up much too high for a nice lady but
discreetly behind the desk—so as not to shock any chance visi-
tors—and what I said to myself—was—"GOSH BUT I LIKE HIM."
Then I jumped up quick and went on to class—for the bell had
rung—And I laughed—I knew you would have laughed if you heard
me say it. I had been reading the letter instead of going to cha-
pel because—Well—of course I wanted to read the letter—and I
had—I didn't want to go to chapel[49]—The Seniors and Juniors all
used to sit in the back of the auditorium—but they didn't behave
very well so the order was reversed—Seniors in front—Freshmen
in the back—and it seems that all the boys I like best sit right at
my feet—and I had stood it for two mornings—and today I didn't
want to—I hate to be looked at—After they have sat down there
a week or so they won't look so hard and I won't mind—Yes—it's
funny—laugh. Sixteen silk shirts—Davis[50]—stopped me in the hall
yesterday noon and told me he thought the faculty looked great—
he enjoyed being on the second row—he could see so well—and
he simply doubled up laughing when I said I didn't enjoy it—

Didn't I tell you about the dance—you asked me so I must have
forgotten—The yellow chariot came down from Amarillo and took
me and the other chaperone[51]—He didn't dance—but I did after
I had watched a little while to see who could dance—It was very
funny. I had a great time—such ridiculous kids—Yes—I guess I dance
rather well—Can't help it, you know—it isn't my fault. It seems so
queer that everyone can't—You ought to see Beverly[52]—he is just a
little hunchbacked—and someway it seems like a Teddy-bear—and

he has more fun dancing than most anyone here—he doesn't do it so remarkably well but he has such a good time that he makes up for any lack of skill—and every time we meet at Hollands and he can get something on the Victrola that he likes—he tries to get me out in the back room to dance—If you could just see Hollands back room—badly lighted—and littered with everything from pills to drugs to fishing rods—scales—stove—desk—boxes—just everything—There is oilcloth on part of the floor—the rest is too rough and the oilcloth is ragged—Can you see it—and the Teddy-bear. I always want to pet his cheek—he is such a nice funny little boy—always though—the hunchback—it hurts you—don't you know—maybe makes you like him better—I don't mind him looking at me—He and Davis room together—The sister is at tennis again—She has two new yellow jackets that look great—and noisy green ribbons—No one has beat her so far—it's bad—you don't improve when you don't get beat—Maybe someone will though [. . .]

What will I say to 291's continuing—?[53] [. . .] it seemed that I would just have to go to New York if you were going to close it—I'd have to be there again—I don't know why—but I must. I thought that this morning before the letter came—Knowing that 291 is—is one of the things that makes life worth living [. . .] And tonight I am only a little girl. More—I want—to say—but—what—I guess that space that is between what they call heaven and earth—out there in what they call the night—is as much it as anything. So I send you the space that is watching the starlight and the empty quiet plains—.

O'Keeffe to Stieglitz, postmarked March 18, 1917, Canyon, Texas

[. . .] Why, I've actually been so full of electricity that my hair stands up straight—about three inches—when I comb it and my skirt—cracks when I walk and the white skirt and black skirt stick together as though they belonged together and sometimes both stick to me till it's ridiculous—I haven't worked since Wednesday—Thursday there was a tearing sand-storm—but Little Cooper had come to a terrible crisis with her lover[54]—I had noticed for several

days that something was wrong—and Thursday afternoon she said she wanted to tell me—must tell someone—and nothing would satisfy her but to walk out into the tearing wind and blinding sand—

And this afternoon—Ted—Ted was raised on a ranch 30 miles from a railroad[55]—but he is tall and lean and good-looking and can think up the most ridiculous things of anyone I know here—anyway he is president of one of the boys' literary societies—and some of the girls were entertaining them this afternoon and he insisted that I go with him to the party—I said I couldn't because I had a hole in my heel but he got a needle and thread—green—it's St. Patrick's day—and sewed up my heel—so I went with him to the party—and another afternoon was gone—I walked a little after supper—but I felt like a kite—The strings were attached to the back of my head and shoulders—and all pulling—and the rest of me felt like air—like flying. Too tired to stay on the earth.

O'Keeffe to Stieglitz, postmarked March 26, 1917,
Canyon, Texas, first letter from this date

Sunday night—A great starlight night—the world seems soft around the edges—cold wind that it seems ought to be warm—but is raw—Windy and sunny all day. I've worked—and such a funny thing I've made—a blue and green reaction from the red, I guess—Not so bad but very tame besides the red one. Very very tame.[56] I just noticed that all the drawings I made last Sunday—no—I should say most of them—have the same line arrangement [figs. 12 and 19]—it's that I've been painting and taught—I walked till eight—I'd like to walk to you tonight—I want to go to 291 but instead—it is just a starlight night—and Texas—It was windy when I came in but is all very quiet now. Goodnight.

O'Keeffe to Stieglitz, postmarked March 26, 1917,
Canyon, Texas, second letter from this date

Good morning! My head aches. I brought the small boy to school today and left him downstairs in the training school—he's a great kid.[57] [. . .] Monday—was anybody's but mine—Jimmie Blaine—Physical

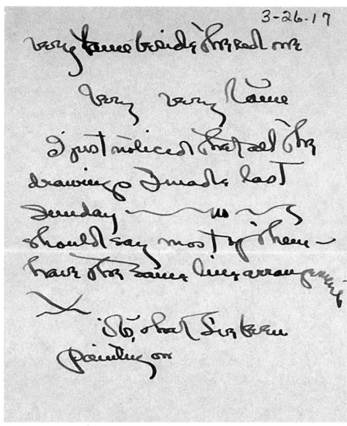

Figure 19. Page from Georgia O'Keeffe to Alfred Stieglitz, March 26, 1917, Alfred Stieglitz / Georgia O'Keeffe Archive, Beinecke Library, © Yale University, Beinecke Library.

Education's five-year-old son[58]—*saw Claudie and me up on top of our house*[59]—*and insisted that his mother phone us to come over and play with him*[60]—*there are two others younger and—they are certainly great kids—all boys. I went—Claudie couldn't—and all the morning went to the youngsters—Claudie hauled me out the window just as "Why Men Fight" came and took this picture of me before I had time to open the book*[61]—*It was a great spring day—*

All afternoon I fooled away with the Freshmen—they were getting ready for a party—And that night—I went to the party—and had more fun than most anybody—I guess—Oh, I forgot—in

between these Beverly and Davis and Fred a boy from downtown and Claudie and I all slaved and tinkered and pasted and tied till we had the most wonderful kite fixed up[62]—and flying—It was a wonder—we wore it out—Did you fly kites—it's great—We are going to fly another—Must tell you about the blue flower—someone stepped through Fred's hotbed glass and all the hyacinths froze. When I teased him about it—his face is very red—a blue streak—scar of some kind under one eye—red hair too—an awful temper—he turned round right quick and—"Why, Miss O'Keeffe, if I thought you were responsible for my flowers freezing—I'd choke you—Yes I would." And he looked as though he meant it.

O'Keeffe to Stieglitz, postmarked March 26, 1917,
Canyon, Texas, third letter from this date

Good morning—It's Sunday again—seems like the shortest week I ever spent—and what did I do—I don't know—Just one mad scramble after another—Read Why Men Fight*—and one afternoon—in a ridiculous mood—went to a picture-show with Little Cooper and Claudie and Beverly.[63] I don't know what the show was, don't remember people or story or anything but I do remember water and it made me crazy to smell it—see it—feel it [. . .]*

Leah—the tall dark girl was up to see my red drawing this week[64]—She looked a long time—and Claudie—impatient when she didn't say anything—asked her what she thought of it—She laughed—"Well—that depends on who I'm talking to and how I feel." She has spoken of it several times since—wanted to come up and see it again—but we are always on the fly [. . .] The Reeves again after dinner[65]—he is nice—a great big long little boy—you feel that he would take great delight in just picking you to pieces like he might a clock—to see how you were made—going to Amarillo with them tonight—there will be just a little thin new moon—It was wonderful last night—early, I like it best when it's very thin. Then I played with this baby. She is so little and funny—and pink and white—16 months old but little[66]—After that—washed my head—A dust storm came tearing up the road when it was almost dry—I had been standing out in the back yard—no fences—Houses

not close—you can see for blocks—watching a man breaking a colt to a cart about three blocks away—If the wind doesn't go down we probably won't go tonight—too dusty. I've been looking out the window at the wind and dust [. . .]

O'Keeffe to Stieglitz, postmarked March 27, 1917,
Canyon, Texas[67]

Monday night—Cold starlight—quiet—The stove is warm though—and it's the little girl wanting to be close to you that's talking to you—makes me feel sort of sick—that I can't be. We had a great time last night going to Amarillo—The wind went down—the sunset was very yellow—like gold—only—warmer— warm—it was warm—green fields—that fresh spring green—dark soil showing through—long blue shadows from very little bumps on the plains made it all look so clean—as though it had been rained on—instead of smothered with dust[68]—but—I was in great good humor—simply couldn't help it when the world looked so good—It was great—just a nice fresh wind—not cold—Laughing—talking—nice good humor—the car open—no top even. The excuse for going was to hear a man talk on Tolstoy[69]—I went for the ride and for the fun I get out of hearing what some other folks that I knew were going would say about it—I don't know much about Tolstoy but don't remember when I didn't know everything the man said so I've had a great time today. It's fun to hear folks air their opinions—I'm such a fool. More fun tomorrow. So much fun to know folks that way. Only on the way home in the dark—I remember looking round over the empty plains—And thinking in a sort of forlorn way—where is someone to think like I think—It was only a moment. Then the laugh—as though I'd see anyone out there in the dark—and as though it mattered—The ride home was great—the thin moon went down—very red—The sky—Oh—it was great—I let my hair fly in the wind till Mr. Reeves objected— tied his handkerchief corners in knots and made me a cap. She has the most contagious laugh I ever heard—yellow hair—and I love yellow hair—like her even if she didn't say a word over my Rodin *Camera Work*.[70]

You ought to live way off like this sometime—it makes you wonder when you see how little Rodin in this form means to most folks—I can hardly believe it. I'm going to show it to a talkative class tomorrow. They might like *The Thinker* a little—The sister didn't even get the water colors—they puzzled her—she wondered—looked several times—always seeming to question—The man on the horse she liked.[71] No one has seen it but Mrs. R and Claudie—I'll take it to school tomorrow—showing it to folks that can't see hurts but I'll do it anyway—Maybe one will like it—maybe two think about it—Don't know—I'll see. Is it because there is more animal in me than brain—that I want to be near you to tell you how much I like it. No—it isn't animal at all—it's touch—Touch may be god or devil with me—I don't know which [. . .]

I've been sitting here watching the youngster's goldfish for such a long time that I'm lost. Remembered that I didn't tell you that I moved in to my white room today—am not in there though because I have the habit of being in this one I guess. And I didn't tell you that I haven't modeled since last fall[72]—The thing looks like a stomachache—There has been an idea—a shape—all made in my head but it's so foreign to stomach-ache that I've hated to make it out of the same stuff—and I really hated to muss up the shape I have—it's so bad I sort of liked it—really don't know where I've put it if it isn't in the top tray of my trunk—I'm glad you asked me about it—I've been wanting to make something my hands could get all round and was thinking of metal—Maybe I'll model the thing I've had in mind so long—I guess it's the plains—I don't know—Maybe I can't make it—guess I'll try—

Fred and Lyman[73] and someone else—don't remember who—came in the post office this morning as I was struggling with the combinations on two boxes—getting other folks' mail for them—They had to feel and admire the green coat—Fred remarked that it had a collar—They had to sound the depths of the pockets[74]—Fred remarked that he wanted to see what my skirt pocket was like inside—said he never had—Crazy—Of course I'm crazy—of course I'm crazy—It's a disease and contagious—I didn't intend to say that twice—Sleepy—Dust has blown all day—A norther came

just after we got in last night—Goodnight—I didn't tell you that I let Fred feel in all my pockets [. . .]

Commentary

This chapter demonstrates how O'Keeffe developed close relationships with men, women, and children in Texas. She wrote of spending time with Leah Harris, a county nutritionist from the San Antonio area, and "Little Cooper," a woman who taught at the Training School with her. She described how much she enjoyed playing with the "youngsters," including the children of her landlords, colleagues, and neighbors. She recorded the fun she had at dances, or flying kites, or taking day trips by car around the region. But perhaps most noteworthy for the moments before the war was her growing closeness with men in Texas, including students at the college—J. Lyman Davis, Fred Heyser, Beverly Sportsman, Paul Bell, and Ted Reid—and older men, especially married men, such as Rector Lester, Don Willard Austin, and Thomas Reeves. She described her burgeoning friendships with these men and her appreciation of their unique personalities—Davis's "sixteen silk shirts and nothing to do but be good looking," Reeves being "a great big long little boy," and Beverly having the physical deformity of a hunchback but still loving to dance. She wrote of her connections with these men, expressing both tenderness and a good-natured humor that brings out her humanity and vulnerability. After April 6, 1917, she saw a number of these men faced with the draft and the reality of war service, and she watched them leave the area to join the fight.

This chapter also highlights her embrace of and control over her mature sexuality, as she openly and unapologetically flirted with men and kissed them; flaunted her exposed body in front of them; "[got] off on lavender nights" with them because she certainly "<u>wasn't</u> afraid"; and let them "sound the depth of her pockets," all the while describing these sexual adventures to her future husband, Stieglitz, who was then still married to his first wife. Here we see O'Keeffe emerge as a kind of playful if scheming temptress—she even said she would "enjoy" conversing with the

devil, hinting at a pride in her own devilishness. She repeatedly taunted Stieglitz with stories of her romantic escapades, which she described frankly as "sport." She even wrote about "how funny" it would have been if Stieglitz had been present to witness her with a "beefsteak" man making out in his car, and what a "good time" Stieglitz would have had "on the back seat" with the two lovers! As she said herself, she was often "out for contrariness more than anything else." She wrote that only when her landlord objected to her bringing a man to her room did that man suddenly become "interesting." It is not hard to imagine Stieglitz, back in New York, being totally titillated by her stories—by knowing what "kinds of kisses" and "kinds of touches" she liked, or how she was "nailed" to a "telephone pole" and her "pockets" were fondled by young male students. Clearly, she was flirting romantically with Stieglitz too at this time, even while she knew that the gallerist was also reveling in those vivid descriptions of her artistic creations that she equally gave him in her letters. How could he not fall for this bold woman and innovative artist, this storyteller in words and visionary in forms? To be sure, in the months covered in this chapter, O'Keeffe appears to have produced some of her best works in response to the Texas plains, from her *Starlight Night* and *Evening Star* watercolors to her *Red Landscape* oil painting of Palo Duro Canyon (fig. 12). As she stated, she was just "liking living" at this time and "feeling human" with little guilt or shame, a confidence in life that seemed to be shaken once war was declared.

[3]

War Declared

"WHAT'S THE USE OF ART
—IF THERE IS WAR"

O'Keeffe to Stieglitz, postmarked April 13, 1917,
Canyon, Texas

[. . .] Cattle in the pens over by the track waked me I guess—I was glad because I like to hear them—and I like to see daylight come.[1] I wish you could hear them in the early morning. It's great. Then it rained for a couple of days—the first since way last October or November—It seemed queer. The lightning was marvelous—The man from Amarillo that I didn't like was down that afternoon—we rode till the sky was too angry-looking—the lightning too wild— another new car—a beauty—I think they must all be going crazy. Lots of work to do—and I've been painting again too—No one thing is right—but the series of seven—all stabs at the same thing—tell it I guess—They are different—seem different to me anyway—they are like my hands have been today—Queer hands—I've looked down to see often if there is something in them—They have been full all day—of what?—touching yet untouchable. The plains are wonderful—so much greener—unbelievable—pale soft green— lavenders and blues—pink over northeast toward the canyon— Leah and I walked toward the sunset tonight till houses were all gone[2]—then lay down on the ground—little short grass—hardly any at all—wet too from last night's rain but the sunset is so much finer close to the ground—I haven't any idea how long we were there—just still—We were not close to one another—she sat right down—almost in the road—I rolled under the fence—out a way where the grass was trying to grow [. . .] I see the *American Art*

News calls me a "Futurist."[3] More crazy folks in the world than you and me. I want to pick holes in everything folks call Art—I'm not trying to do Art—I'm digging stars [. . .]

O'Keeffe to Stieglitz, April 19, 1917, Canyon, Texas

Good Afternoon! It's sunny—warm—green—just spring—Last night another play—I wasn't much interested but—as fool's luck usually goes—it seemed to turn out better than any so far—I don't know exactly what happened yesterday that I didn't get any farther—Except that Watkins was down again in the afternoon[4]—we rode for a long time—It was great—such wonderful long strips of color in the plains—spring color—From a higher part in the road out east the town is just a little streak in the long ribbon line—horizon way above the town—It makes paint seem impossible—wonderful light greens and blues and grays and lavenders—When we went back to town Leah decided after much comment that it would be fun to go to Amarillo with him and come back on the train—It was a great ride up—a little rain—much sun—tremendous clouds—I wouldn't have missed the sky for a whole lot—but could very well have gotten along without the rest of it [. . .] Maybe it's the impossibility of living—I don't know—So I went out and gardened—Did I tell you before that I have a garden—It's in the school garden—too far from the road for anyone to get you in a car and too far from other things for folks to walk to you unless they have to go to the garden—It's a good place to go to—I like to get very tired like hoeing and planting and watering and scratching around ought to make you—but I'm even getting used to that—almost four hours of it today and not a sign of being tired—The wind blew very hard—Sky and plains all around except to the Southwest—big clouds today—great shadows on the plains—

Boys leaving school and going to war—the best ones it seems—some waiting till the end of the quarter—Vacation—three weeks—vacation in three weeks—I don't know—it's bad—a few new ones getting the fever every day—leaving on one train or another—They can't see at all—I can't see much—but I can see enough to know I can't see—It's like sending the cattle to market—Goodnight—I'd

like to give you both hands and be very close to you—for the world hurts—Someone to feel it like I feel it—All these other fellows— like—oh the ones that make me hate all the men in the world—They don't think about going to war—They will still be here with cars and their despicable selves—It's only the nice youngsters that go—

Friday evening—shadows growing long—yesterday a large wind—all quiet tonight—Your two letters this morning—Nietzsche and a letter from Dewald again[5]—Leah and I have been fighting over the book all day at odd moments—both wanting to read at the same time—I'm going to bed with it tonight—I read all the letters at the dressmaker's—had gone on an errand for someone else—it's right beside the post office—dirty little room but the morning sun comes in—She is a good old soul—and I didn't want to wait till I got home to read—She never said a word while I read it all—I think I'll have to have her make a dress for me—I haven't any and she looks as though it would do her good—It's almost warm enough for white again.[6] [. . .] No—young men can't understand— they make me laugh—I wonder why they ever try—Very young ones like me—little boys—the students here—sixteen to twenty-four—they do not try to touch me—they leave me alone—I don't know—I feel like one of them—They talk—maybe it's because they like to talk about themselves and I like to listen—It interests me— Then too I'm "different" to them—they think I'm queer—I don't know why—They expect nothing—neither do I—That I think and talk and act differently from what they have known before does not scare them—doesn't insult them [. . .]

O'Keeffe to Stieglitz, April 24, 1917, Canyon, Texas

It's another day—spots of blue sky and clouds—not much sun— Again it's war—girls learning to can and feed folks[7]—what in place of wheat—? New classes formed—the sister going in for it—She had a letter from Buck—one of our liveliest boys[8]—He had just arrived from El Paso—She thinks she is going to can beans—Some of the girls come to school in sunbonnets—Not on account of war—they always have—More boys gone—Mothers come to tell them good-bye—Leah's lover's brother died and she seems to be exceedingly

*fond of the whole family—I don't know—A bad day—And things
ahead look worse—Wonder—*

I went to the dance—Yes—and danced too—Ted is funny[9]—and
likes it so much you can't help it—Lester was there[10]—I thought
he wasn't even going to speak to me—but after watching for some
time—across the room out of the corner of his immoveable face
he came over—He can dance—really well—neither of us said any-
thing—but that the other danced well—When I found I had danced
four or five times with him I went home—that was enough—it was
funny—So absurd—And—darn it—I dreamed about him—I had to
laugh—It's a queer day—

*What's the use of Art—if there is war—It's queer enough to get
excited over it when there is no war—But when there is war—And I
painted all day yesterday—would today too but haven't time [. . .] Fri-
day morning—I've been on the run—almost flying every night—Wat-
kins was down Wednesday night[11]—I like him better—he's funny—
honest—anybody frank seems queer—it's like fine cool water on a
hot day—He is going to war too—Coming again today—Your letter
this morning—It's hurt everywhere these days—everywhere you turn
something to tell you of it—Hell for folks like you—And me—There is
a deadening sort of consciousness of it all. Will something particular
for me to do come—I don't know what it will be—Faust—Nietzsche—
We have nothing like that—that I've ever seen—What's it all about
anyway—I cannot clap and wave a flag—I must go—*

*O'Keeffe to Stieglitz, postmarked April 24, 1917,
Canyon, Texas*

[. . .] If you know Dr. Mac and Billie Mac[12]—I've never told you
about them in spite of the fact that it's their house I usually go to
in Amarillo—Guess I never told you because it's such a queer mix-
up of women and men—a tangle—and I like to go there and at the
same time hate it—They came through—a car full and we went
down to their ranch—twenty miles below here—that was in the
afternoon—the morning was all sorts of things strung out—I went
back to Amarillo with them—It was a great day—a great ride—all
so funny [. . .] Spring—early green and I knew all the cross-cuts

and cracks in the walk almost—passed the house where I used to live. I've painted all day—as if my life depended on it—It's clearer color—the color pleases me but the shapes are hopeless—The color surprised me when I got ready to wash my brushes and compared it with other things—even my red one. [. . .]

O'Keeffe to Stieglitz, April 29, 1917, Canyon, Texas

Greetings—my hand—It's Sunday night 9:30—The sister and I walked—north of town—about three miles—out of the basin where the Canyon begins—You go up a fairly steep—white hill—and at the top of it is the levelness[13]—We started just before dark—just when the moon began to make our shadows pale on the white road. We lay down up there on the edge of the levelness—talked—great sky—I almost went to sleep—Coming home—I was afraid—didn't say so—but I was—I can't get over being afraid—there is nothing to be afraid of either—even in the moonlight you can see for miles—We saw the train coming way off [fig. 16]—waited for it at the crossing—a long freight train—coming out of the night—I was terribly afraid—but it was worth it—Clouds had covered the moon—So the black streak—bright yellow streak—soft white smoke strung out—roared and crawled and creaked up on us—out there where there was just nothing around—I can't help being afraid of it—It isn't a train to me—it's an awful live thing—I like the rattle of it as it goes bumping on its way[14]—

Yesterday and today have been bad—Yesterday—I don't know why but I had so much to say and no one to say it to that—I came home and went to bed and covered up my head at about five in the afternoon—Just nobody to talk to that would understand even a little—and I had so much that I wanted to say—So I just covered up and shut my eyes tight—Watkins' car waked me up—I wasn't asleep—I just knew it—Of course I sat up and looked out and he saw me just as he stopped—He is funny—I like him—He thought it a large joke that there was nothing but my head that I could show—And I wouldn't go down because he had a man with him—I've often seen the fellow with Lester—often seen him on the streets—No one ever told me who he is and I never asked—but

he looks at me too hard—and I don't like to be looked at—He is enormous—drives a good car—if I knew him I wouldn't have any better sense than to ride in it—and I just don't ever—Bah! I hate to be touched. Still he looks as though he would be fun—

Today—I've spent mostly with the Gellers[15]*—He teaches Agriculture—They are both sick—I didn't want to stay but I am sorry for them—He is a Rumanian—she a German—Been here seventeen and twenty-two years—Foreign—and some way folks do not understand—It was bad—I didn't enjoy it a bit—He very quiet—she nervous and excitable—It is terrible. It made me ridiculously glad I'm not married—GOSH! [. . .] Then the Masses came—I feel like chewing nails.*[16]

Goodnight—I've just been wondering the past few days why I—and the sister were put in the world—I feel like such a misfit—She doesn't know it yet but she will in time be as much a misfit as I am and I'm sorry for her—I never ought to talk to folks about anything but the weather—I always horrify them—And it always surprises me when I find out how differently I think about things—I talked at dinner today—last Sunday too—without intending to—Open mouths and queer looking eyes waked me up both times—I don't know how I grew queer—how it happens that I'm almost always alone—And I don't care if I am alone. I'd rather be alone than with them [. . .]

O'Keeffe to Stieglitz, May 1, 1917, Canyon, Texas

It's night—I've just come in—great out—I was out hoeing and watering my garden while the sun set till it was too dark to see—Then I went by the Normal on my way home to get a drink—They were practicing the senior play—Ted and I lay out there on the big flat cement piece on the side of the steps—looking up at the sky for a long time.— Talking—Ted is a nice boy—No that's not the way to say it—I like him says it better—He is one kind of cowboy—Thinks he can't go to war right now because he has a lot of cattle down on the ranch that they have to keep through the summer—Anyway—he wants to see what's happening—first. He was down there Sunday—and got all excited telling about it—"And don't you know—I have the greatest mother

in the world—at least to me." Tall and thin—muscles like iron—He asked me something—I don't know what—then rose right up—and asked why I always smiled such a funny smile—and changed the conversation so quickly when he tried to find out if there was a particular man—I had just started to try to tell him—I don't know exactly what when someone came along—He is good-natured—funny kid— has such funny kinks in his brain—I like him—Some way or other—I doubt my sanity tonight and I don't know why—Goodnight—it's a great night—

O'Keeffe to Stieglitz, May 3, 1917, Canyon, Texas

Thursday night—Quiet—perfect—such stillness—a wonder world— Your letter this morning—very busy all day—my garden at sunset— when I couldn't see to hoe I started in with the hose. It must be watered every day[17]—sometimes the boys do it for me—it's fun though—Leah and I go out there in the moonlight—the sky still red—it stays red so long here—making the ground black and wet—I can almost see my beans grow—get so absurdly excited over it—Mrs. Pennebecker (I don't know how to spell it) talked on women's work in the war— right now—tonight. I like her—then Leah and I walked a little in the night—It's a great night [. . .]

I told you Watkins was coming in the morning—He hadn't come at ten—so—I went to school and took a bath—I don't know why I didn't wait for him—it was a perfect morning and I wanted to ride— I just can't help doing things like that—At noon when I came out of class—I got in a car with some other folks—talking and didn't notice him or his horn or anything—till he drove past us—and almost died laughing when I scrambled out and got in with him— He was a bit grouchy because I hadn't waited—picked Leah up and we rode out south—I was furious with myself for missing it in the morning—We didn't want to come in for dinner but he made us— No use to tell all about it except that—way yonder in the night—I don't know—it was all so queer—I feel so at home with him and he is so funny—Leah had gone in to Dr. Mac's—He kept me talking—"I want you to be to me—say to me—anything you want to—I want to kiss you goodnight—if you want me to—not if you don't want

Now.

to"—He's the most natural sort of human I ever saw—Of course I wanted to kiss him—couldn't help wanting to—I never saw anything so queer—Honesty given you and a chance to be honest—He could hardly understand I think—It seemed impossible to me—we both laughed—And I find myself afraid to be honest—It was all funny—really ridiculous—I couldn't help shrinking from the second one—so hot—Gosh it was—I don't know—queer—He's married—gives me the feeling that he is falling through all space—all the world to satisfy a fine kind of hunger—Leah had been driving the car—we had just talked of many things—we had picked her up after a long ride out south after school—had been riding for hours—It was queer—I never felt the fence so completely down between myself and another—It's not that I care so much—care at all—not that he cares—it was just like the frankest sort of acknowledgment of the fact that I really—honestly—like you immensely—I wonder—have I made you understand at all—It seemed that not to kiss him meant the lips a little tighter—the eyes colder—the face turned more rigidly toward space—a gnawing sort of hurt—he hurts inside—And that a woman's daring to be human—honest—have faith in him warmed him—He's queer—I wonder do you think I'm completely crazy—I wonder too [. . .]

We didn't stop at Dr. Mac's—we came home—after sitting there in the car for ever so long—just decided to come home—I don't know—I can't understand—He said he might go on to camp[18]—not be down again—but I know he won't—I know he will be down again—He tried to make me promise to go down near the camp for my vacation—Leah has a house twelve miles from where he is going to camp—He's so funny—really downright amusing—besides being so comfortable to be with—I may go—I don't know—and he has such an amazing amount of nerve—I just like him—

Yes—I'm apt to be talked about—he's apt to be caught—and Billie Mac is apt to get Leah—Leah told her last night that I was out there in the car with Marion—I wanted to shoot her—Isn't it queer how folks are not supposed to be human—It just makes me want to yell—Your little girl tonight feels very quiet—I dreamed of him—all the time it seemed—when I dozed a little last night—That queer

consciousness of having touched another real human—touching it
yet through space because I know it exists—I would like to put my
head in your lap and go to sleep—It's so quiet out—Goodnight.

O'Keeffe to Stieglitz, May 6, 1917, Canyon, Texas

It seems that I've never felt more devoid of feeling of any kind than
I do this morning—Yesterday was cloudy—damp—windy—a little
rain from time to time—Today is Sunday—The world is white with
snow—almost a foot of it[19]—heavy on everything—young spring
green on the trees shining through or hanging broken—A white
world—I'm glad it's white—glad it looks different from other days.
I wish I could see you—don't know why—
 Watkins was down again yesterday—all day—I knew he was
coming—don't know why because he didn't tell me—even when it
rained I knew it—And—Oh—I don't know—The plains were very
blue green and violet and purple—Soft wonderful gray—I don't
know what to say about him except that he has left me absolutely
devoid of feeling of any kind—He wanted me to go back with him—
waited around all day for me—I had much to do—He took me so
far at noon that by the time I got back to work it was impossible to
get through till nearly six—Queer the way I like him—only he likes
me—maybe that's not the word—too much—both so queerly hon-
est—We rode till almost dark—blue green—lavender and purple—
unbelievably long thin horizontal streaks of it—I would <u>not</u> go to
Amarillo with him—I don't know why—something made me feel
I mustn't—and today I'm so glad I didn't and I don't know why—
Twice he brought me back—stopped the car—and both times
snapped his teeth right tight—and the door of the car—and with
that hard look straight ahead said he couldn't let me out—had to
take me and we rode on—It was very bad—He thinks that I feel like
he does and won't give in—and you know—I don't—Maybe several
things keep me from it without my knowing I'm so reasonable—If
he would just be friends—because I like him immensely—Maybe
there just isn't any fire in me—maybe it all died last spring—It
hurt—hurt terribly—I hated to see it—Then too—it surprised me
so—That he should get on such a tantrum with so little excuse

for—and so many against it—He said so many things that made me laugh—surprised—wonder—once I almost cried—many that hurt—Still—just being by him is a kind of rest I almost never get— He wonders—believes—yet can not believe—queer that honesty should be so rare—He says he will not come again till I ask him to— Not—exactly that—Tell him I want him to—And today I wonder—I would be tremendously glad to see him walk in right now—he is good to talk to—the laugh is nice—We laughed often though he reminded me that it wasn't funny to him—I don't think I'll want him enough—to say so—won't want another ride out into the night— at all—I guess—Isn't it queer—And I seem to know that he will come again—Of course he'll come again—he will want to—and it's his damnable nerve that I like for one thing—"No—I won't come again—but remember—it won't be because I don't want to—it will be because I know it's not best for you"—And I have to laugh—I know he is so selfish—And he doesn't know it himself—

I'd like to bang my head against the door today because I can't see why things are like they are—"I am always waiting"—I'm going to be very busy all next week—then after that three weeks to do as I please—There are several things in the wind—two trips overland to San Antonio—but it all sounds so much like greased lightning that I think I'll go off somewhere and sit in a corner by myself— and not even breathe—just sit there quiet—alone—and watch the dust blow by—I'd like a dust colored vacation—Just a little girl this afternoon—be very good to me will you? I don't know—he was very good to me but some way—You see—I am just woman to him—In the course of the afternoon I remarked that I ought to be shot—he reached over toward the pocket of the car where I know he keeps a long slim black pistol—and I quickly told him—not today—thank you—Still—why not—. The snow is almost gone— it's late afternoon—

O'Keeffe to Stieglitz, May 9, 1917, Canyon, Texas

I don't know how to begin—don't know that I have anything to say— Only all inside I'm crazy and I don't know what over—how—why or

*anything—just don't know anything—I wouldn't mind dying when
I feel like this—Ted told me I was pale—Was I sick—I'm feeling
great—not sick—but—what is it—it is just so full of woman that I
feel—Been looking out the window—it's cloudy—raw—cold—For-
got where I was at—I don't know—what it is—My hands so full—full
of what—I don't know—Ted thinks maybe he will go down on the
Rio Grande to be a River Guard—would rather do that than be just
a straight run along soldier—Has a ranch and cattle down there—I
want to go along—I want to get right out and go somewhere now—I
was laughing at the way he walks today and he said—Why that's
because I've always lived in boots—Queer the way I like him.*

What in the world is the matter with me these days anyway. I
feel full of wheels and empty spots—Out of kindness to the rest
of the folks I ought to leave everyone alone—I feel like a curse to
everyone I talk to—I ought not to even let Ted look at me—It's
something tingling to my very fingertips that I feel almost burns
folks. The queer over-sensitiveness toward everyone—feeling
and seeing with them all even more keenly than usual—Your lit-
tle girl—a piece of fast-burning wood—Hot—moving—easily put
out. Next week all will be different—so much between now and
then that it scares me—What—The other teachers here don't
have the sort of time I have—but I can't help it—I feel like a fire-
cracker.

*O'Keeffe to Paul Strand, June 3, 1917,
on the train from New York to Texas*

[. . .] *I saw my brother in Chicago*[20]*—He enlisted in the officers camp
of engineers at Ft. Sheridan—is hoping to be one of the first from
there to go to France—and doesn't expect to return if he goes—A
sober—serious—willingness appalling—he has changed much—it
makes me stand still and wonder—a sort of awe—He was the sort
that used to seem like a large wind when he came into the house. I
understand how it happened—I understand your feeling about it—
You are both right—I say I understand you both—Is it true enough—
Do I understand anything—I do not know.*

O'Keeffe to Stieglitz, June 5, 1917, Canyon, Texas

[. . .] Quiet this morning—I read your letter on the way from break-
fast—white linen again—leaned against the porch arm at the steps
to finish it—the walk from breakfast is only a short block—I'm
afraid I would have cried but I had to come past people in the
house maybe to get upstairs—I felt as I left that I meant a lot to
many[21]—and it seems so queer—it bewildered me—The sister
just came in—saw what I had painted last night—standing in a
row on my bed. "Why they look just like people—real people—dif-
ferent ones—No—all the same—naked people." It made me feel
uncanny—sort of crawly way down to the ends of my fingers—
for they were people—and it seemed so real to her—I guess they
are Strand[22]—anyway—it's something I got from him—I wanted to
paint longer—do it again and others—but it was too dark—And it's
queer—I rather enjoy having it still in my head yet [. . .]

O'Keeffe to Stieglitz, postmarked
June 8, 1917, Canyon, Texas

[. . .] The day was just a mad rush—When I started home at noon I
was late—people talking had kept me—Everyone seemed to have
gone—I stood there—looking at the emptiness—listening to the
dry rattle of a lot of rye—planted on part of the campus to get
the soil in shape—I was beastly tired—breakfast at seven—peo-
ple asking questions when I hadn't classes all the time from then
on—The hot wind—hitting and hitting you—it seems to come
right along and slap your face—I didn't mind it only—so tired and
so alone—I wish the wind were a someone that loved me—that it
were all around me—and would blow me away. Blow me away to
nothing—anywhere—nothing—Then a man came along in a car—
rode—talk—he lives across the street—took me back again after
dinner—He is funny—teaches Biology[23] [. . .]
 It has been a wild day—Wednesday—I spent last night at my

sick lady's house—Her husband was away and she wouldn't have anyone but me—It was terrible—She is so nervous[24]—Then trying to get classes straight all day—I had seen Watkins yesterday too—and his eyes—Gosh I thought I'd die—Ted at a distance—Today right at me—"I was terribly afraid you wouldn't come back"—He looks different—Had spent several nights—awake all night—There is something great about him—really fine—We talked a long time and have a lot more to talk—He makes me afraid of myself again—There is something I can do for him—something that will matter a lot in all his life—I don't know what it is—It will just be in the way I act—You see—it's hard for him to understand me—I sort of feel that I mean woman to him—almost more than a particular woman—When I've gone—will he be sure that they are fine—My honesty makes it hard for most twenties to understand and believe—and I so much want him to—

Many folks stopped me and asked me about some things in my work that surprised them—I had to go to the dressmakers to get some buttons fixed and other little tag end jobs that I won't do myself—More people—the folks in the house here—I had to talk to—Then a little time to paint before dark—Just as I turned on the light—I was sitting by the window—up drove Watkins—I got out on the roof and talked awhile[25]—He wanted me to get Claudie and ride—not me though—enough. I decided it was a good time to tell him that I must stop—he mustn't come around anymore and mustn't phone—so went down and told him—Nice sort of chap—he understood—Not safe for either of us—he knew it all the time—Isn't it queer—the way he likes me—yet would make trouble for me if I'd let him—Queer way of liking a person—isn't it—He would just walk on anything to get what he wants. I both hate him and like him for it—The amusing thing is—I was painting on him when he drove up[26]—He gave me such definite creepy crawls—I had to make it and now I'm just torturing myself by leaving it on the wall—It makes me feel like I have felt all day—as though I can hardly stand living—I can hardly stand that thing in the room—The look on his face yesterday [. . .]

O'Keeffe to Stieglitz, June 11, 1917, Canyon, Texas

[. . .] I hear that I am the most talked of woman on faculty—I don't know why—It makes me want to put a few things in Anita's little bag and leave—quietly—on the night train—I believe I'm considered "queer"—"different"—and if I were different from what I am I'd be artificial—or something that's not me—I don't know what I'd be—I thought I was going very quietly about my business—Saying very little to anyone outside of it—So was greatly surprised to learn that I was being very much discussed—My clothes—my shoes—my hair—my face—my talk in classes—the things I say—I don't like it—You see the summer folks are different from the winter folks—older—most of them teachers—I wonder if I as a person get in the way of what I am trying to teach—Isn't it funny—It's so absurd to try to teach anything—and I—as a person—to myself am just nothing—it seems so ridiculous that anyone should think to talk about me.

It's raining—lightning—thunder—Much needed rain—everything was burning up—I don't enjoy rain—The thing in your letter this morning has been—in my mind rather often during the day—What you said about being free—Why of course I feel free—Never occurred to me to feel any other way—Why shouldn't I—I owe you nothing—You owe me nothing—still—The sister and I walked a long way this evening after it was too dark to work—In talking—our talk was interesting—in a way—I said some things I wanted to say to her—I tell her some things that happen to me hoping that some way things will help her—Living is going to be queer to her—and I want her to understand—What—I don't know—I don't understand—anything myself—how I can help her—We were talking about my different friends—When she mentioned you—I made the remark that I just didn't see how people could get along in the world without having what you mean to me—She remarked that as far as I could see not many people seem to have it—She is a funny little girl—I am beginning to feel that maybe she is rather fond of me—I never felt it before [. . .]

O'Keeffe to Stieglitz, postmarked
June 12, 1917, Canyon, Texas

[. . .] I've done so many things today. There is one class of 68 that has almost crowded me out of the room—Maybe I'll let them stay in and I'll go out in the hall[27]—Yesterday it seemed everybody and everything riled me—today was almost as bad—such stupidity—yet both days many things have been fine. Last night I was ready to quit—let someone with less sky-flying notions than mine try it awhile—but there is the sister—so I can't—Anyway there is so much Irish in me that I guess I rather enjoy the fight—enjoy getting what I want in my own way in spite of anybody though my first impulse is to just sink things in the ocean—out of sight and hearing rather than even argue about them—Think and do my own way and give the other fellow the same privilege—only I want him to leave me alone. Another bum teacher in Little Cooper's place in the Training School and there is no excuse for it. Not prepared to do the work. I've taken the 1st and 2nd and 9th grades and have four classes in the Normal—I'd rather do it than have her make a mess of them all—Worthwhile? Yes it is—interests me enough so that I don't much care if I am sick. [. . .]

O'Keeffe to Stieglitz, postmarked
June 14, 1917, Canyon, Texas

Wednesday night—The most terrible sandstorm—cold—came up last night while I was reading—It tore things around all night—I went to sleep with the terrific noise—the change of sounds put me to sleep I guess—I waked often—amazed at the wind—had to close my windows—a lot of wind and sand came in a hole in the glass right over my head—the youngsters threw a ball through it—I never saw such a night—it was funny—Today wonderfully cool[28]—I went back to the black dress it was so cool—

Had a long talk with Mr. Cousins this afternoon[29]—Tomorrow in faculty meeting they will probably throw brick-bats at me—I like

him immensely—but he is a long way from me—Minds working altogether differently. I think I see his—I like what I see. However— it doesn't fit me at all—He doesn't get my point—I've never forced it on him. It feels as if something is beginning. I felt great after I had talked to him. I said most everything I wanted to—Then I talked to a first-grade teacher I like for a long time. Then after supper— worked—Painting gave me a queer satisfaction—never quite like it before—I hate what resulted—

I walked a little in the night—I seem to feel folks looking at me queerly lately—I don't know why—and to feel a curious antago- nism—what over I can't imagine—It must be imagination—I've said little to anyone except about work—they all rile me—I don't know why. All my classes are great—It seemed I never liked work better— It's the things I hear said—the things done outside that rub me the wrong way. I ought not say it maybe—to you—especially now—I don't know why it is—no particular reason—only it seems I can hardly stand anyone and I don't want to live—it's so funny—There doesn't seem to be anything in it—Why should I—Of course there is no reason why I should but it's so absurd for me to be feeling that way about it—Still I can't see any use in it—I'm ready to quit—Or why doesn't anyone shake me and wake me up. I laugh for nothing— for the same reason I don't care for tomorrow to come—and as for weeks or months ahead—I don't seem to be able to imagine it [. . .]

O'Keeffe to Stieglitz, June 16, 1917, Canyon, Texas

[. . .] It's Saturday night—I painted from supper till dark—The way I'm painting makes me think I may be crazy. It's just sort of ram- bling around with color—such a curious half-indifferent sort of way of going at it—always wanting to—but only feeling about it—I can't exactly explain—The thing I worked on today—dry paper— then wet looks like a poor imitation of Marin[30]—I certainly had no such intention—it looks like my left hand too—No—I guess like both of them—the inside and the outside—Of course I can't tell much by the electric light—it's just a senseless absurd blob—and I like it—still have to laugh at the half-awake humor I was in when I made it. I'm tired tonight—so tired that my head almost aches—

Yesterday afternoon I met Ted on the street by accident—Said he had been looking everywhere for me all the week and never could find me—where had I been—wanted to hear me laugh— When he had been funny till we got to my house he said—Yes— and here I've been wanting so much to talk to you—now I've had a chance I never said a thing I've wanted all this time to say—I've just been talking nonsense—Still it seemed I just couldn't think of anything else—And he turned around—with his back almost to me—and said—Tell me anyway—Do you still like me—I said—Yes, Ted I think you are great—And we both laughed—and he said it was all right then—And we turned and went on—Funny—it tickles me in such a peculiar way—and it feels so right—We are both so funny—I'm tired—must stop—Goodnight [. . .]

O'Keeffe to Stieglitz, postmarked
June 19, 1917, Canyon, Texas

[. . .] I showed my face and hands to Ted this afternoon[31]—It was after supper. He liked me sober best at first—Then held the smiling one beside it a long time—He liked the smiling one because he likes me to laugh—likes me to have a good time, as he puts it—Finally liked the smile best—I almost gave it to him—We are still a bit riled up. When the water is still and I can see more clearly what is in the bottom of it I will know better whether I want him to have it or not. I'm not sure of what I mean to him—he isn't either—Showing them to him was lots of fun—Queer the way I want so much to mean something worthwhile to him—He, a piece of the outdoors, gets my honesty at a queer angle. He is all right—and I am all right—but the rest of the world is in the way between us. What do you suppose I was born for—I just seem to hurt all the people I like and all the people that like me [. . .]

O'Keeffe to Stieglitz, postmarked
June 22, 1917, Canyon, Texas[32]

[. . .] No—I've never made Ted—I wonder why—Some folks make me see shapes that I have to make—other folks don't—I was

trying to tell myself why—It seems with him—there is something so fine—so beautiful—just a very slender streak of it—sometimes wider sometimes very thin—almost to breaking—so delicate. And it terrifies me when I feel that I may unwittingly break it.—I don't know any lines fine enough to make it [. . .]

I guess that third series is just me—shapes I had in my mind from things that were happening—and just felt—It seems that I was just playing with color that I felt—I can't tell it any other way—I had Strand all painted in New York but didn't have any paint[33]— or time—Telling you that now reminds me of some other things I painted in New York. Yes—I felt that the red one was better—but it got to look very flat to me—I have that painted again too—in my mind—A fool brain I have—Today I've been down making drawings of the girls in the swimming pool[34]—It was lots of fun—They are great. Results not much—You see I haven't drawn for a long time like that—I've been painting on the sister. The girl I sent you was Leah—It was sunset as we were going up to Amarillo when Austin was here[35]—I painted it from memory about three months after the time I saw it because I kept remembering—I always intended to make the cheek go round better but didn't[36] [. . .] After dinner— I was tired—didn't want to sleep—but you know I'm such a good for nothing human that I have to waste a lot of time taking care of myself whether I want to or not—so after dinner—much against my wishes—I stripped—and slept or dozed all afternoon—When it was almost six and I decided I could get up—I rolled over and stretched—and while I stretched I just happened to look down my own length—The long dark skinned body—smooth looking—and I almost laughed aloud at myself for having been stretched there—a whole afternoon—just sleeping—nothing on [. . .]

O'Keeffe to Stieglitz, postmarked
June 25, 1917, Canyon, Texas

Saturday night—Between nine and ten, I guess—Undressed— curled up on my bed—in a particularly nice gown—because it's very thin—Still it's something [. . .] I can hear cars way out over the plains—nearer and farther away. Just a little air moving—and I

think there is just one cricket in the Panhandle as far as I can make out—I hear him and a windmill—I don't know where that windmill is [figs. 6 and 7]—I never think to look in the daytime—Of course I wouldn't look at night—I had to go to town after supper to get some packages—just little ones—done up and sent off—and of course—just as I came out of the house—along came Ted—He helped me fix them all—I really can do things like that myself—better than most folks can do them for me—only I never want to—it seems such a waste of energy—I guess I just make folks think I can't do it—then I always have to laugh [. . .] He tied one little package so tight it was funny—I laughed at his—pulling the string so tight—and he said, Well—that's the way you have to tie up a calf—It was just funny [. . .] I walked toward the sunset—blazing—after we dropped the package in the box—The world looked small—small sky—it surprised me so that it should look so small. I didn't go far—was too tired—I wondered and wondered—What is one to do with the days and days and the things that happen—He doesn't like me any better than I like him but it means more to him—He doesn't know what—there is no way to tell it—However that is only a small part of the day—though—it's the second time he caught me today [. . .] I get too tired to do anything by night—Even then sometimes folks come and talk to me till there is no time left [. . .] I remember one thing more than any other that I was going to tell you was how much fun my little folks are at school—they are really great[37] [. . .]

O'Keeffe to Stieglitz, June 29, 1917, Canyon, Texas

Friday night—nearly twelve—I just came in from the night—very light breeze—moonlight on the bigness—Last night I wanted to write—Claudie and I lay out on the plains watching the sunset go—the stars come—I was very much aggravated with some folks and things—I had to get out where the world was big and empty—She was in a very good humor—I was very tired too [. . .] Today a book man who had pestered me yesterday came in and pestered me again—When he came in my office I was just showing the music lady what Fisher had written about me[38]—All year she had been feeling around to find out what I am driving at—No—it

dates from the talk I gave the faculty—she was reading it—told him
what she was reading—that started him—He sat there on the desk
talking for nearly two hours—It was fun to me—in a way because
I so seldom talk to anyone out here about my work—I did most of
the talking—He said no one had ever made it so clear to him—Art
stuff—What I aimed to teach and what I was trying to do myself—I
told him some things about his own stuff—He remarked that the
folks out here were not going at it like I am—Then said: "What
are you doing out here anyway—You don't belong here—There is
nothing here"—I laughed and told him that was why I liked it—It
was funny—I don't often talk much but when I do I almost blow up.

I went down to the swimming pool again—painted this time—
It's great—Haven't made anything much yet but maybe I will—
don't know—After supper George Ritchie—nephew of one of the
English faculty[39]—was going to take me out to see the sunset—We
changed our minds and went in to play some new records—He is
just a youngster—a queer one too—only here for the summer—
seventeen—Then we decided we would go up to the Normal and
swim—after that we got Claudie and rode a long time—A woman
kicked me in the jaw—She was big and I was helping her out of
the pool—and she seemed to get hung [up] and almost kicked my
head off—right under my chin—Lucky it didn't make me bite my
tongue—My whole neck is sore and stiff—can hardly swallow—It
makes me laugh—I didn't tell her how bad it hurt—She couldn't
help it and it would make her feel bad—It seems to hurt more all
the time—still it is so funny—She is so big—very good to look at—
Out in the night we passed some wheat fields—burned yellow—
very big ones—almost as far as you can see at times—In the moon-
light they were light—about the same value as the sky—A little
dark streak of the other land way off—Some way it seemed star-
tlingly like water even though it was light—it's a wonderful night—
Between Claudie and George and my own queer self—I guess the
conversation was a bit queer—three queer folks [. . .]

O'Keeffe to Stieglitz, July 1, 1917, Canyon, Texas

[. . .] Yesterday morning I waked up early—thought of you and
291[40]—The last day of it—I thought to get up and write to you but

instead—looked out the window—Shut the glare of the sun out—
then went on thinking about you [. . .] I went to bed early—before
ten—Had a long talk with Ted—and it was queer—I am queer—
He is queer—They had phoned me to go up to Amarillo—George
came to take me to the station and I didn't go—couldn't make
myself—Ted was here at the time anyway—He tried to make me go
and I wouldn't—I didn't want to—When I came upstairs—my head
ached—I put out the light to think—my eyes hurt too—And I went
to sleep [. . .] This afternoon I've worked—Had to do something
with this headache—I wish you were here—I'd like to show it to
you right now—Isn't that absurd—You would laugh at my room—
perfectly bare—floor and all—Nothing on the dressing table but
a plain white cloth—The table is stacked high—I'm going to get
a new one about four to six times as large—it will take up most
of the room I'm afraid but I don't care—You would laugh too at
what I've been doing—I don't know whether to tell you or not—I
couldn't get what I wanted any other way so I've been painting
myself—no clothes [fig. 4][41]—It was lots of fun—Stupid of me
never to have thought of it before—I had thought of it but never
enough to want to before—Today I wanted to paint nakedness—It
makes me laugh—I had such a good time headache and all—And
when I tell you about it I feel like such a funny little girl [. . .] I don't
know though that they feel any more like nakedness than a land-
scape I've been working on does—I think I made the eighth and
ninth editions of that today too—There seem to be wheels in my
head—I see and think of so many things—The sheet on the bed is
a great twist[42]—Two different places are fine. Can't do everything
though—the sheet is just good to look at—

My blond boy has been crazy as a loon this week[43]—went home
last weekend and came back in a great big car—Well—he has been
like a whirlwind on a very hot day—I've hardly seen him—So
busy—I sort of forgot him till he came in yesterday and forcibly
reminded me—face red—hair flying—blood about to spurt out of
his veins anywhere—Then I remembered I had seen him shooting
around several times with the car full of boys and girls—and that
a couple of times I had seen him standing for sometime waiting
to talk to me when I was busy with others and I guess I never got
to him before he tired of waiting—Dear me—I'd like to be about

six people—I'll remember him specially this week—So many force themselves on you—that you don't have much chance to reach out to anyone else—You know schoolteachers are maddening with questions—

My little folks are great—A little boy made a landscape for me yesterday with a purple star about three inches in diameter in the middle—a house on each side—a tree on each side—tiny little house in the middle—It was so funny—but I liked it[44]*—I'd like to tell you about them all—Two made submarines—one had a gorgeous orange sail boat above the dirty gray little submarine—He lives across the side street—Shoots me every time I go by—Always war—The young-sters get more of war than the older folks—One youngster explained a few days ago that the bright colored spots all mixed up—sort of like a sunset—was war clouds in Europe—*

My neck is recovering—doesn't hurt much to swallow any more—My headache is gone too—It's dark. The windmill [figs. 6 and 7]—I had intended to sleep out on the plains tonight but it's too windy [. . .] I stopped—and looked past the light of the room out into the blue of the night—wonderful dark blue—almost black—night [. . .]

O'Keeffe to Stieglitz, postmarked July 9, 1917, Canyon, Texas

[. . .] I can't see anything ahead for myself—can't see anything of any kind—I do not look—I do not care—I have been trying lately to imagine how my work will go in school next year—and I can't see it at all.—I don't see anything. I don't seem to have much ambition as an Artist—What ambition could I have but to satisfy the desire or need of expression more fully—Money from it—from anything means little or nothing to me except that it gets me the things I want—I don't look ahead—don't ever plan to save any—I don't want many things—When I do I look around for a way to get what I want and I usually get it—I don't think I can keep on teaching here for long—restless—nobody to talk to—I feel almost like bursting now—To fit this machine—I'd just have to kick a lot of it all to pieces—to nothing. Someday I'll simply pack up and leave rather

than kick—leave probably without knowing where I'm going—I don't know—Goodnight—Friday night.

O'Keeffe to Stieglitz, July 13, 1917, Canyon, Texas

[. . .] I undressed—painted again on myself[45]—I guess that excited me—my head full of wheels again—Seeing things everywhere I turn that I want to do [. . .] I get so excited painting—One is on the wall—watercolor—I painted them all red—It has a curiously funny quality—A feeling of bigness like the red landscape—still the body has an almost affected twist—I just caught myself in that position by accident—it's funny [fig. 4] [. . .] Yesterday I looked at the paper that came with Strand's print—Why—you know I'll hate to paint on that—I don't know—I'll see. Cheap paper like this is a great friend lately—A stack of it almost a foot high makes me feel downright reckless[46] [. . .] Many stars—A cool breeze—soft warm feeling—The windmill [figs. 6 and 7]—One ought not mind staying awake—Night is very lovely—

O'Keeffe to Stieglitz, August 6, 1917, Canyon, Texas

It's Monday noon—No—almost three to be exact—I've been sewing since dinner—I've told you before that I sew when I want to think [. . .] It's glaring sun and wind—Not hot here in my room— but hate to go out—and I ought to go to the Normal—getting things straight for the last week—I was there all morning—Last night again was wonderful moonlight—And Ted took me way out into it—We watched the moon come up out of the Plains—and stayed till it was high in the sky—He is so funny—And I guess I'm funny too—Why I think maybe I'm crazy—but I know I'm not—I'm beginning to think like you said of yourself—that maybe I'm too sane—I don't know—I can't say anything to you—it's all so intangible that you can't get it into words—It makes me laugh—and he laughed too—and then we talked some more and reasoned some more and couldn't make anything work out so that it would seem like any sort of sense to anybody else—So we laughed again—He wants me

so much that he just can't take any pleasure in liking me because he thinks he can't have me like he wants me—ever—And I—Why—you know it seems living with him would be lots of fun—it seems as though he is the only person I ever knew who would take me to the tail end of the earth where folks wouldn't bother me and then let me do as I please—And he said—if we can't make it work we will quit—You know in the spring I wanted to go with him more than I wanted anything—Just put my hand in his and walk out into space—While I was in New York I almost forgot—And now—little by little I've grown to like him again—It's so queer—like two children playing—He had me all curled up in a little knot last night—"Why it would be so easy to just pick you up and carry you to town—you are so little"—And I was so comfortable I wanted to go to sleep that way—I seem to like him like I like myself—And when I look around here—at what I am doing and things as they are—I wonder why I don't marry him today—

Why do I stay with this—Isn't it funny—I would like to be out in the night with him tonight—I was afraid two or three times last night—Then laughed—then he laughed—laughed through it all—our acquaintance began with a laugh—We have always laughed—What is worthwhile in living anyway—School is over Saturday morning at about eleven and I haven't an idea of what I'm going to do—I don't know that it matters—I don't seem inclined to plan anything so I guess I'll let it take care of itself—Am I queer—He said I was—then right quick said—No—it's just that I never knew anyone else like you—and I know I'll never let myself like anyone else so much again—I don't know—

O'Keeffe to Stieglitz, August 15, 1917, New Mexico,
en route to Colorado

Wednesday—I'm out here in New Mexico—going somewhere—I'm not positive where—but it's great—Not like anything I ever saw before—I want to stop everywhere—The Indians and their black hair and very bright colors—dark skins and eyes—the square little adobe houses are great—I'm crazy to live in one—It has rained lots this afternoon—still gives the feeling of a land of sunshine—I

wonder why—Spaces—Why Texas isn't in it—There is so much more space between the ground and the sky out here it is tremendous—I want to stay—I've wanted to stop most every station—The first glimpse of the Rockies—Gosh—there must have been a time out here when they were made—There was a peak that had a backbone of different kinds of rock turned right up to the sky—running in wavy ridges—deep blue peaks and peaks—big ones and little ones—and the bareness of them—and the deep blueness of them—They hardly seem possible—Why don't you come out here[47]—isn't that a funny question—It makes you feel like a sky rocket—or something that's going up in the air—Seven thousand feet high here the sister just came and told me—Canyon will forward mail—

Commentary

The letters in this chapter reveal that O'Keeffe was living life in the midst of and in spite of war. She continued to find time and inspiration to make art and remained dedicated to teaching and sharing her ideas with her students (from young children, to college-age pupils, to itinerant book salesmen who stopped by her campus office). She also sadly watched as boys from campus, boys she cared about—the "best" ones—disappeared on trains to training camps in preparation for military service. One way she coped with this loss and the changes she observed was to write about her feelings. She often compared herself to things that flame up intensely and then fizzle out—"a piece of fast-burning wood—Hot moving—easily put out," a "firecracker," and a "sky rocket." In these comparisons, we feel her bursts of raw, exposed emotion that contrast with her moments of dejected sadness and worthlessness: "I don't see anything. I don't seem to have much ambition as an Artist"; "I can hardly stand it anymore and I don't want to live"; or "I wouldn't mind dying when I feel like this."

And amidst this doubt, she also expressed both frustration and pride in being "queer" compared to others around her. To be sure, her use of the word "queer" again and again—thirty-six times in this chapter—registers a sensitive and almost proto-postmodern

understanding of the word.[48] She explained that her queerness was based on her thinking, talking, and acting "differently" from the norms for her age and gender, especially in her alternative clothes, shoes, hair, and physical appearance, as well as in her "talk to classes" and the things she said in public. But the word "queer" also referred to how she accepted and embraced this difference with a unique "honesty" and a refusal to deny her true self: "If I were different from what I am I'd be artificial—or something that's not me." She believed in reciprocal respect for everyone, stating that she liked to "think and do my own way and give the other fellow the same privilege." This progressive attitude fits well with how Linda Grasso defines the "New Woman" of the time; though O'Keeffe never called herself a "feminist" and did not like to use the term, she acted and behaved with a politics that is clearly feminist, especially in Texas.[49] And though the term "queer" in its use today usually references alternative sexualities above all else, O'Keeffe's frank acceptance of alternative lifestyles, including but not limited to her open, if hetero, sexuality, deserves close attention for what it can mean for the history of gender and queer theory.

That O'Keeffe sought even more heightened romantic experiences with several men—the New York artist Paul Strand, the married man Kindred Marion Watkins, and Ted Reid—seemed to provide her with a means to cope with the ongoing landscape of war. She wrote about the sheer "hotness" of kissing Watkins and the deep desire she felt to find a future with Reid, "who would take [her] to the tail end of the earth [. . .] and let [her] do as [she] please[d]." She painted her feelings for Strand and Watkins into throbbing forms of burning color, abstract portraits in blood reds and deep blues, passionate mixtures of hot and cold, fire and ice, but said she could not find lines "fine" enough to make Reid. It is as if, once the war began, she felt she had nothing to lose and continued to open herself up romantically and creatively in new and even more daring ways. She also found solace in rendering her own nude body. Representing her raw nakedness, her own uncovered truth, seemed to help her feel more in control of the world around her as a woman who couldn't join the adventures of war. She actively created her own adventures in her daily life and

artistic production. When the "world" was in "[the] way" and when "hurt was everywhere," she pushed on, loved even while she lost, and found pleasure along with the pain.

At the same time, O'Keeffe continued to indulge her desire to tease and taunt Stieglitz in her letters. We must remember as we read these lines about her love life and sexuality that she was writing them to Stieglitz, toying with him about being gazed at by other men and about gazing at herself nude and enjoying it. For instance, she exclaimed that she "couldn't help shrinking from" Watkins's kisses and noted that Watkins was a married man. As Stieglitz was a married man himself, this fact would have clearly sparked his interest, for as with her descriptions of Austin, Reeves, and Lester in the last chapter, Stieglitz again learned in no uncertain way that O'Keeffe was not afraid of adultery but rather found the danger in it appealing. And in the middle of her moment-to-moment rehearsal of her steamy session with Watkins, O'Keeffe declared that this romantic encounter made her realize one thing: how attracted she was to Stieglitz, not Watkins! She described such sexual games as "daring to be human," but it equally registers as coy and manipulative of Stieglitz's emotions and libido. Yet even while she documented her affairs with other men in detail for him, O'Keeffe always made sure to reiterate how much Stieglitz meant to her; indeed, her letters show that in Texas she was a master of keeping men on the hook without commitment, and playing the field without any guilt or shame. Perhaps the strain and stress of the war compounded this behavior, making her feel that she should enjoy her freedom and womanhood, even if it meant she was seen as "queer." If she couldn't be a soldier in Europe, she certainly wasn't going to live a boring life back home.

[4]

Fall 1917

"WE ARE SHORT ABOUT A HUNDRED—
WAR AND BAD CROPS"

O'Keeffe to Stieglitz, September 20, 1917, Canyon, Texas

[. . .] Yesterday morning in chapel it suddenly struck me how absurdly empty some of my letters to you [are]—what queer things I told you in others—No not sorry—I only realized it—Though I am feeling nothing I seem to be seeing more clearly—The English Professor is so absurd—he just fits my humor[1]—I told him he better leave me alone—I don't want to bother him and I probably will in time if he doesn't leave me alone—however—I warned him— Makes me laugh—He will not bother me—unless in time he bores me to death—

Yesterday I had just washed my head—put on a clean white dress—feeling too clean to feel natural—started to dinner—and up rolled Watkins in a big dark blue—almost black—car—We both laughed—I'm disgusted that he hasn't really gone to war—or something[2]—apt to be called any time—I don't know exactly what— didn't try to remember—We talked awhile—I wouldn't get in—simply can't do it—Tongues might get me—I guess I didn't want to get in anyway—even though the car looked good and it was a wonderful day—He isn't funny anymore—He's too serious—is always trying to understand and can't—When he is serious he doesn't say funny things—he's just plain stupid—Asked all about me—my work— where I had been—what doing—Nice questions—in a nice way—my sister—Makes me sorry in a queer way—but goodness—what can I do about it—I've been wondering what living is for anyway—The plains are very wonderful—I've been reading about the earliest traces of man in Europe—thirty thousand years ago is a long time—and what

is it all about—Probably most of them have wondered—have any of them ever found out—There seems to be some use in it when all one's short time is full—or at least—then one hasn't time to wonder about it—to doubt it—But—well fed—well housed—time to think—and wonder—feeling nothing—this window looking out on the big emptiness—It seems queer to have time to sit still and think—Where emptiness hurt before—it seems now that I ought to fill it with something and I just look at it blankly and wonder what—It doesn't hurt—Nothing seems to hurt now [. . .] Painting seems such a sickly part of the world—Outdoors is wonderful—I want to take hold of all of it with my hand—

O'Keeffe to Stieglitz, October 1, 1917, Canyon, Texas

Good morning—Monday morning—I want to write you and I have nothing in particular to say but I want to write anyway—and I won't let myself wake up and so have to laugh at myself—It's great to see yourself asleep. My bed isn't made—things are strewn all over my room but I want to write first—I just came from breakfast and the post office—your yellow letter paper—The *Negro Art* and a page from Strand[3]—There is something great about him—but somewhere—he seems to be getting too old too soon—What is it I want to say—too fixed in some of his ideas too soon—That makes me laugh—Mr. Cousins told me the other day that my ideas were still in a liquid state[4]—I think that was the way he put it—And you know I'm so feeble minded I don't imagine they will ever be in any other condition—and I don't care—It seems hilariously funny to me—<u>I didn't tell him so though</u>.

He asked me to talk in chapel next week—on account of some other work interfering I put it off till the week after—And even then— What am I going to talk about—I never talked to so many folks— about five hundred I think—We are short about a hundred—war and bad crops[5]—However—that doesn't matter—What I say can't be any more stupid than what some other folks have said—The thing— is—When you get a whack at them—what is worthwhile—It seems that so many things said to them are not worthwhile—And how do I know what is worthwhile—It's funny—I don't want to waste my

*chance—Still I'm not sure that I know how not to—It scares me and it
makes me laugh—*

I'm glad painting is worthwhile to you—glad mine is some-
thing to you—To me it is a necessity at times—You know all that
though—A good many of these folks have never seen a painting
though—You know I would like them to see Hartleys—I don't know
why Hartleys—the different kinds of Hartleys seem so real[6] [. . .] I
wonder could they see then how a man's painting is the expression
of himself—his life—Oh—I'm wondering—I didn't intend to write
that last page—it just happened—It's a sunny windy dusty day—a
little cool—the wind warm [. . .]

I played with the baby a long time[7]—out in the side yard—a
swing—zinnias and sweet peas between us and the road—a cou-
ple of hours—She doesn't look well—delicate and dainty—seem-
ingly too pale lately—two—teeth are bothering for one thing—It
bothers me to see her so pale—it's such a little life—mother and
father both very big and husky—She won't talk either—but she
is so nice—Mr. Lentz—the engineer I told you of up at Ward [in
Colorado]—dropped dead in the railroad station at Boulder last
week—He was—I don't know how to say it—fine may express it—
but it seems such an ordinary word for him—he was most extraor-
dinary—So fine and quiet—so comfortable to be with that it was
an event—He asked me two or three times what I thought came
after living—I did not know—Quiet—But a nice way to die I think—
Never in bed—no fuss about it—I believe he would consider him-
self lucky—He hated bothering folks—a grown family [. . .]

I went to Amarillo one day this week—Mr. and Mrs. Terrill[8]—
The country is really wonderful—and all so flat and empty—a
yellow look—quite brilliant over it all—I just want it all I like it
so much. Another day I went to the Canyon—supper on the edge
of the plains—the long drop right off the edge—the tremendous
stretch between us and the other side—Four or six miles at least
I should imagine—wonderful colors—all colors—the shadows
forming—one place where we could see it winding on it must have
been much more than six miles—so far away that the color went
in with the sky almost—We had supper on the edge—between the
sunset and the moonrise—Three of the faculty and Claudie and

myself—It was the most wonderful view I have seen of it—I engi-
neered the party—went through POSTED land—off the road right
into space—not knowing where we were going except that I knew it
was toward the Canyon and I knew it must be deep and wide—They
were afraid—I wasn't—I knew the man wouldn't arrest a bunch of
old maid school teachers—Saw hundreds of cattle coming up the
paths—smooth paths in the bottom—You can't see them till they
are almost under you because you can't see the real bottom of
it all—The long line of them wound up crooked paths—the other
side of a little gulch and finally came out—looking like narrow
black lace on the edge of the plains against the sunset—hot glow-
ing sunset—It was great—I had wandered from the others—found
the cattle alone—watching them—alone—You see I didn't eat sup-
per—I helped get it because some folks can't build a fireplace that
will hold a coffee can and they can't open tin cans without open-
ers and things like that—Then I wandered off—Over an hour by
myself I guess—I had collected the lunch on about ten minutes
notice because I wanted to stay late—knew they must be fed—so
I had to get it into eatable shape—And I watched the moon come
up and the sun go down—and the cattle—it was a wonderful mov-
ing line—and the great stretch of color—changing tonight—And
I don't know—I felt something—but I didn't wake up—I saw it all
as though I were sleeping—and I came home and slept nine hours
straight—And laughed when morning came—

Had a bad headache two or three or four days this week—
stopped eating and tried to walk it off—Committee meetings
took up other time [. . .] A little girl—yes—probably more than
ever—Not even knowing what to ask—It's like walking around in
a dream with your eyes open—a queer stupefied sort of existence
all—???—I don't know—In the wind my black close hat brim is like
a flickering shadow between me and the gold of the plains that
stretches seemingly to never and the gray blue of the sunny windy
fall sky—The only other thing that seems to impress me is glar-
ing white house ends or fronts—against the sky or plains—glar-
ing white—ugly slopes at the top—ugly windows—Most of the
houses here are ugly—the ugly windows make dark holes in the
white fronts—Gosh—They are white—The sun relentless in its

whiteness—The wind is careless—uncertain—I like the wind—it seems more like me than anything else—I like the way it blows things around roughly—even meanly—then the next minute seems to love everything—some days is amazingly quiet. I wish you were here—or I was there—or something—I don't know what—I want to go to Alaska—

O'Keeffe to Stieglitz, postmarked October 5, 1917,
Canyon, Texas

I'm not going home to dinner. Haven't had time to take a good breath all morning—I should only have taught one hour but I taught three—Little Cooper can't do anything[9]—no it isn't that— It's that she won't put her mind on it—I would enjoy scalping her—She would be so much happier if she would just wade into something instead of swooning. (a putty faced individual gone to war) So I spent two hours in first, second, and third grades. I like it—really had a great time. But I want to stay in a room by myself for a while—Most of all I don't want to eat dinner with the folks I'd have to eat with. Little Cooper is at the table and I feel as though I'd like to just stamp on her toes. It's so easy to make work with youngsters—just plain drudgery—and so interesting—so maddeningly interesting if you are really interested—it's really great[10] [. . .] I've really been working like a fool—and another job ahead—The fourth and fifth grades are going to make a Mexican—or Indian town of adobe houses—and I said I'd help—I must be crazy. But those Mexican and Indian villages in Mexico are great—The adobe is the only house I have seen that seems to fit this landscape out here—It seems to belong—All the other houses seem out of place. I said I worked ten hours a week—but am giving myself the pleasure of nearer ten a day than ten a week.

Yesterday when I was hunting for some particular pictures I wanted I came across lots of blank paper—Some you sent—and some other—And you know—it just looked so good I liked to feel it—bare—Then thought—Goodness—what am I doing with so many things I don't have to do for—I believe I'd like to paint—Then I slammed it down and went on hurriedly. [. . .] Right this minute

I don't feel as if I have time for anything. [. . .] Last night—so stupid—I rode with old Latin across the street[11]—just a little—into the sunset. The sunset looked like a postal card and he is fat and I had my head so full of other things I wanted to do that it was very stupid. Later when the moon was coming up I walked with a funny old girl I like—She teaches 2nd & 3rd grades and is alive. If I were to do that red landscape over [fig. 12]—do it again—you wouldn't be able to stand it in the room—I don't know why but you wouldn't—that is if I could do what I want to with it [. . .]

O'Keeffe to Stieglitz, postmarked October 14, 1917, Canyon, Texas

[. . .] I'm growing feeble-minded—Certainly—Yesterday and day before I spent in Amarillo—it seemed I forgot that I belong down here—that I'm teaching school down here—it's such an absurd thing to try to do—Acquaintances—many—but—Horses—a lot of Percheron stallions—tremendous beasts—And cattle—even finer than last year—only beef cattle you know. [. . .] I seem to be detached from myself—So many different wheels whirling in my head—no they aren't whirling—they are stupidly grinding—I came down late last night—overland—The trains are so dirty I hate to ride in them—and it is always so much more fun riding right out in the night in the air. [. . .]

O'Keeffe to Stieglitz, October 18, 1917, Canyon, Texas

The forty-two pages this morning was astonishing to say the least— I never had such a long letter—I liked it—yet I hated it—Time has been very full [. . .] My darned head was so stupid and so full. You will understand—Ted was up Saturday night—A dance—he came in late with an older brother and a girl he always trotted around here from habit, I think—She was from near his home—a really nice— lovable sort of girl—but as he put it—"There is something in you that she hasn't got—she just hasn't got it—nobody else has."[12] He brought the brother over—we danced and talked cattle—He dances just like Ted only not so much of that damnable self-assurance—Ted

told me about him—long ago—a girl spoiled things for him—I liked him—The dance was lots of fun—Mr. Blaine was there[13]—I don't know exactly why—but it was more fun than usual—

It was great to see Ted—his face very red—outdoors all the time— seventy-five miles to get here—faces turn a wonderful color from sun and wind here—His eyes so shining—Not exactly happy—war— everything a turmoil—grabbed my hand right tight—dancing—I don't know anything—Do you?—I believe he is trying to like Ruby because he can't see me within reach—It seems I never saw such a live— seething piece of humanity—making such an effort to manage it all—

He was here all day Sunday and didn't even phone me.—I'm sitting on the porch—it's a warm sunny afternoon—cowboys went by with a bunch of horses a little while ago—A bunch of cows and calves going by now—I want to get right up and go with him—if he would only come and ask me again—It doesn't seem that it would even be necessary to get my hat—I'm ready right now—Going seems out of all reason—but does reason amount to anything— Why couldn't I have been ready when he asked me so many times so earnestly—and half afraid—I said it wasn't reasonable—he said he knew it—I don't know—it seems something must happen—Long ago I told him—before I knew how much he cared—way last spring when it was cold he sat here on the porch with me in the moon- light—after dancing and a long walk—and I told him he ought to plan to marry Ruby or leave her alone—he would make her like him too much and maybe hurt her—If he would marry her—it would be all right—knowing he was forgetting—It's feeling that he wants and I want—and the damnable little things that keep us apart—I know it would be foolish—no not foolish—against what everyone would expect is more to the point—and how I would make out living his way isn't at all certain—it's all so uncertain—He said—Well— we can quit if we can't make it work—sometimes I think you would like it and sometimes I don't—Then we would laugh about it all—I don't know—it all makes me want to get up and go to him and tell him I'm ready—and if he has changed his mind—has reason—now that I haven't—just wander off into space away from everything I've known—I hate it here—It's a lifeless bloodless sort of life to live—No one I can think of here seems to have anything but white

blood—no red at all—Then there is Claudie—So long as I am respon-
sible for her I am only half human—I wonder what I'll do when she
is gone—Watkins in Amarillo—and some other folks—but they—I
don't know—I hated them—Guess I hated your letter for the same
reason this morning—One thing saves me from wanting to shoot or
strangle or drown you—You understand—I wonder if you know how
great that seems these days—

O'Keeffe to Stieglitz, October 29, 1917, Canyon, Texas

*[. . .] The week has gone very fast—and mostly I've been in a turmoil
thinking and feeling—I wish there were another country to go to—I'd
like to leave this one for a country where there isn't war—or else I'd
like to go to Europe and see what it's really like—Still—it makes me
sick—nauseates me just to talk about blood—and internals—I wonder
what it would be like to see folks mutilated—only parts of folks—won-
der if I'd get used to it—I'd like to try—You know—I feel as if I can't
stand it here much longer—I don't know where I'll go or what I'd do—
but—it feels like it is coming—just that I can't stand it to look at these
folks and hear them talk and see how they are thinking—I guess it's
the same everywhere—If I were a man I'd get up and go to war so
fast you couldn't see me—Everything just seems awful around me—I
seem to hate everyone—Claudie is the same—It isn't exactly hate—it's
more impatience with everybody and everything—All living seems to
be changed—It's as though the sky will never be clear again—*

It's a cold weird moonlight night—a tearing north wind—sand
blowing and dried little green locust leaves on the almost bare
trees seem to string out in the wind—I never saw such a night—
whistling and rumbling wind—the bare dusty moonlight—uneven
gusts of wind—I could hardly walk against it—It's terrible—and
yet I like it—

Strand sent me a copy of his 291 article and a couple of poems[14]*—
They gave me a great time—especially the 291 article—I hope it's
published—it's great—Made me feel just like his work made me
feel—there is certainly something fine about him—I'm so glad we
met—But what is the war going to do to him—I wish I could talk to
him—There isn't a single person here that I want to talk to tonight—I*

*feel as alone as though I were the only person in Texas tonight—The
only person up here on the plains country anyway—No I haven't
worked any—I'm just all tied up—I just haven't anything to say—I
never felt so dumb in my life—it's an effort to carry on the most
inane sort of conversation—to even remark on the weather—and
to laugh—Gosh [. . .] I've simply been dumb—Like a machine I've
tended to many tag ends of work this week. I seem bent on trying to
get things in order—as though I'm getting ready to leave—Isn't that
queer—There isn't much sense in it because every other place is just
as bad as this I guess—I don't see any place to go to [. . .]*

<p style="text-align:center">*O'Keeffe to Strand, October 30, 1917, Canyon, Texas*</p>

*I guess I can't work because everything seems so mixed up—so incon-
sistent—I cannot really be any one thing enough to want to say any-
thing about it—Everything seems to be whirling and unbalanced—I'm
suspended in the air—can't get my feet on the ground—I hate all the
folks I see every day—hate the things I see them doing—the things I
see them thinking—I should think going to War would be a great relief
from this everlasting reading about it—thinking about it—hearing talk
about it—whether one believed in it or not—it is a state that exists
and experiencing it in reality seems preferable to the way we are all
being soaked with it second hand—it is everywhere—I don't know—I
don't know anything. There is no-one here I can talk to—it's all like a
bad dream.*

<p style="text-align:center">*O'Keeffe to Stieglitz, postmarked November 2, 1917,
Canyon, Texas*</p>

[. . .] I wish I were in New York—I don't want to be here anymore—
still there is no reason why I should be there—no particular thing
to move me—I don't know—things are queer—I seem to have
stopped thinking about Ted even—I guess I'm feeble minded—It's
really terrible. Everybody looks and seems so stupid I can hardly
stand any of them. I want to smash everything—Then sometimes I
hear my own voice—sounding exactly the opposite of what I feel—
I want to take my face right off and look at it to see if it's really my
face the sound came from [. . .]

O'Keeffe to Stieglitz, November 5, 1917, Canyon, Texas

I just came in out of the night—wonderful black night—some very bright stars—It's ten o'clock and I'm here all alone—no one else in the house—so I haven't taken my coat off—My hands a little stiff with cold—my lips burning from the wind—Being in the house alone is a bit uncanny—I don't like to take off my coat—A man down from Amarillo—taking a car he had sold to a man out in the country from here took Mrs. Reeves—I went with Mr. Reeves[15]—the other man left his car and came back in the Reeves' car—gone about three hours I guess and it was great out—Only we talked war all the way out—I can't talk it with many folks—they are so stupid—or I am—that it just won't work—The night was great—it was great to talk—man and woman are queer—Everywhere the same incongruous puzzle—inconsistent—reasonable—unreasonable—war—or ride in the night—it all looks the same to me—it's the same thing everywhere—I've seen women and children in South Carolina living in a kind of poverty I couldn't imagine if I hadn't seen it—I haven't seen children with their hands cut off yet—but I've seen things that seem just as bad—if not worse—in a country not at war—Will war help those folks—I like to think it will in time—I ought to stay away from Reeves—it seems I ought always to stay away from anyone I like—

She phoned me and asked me to go—I didn't know I was going with him—as I got in the car he laughed and remarked that he had done some tall scheming to get me in there—It doesn't matter—Nothing does—Everything is right or wrong—crazy or sane—according to the way you look at it. And I just don't <u>know</u> anything—Seeing Leah this morning—Reeves tonight—two human folks in one day—it's almost too much—Wish I could burst and be through with things—Claudie just came so I'll go to bed—it's rather chilly—Goodnight.

O'Keeffe to Strand, November 15, 1917, Canyon, Texas

At home again—Three letters from you waiting in the post office—Ted at the station—going to war—aviation.[16] [. . .] There is no hesitancy in what I feel for him—We meet equally—on equal ground—frankly

freely giving—both—You pull me in spite of myself—I've talked in Faculty Meeting—a rearing snorting time—it was amazing to me—I just knocked everybody's head against the wall and made hash—and told them what I thought of school teachers and their darned courses of study and raised a time generally—It was an event—Rather surprising too—to have the whole bunch each old chap and each old girl—most of them anyway—come up and squeeze my hand or my arm and pat my back—when I had half way expected they might not speak to me after the things I said—I half way expected to be run out of the room—I talked for conservation of thought—in the child and student—education for the livingness of life rather than to get a certificate—That teachers are not living—They are primarily teachers—War is killing the individual in it unless he has learned livingness—if he had it he wouldn't be a good soldier—Art never seemed so worthwhile to me before—I have a million things to do—Must paint too—Must write too—I'm on the war path at such mad speed—against their hate and narrowness—it makes me laugh. And they seem to be with me—it's funny. Haven't time to write more but I certainly gave the old boys and girls a good jolt—They laughed and they clapped and they looked at one another in amazed wonder—It was great to just Knock things right and left and not give a DAMN. Goodnight.

O'Keeffe to Stieglitz, November 20, 1917, Canyon, Texas

[. . .] A bit uncomfortable because I've been hearing the rumblings of a family row below me all the while—He seems to be at the end of his rope tonight—It is a long sitting room—an open fire—She crying once in awhile.—He is just going after things[17]—A tall very good looking man thirty-five I think—She large—also very good looking—His voice is low and very quiet—I have a feeling that she needs a good laying out—The humdrum of housekeeping—care of her two children—she doesn't like—And she has a terrible fear of having another—It makes her cross—His good humor has been a marvel to me for a long time—all things considered—I don't know what the row is about tonight but I hope she gets what's coming to her and she seems to be getting it—It's all just her attitude toward life—it seems so stupid to me. Gosh! I'm glad I'm not

married—Would I be in a devil of a fix—No—I wouldn't either—I would like it or else I'd quit—that's all there would be to it. [. . .] A train—going away and away—a quiet night and the sound seems to stay with us a long time [. . .] I seem to be quieter today than the last day I wrote to you—didn't sleep till after four this morning [. . .] The sister? I don't know—I don't bother much about her—She was thrown from a bucking horse the other day—and I believe it did her good instead of hurting her. [. . .]

Watkins was down the other day—it just happened to be great to see him—We rode southeast till the grass and sky were not red anymore then back into the gray and night—And he can't understand and I'm sorry for him and like him too—Poor stupid thing—clean-cut—alive in a way—feeble-minded too—A great letter from Buck too[18]*—Rheumatism and can't go to war—and he hates it—terribly alive. And all the women I know—see around here—seem to give me the crawls—whatever that is—I haven't any other word for it—Some of the girls I like—like very much* [. . .]

Commentary

In this chapter, O'Keeffe's doubt, hopelessness, and frustration worsened as the "turmoil of war" continued. She felt herself settling into a life where everything seemed the same: "War—or ride in the night—it all looks the same to me—it's the same thing everywhere." It all seemed absurd, all "crazy or sane," and she didn't "know anything," didn't know what was "worthwhile" and felt "stupefied." She found it particularly difficult to make work in this state of mind: "just haven't anything to say—I never felt so dumb in my life." She also expressed regret for things she hadn't done, words she hadn't said: "Why couldn't I have been ready when [Reid] asked me so many times so earnestly?" She longed to keep her thoughts occupied and to keep her "short time" full of work, perhaps responding to the fleetingness of life in a time of war. When a friend of hers from Colorado passed away, she contemplated the pleasant way he died—"Never in bed—no fuss about it"—compared to the "blood—and internals" that the soldiers saw in battlefield deaths. She filled her days with the "interesting drudgery"

of her young children at the Training School and gave herself the "pleasure" of working there ten hours per day instead of her required ten hours per week. She also admitted that painting was a "necessity" for her, even though she made little work in these fall months. She found comfort in how her ideas were still "fluid," unlike those of others, especially Strand, who seemed to have too much solidity to his notions, a certainty she found futile. At other moments, she found her anger bubbling up about education and war, as when she spoke to hundreds of students and faculty at chapel in mid-November or grumpily described the citizens of Canyon as "stupid" again and again. Expressing this anger, she wrote of wanting to "whack" people, to "scalp" them, to "stomp on their toes," to "smash things" and "knock things right and left and not give a DAMN." She vacillated between fighting—"If I were a man I'd get up and go to war so fast you couldn't see me," fleeing it all and finding "a country where there isn't war," and simply accepting that the "sky" might never be "clear again."

[5]
Winter 1917–1918
"IT'S THE FLAG AND I SEE IT FLYING"

O'Keeffe to Stieglitz, November 29, 1917, Waco, Texas

Good Morning—You see where I am and I am so glad I'm here that I just can't tell about it—Soldiers and soldiers and soldiers—and last night my brother and a friend of his—dinner—then we walked and walked—It almost turns you inside out—It's tremendous—seeing and feeling what it's meaning to them—It makes you think and feel things you never thought or felt before—makes me sure of some of the things I thought before—many in fact—Many folks coming along here—I just wanted to tell you—.[1]

*O'Keeffe to Stieglitz, December 2, 1917,
en route from Waco to Canyon*

How are you? I seem to feel as though I've come out of a blinding fog into a little light—But my voice—it has almost left me and hurts way down the front of me. I feel almost like a brand new person—I've seen folks—and how they live and move around—and I liked it—I talked to many—folks I like in a queer way—Soldiers—my brother[2]—his side partner—both engineers—What it is all doing to them is astounding to me—I seemed to feel like adopting his friend as a brother on sight [. . .] I couldn't leave him alone—he looked so forlorn—He won't see his people or the girl again—before they go over—as they think things now—And I couldn't help slipping my hand though his arm—The smile—why you know—I'll never forget it. Being with them was wonderful—I think I'll go again at Christmas if they are still there—the brother said I had to—Curry just smiled—Why coming out of a fog—because I think I see something

*to do—"conservation of thought"—Maybe I'll get it into other words
later but—as I see it hearts and souls and minds are being so rapidly
worked and wrung dry of their larger fineness—realities becoming so
real that we see all life at new angles—The soldier mind is a revela-
tion to me—It seems as though I never felt a real honest need of Art
before—it never seemed <u>necessary</u> before—It seems as though I feel
more on my own two good feet than I ever have in my life before—I
hope they don't dampen me completely the minute I get off the train
in Canyon—I wanted to stay in Waco—I didn't want to come home—
but I feel as though I have lots to do—<u>lots</u>—and one thing to paint—
It's the flag as I see it floating [fig. 13]—A dark red flag—trembling
in the wind like my lips when I'm about to cry—There is a strong
firm line in it too—teeth set—under the lips—Goodnight—My chest
is very sore and I'm tired—couldn't sleep or eat for excitement down
there—and hurt—and wonder—and realizing—*

O'Keeffe to Stieglitz, December 7, 1917, Canyon, Texas

*[. . .] I've thought of you often this week—feeling glimpses of you
but I've been like a young tornado—tornadoes don't have time for
anything—but good—they raise a line—Ted met me at the station—
bent on aviation—This afternoon was asked to report on the trip to
the faculty—another woman—a man and myself*[3]*—Well—it was an
event in the history of that faculty I guess—judging from what I've
heard since—It seems that it was an explosion I've been growing to
all my life—and I tell you I had it—I took each boy in turn—Fatty Staf-
ford—Latin*[4]*—first and knocked him down and jumped on him with
both feet—then took all the rest in turn—I told them their course of
study was a failure and that many times they didn't know what they
were talking about—That they were <u>teachers</u> not human beings and
trying to cultivate another crop of the same thing—The Army and the
art talk at Waco started me—The art was rotten because it has no
relation to life—They don't know what they are trying to do—And as
I see it the men of the Army haven't the resources within themselves
to handle what they are up against—and it is because they have tried
to fill up curriculums with "SOLID" work that is not vital—Their edu-
cational system is not built on the development of natural human*

*needs—desires—emotions—Too many students are just working for
certificates—diplomas—degrees and the like instead of learning to
live—Too many folks working for money instead of working because
the thing means something to them—I had a great time—and almost
every old boy and every old girl on the faculty came and talked to
me about it afterward—The women tremendously tickled because
no one had ever dared stand up to and tell those particular men that
they didn't know what they were talking about and that what they
were teaching wasn't of any use to the people they were teaching it
to—And I was afraid four of the men were going to hug me—It was
great—but the excitement almost killed me and I can hardly speak
aloud for more than five minutes at a time my throat and chest hurt
so. I stayed home today—thought maybe a day's rest by myself—no
one to talk too—would help me. I've been so full up that I've <u>had</u> to
talk in class—and some of the boys back from the training camps
talked so much and kept me talking so much that I almost haven't
any voice and haven't been able to sleep or eat enough—But it's all
right—I feel as though I've waked up with the loudest bang yet. It
seems so funny to remember the way I was feeling before.*

*And why don't I read the letters—three from Strand—two from
you—one from Bement[5]—two others that ought to interest me.—
Claudie was gone when I got home—down in the sticks somewhere to
teach[6]—have heard little from her—I just wonder that there is anything
left of me at all—I have made up my mind I'm going to stay here—The
rest of my life it seems now—unless they fire me—They may—I'm
going to talk some more as soon as I get voice enough. I'm on the
warpath—it seems wanting though—in spite of my savageness—to be
held close to someone—as though it might quiet me—*

O'Keeffe to Stieglitz, December 10, 1917, Canyon, Texas

[. . .] I would like to buy a set of *Camera Work* for the Normal—I want
to put it on my book list and I haven't any idea of how much it would
be. I don't mean that I am going to buy it myself—I mean I want the
STATE to buy it—I believe it would be good for them.—I may not
be able to convince them but I can't even try till I get a price on it
so I must ask for the price. Nothing to write except that my head is

going at the rate of forty miles an hour—After being asleep so long the waking up almost takes all physical life and strength—A lovely old gray haired lady—forty I suppose—sat down by me tonight and asked if I were feeling better—"I guess it's excitement more than cold or anything that's the matter with you."—After my explosion in faculty meeting she came up to me and laughed and remarked— "That was great—your standing up there and telling those men they don't know what they are talking about—and that what they are teaching isn't doing anybody any good"—She teaches sewing— I guess they call it Domestic Art[7]—I don't know [. . .]

O'Keeffe to Stieglitz, December 14, 1917, Canyon, Texas

[. . .] *Everyone has gone on about their work—it's quiet here—so here I sit—feet on the stove—No class but many things to do at school— Shall I go to school or go home. I seem to be sitting here—It sounds so funny when you remark that I am going to paint the flag—I haven't had time yet—and what I had in mind wasn't the flag at all [fig. 13]— it just happened to take the flag shape—I'm so tired—I'm ridiculously glad to know that tomorrow is Saturday and only four days to teach next week before Christmas holidays—Absurd to be so tired—*

I'm going to stay here Christmas as far as I know. It's queer—I plan to stay here—I feel too tired to go anywhere but a sneaking notion up my sleeve seems to tell me I will be going somewhere in spite of myself—I don't know—Don't care. It seems so queer to think that Christmas is almost here again—Last year seems so little ago. I have some nice folks at school that I like—I seem to be waking up to some very funny things lately—Claudie used to tell me I was the most innocent person she ever saw—She said— "You expect other folks to be like you are—think like you do and feel like you do—and it isn't that way—You are different."—And I've been finding such funny differences—things almost unbeliev- able—they don't seem human. I would like to be in New York for a few days—and see you—and talk to you—I want to see a real live talking—moving—living—thinking human being [. . .]

Night again and I'm in bed—I've been reading—Everything war and I can't get enough of it—and still it almost drives me crazy—I'm

*not at all certain that my feeble mind has been able yet to center on
anything that would make me willingly offer my life if the excitement
and adventure were taken out of it all—I wish that for a thing so tre-
mendous and terrible as what is happening I might put my hand on
some cause and desired result—that I could feel definitely justifies
it all—but I hunt all around—it is like chasing an almost invisible
slippery nut—small—slippery—hard to crack—slippery—Everything
contradicts the other—Goodnight—I almost went to sleep here—so
tired inside and out.*[8]

*It's Monday morning—Bright sunshine coming in my windows—
some greenness shining in it. My room is warm—it's a nice place—
Last night was cold still starlight—I saw the sun rise out of the enor-
mous stretch of blue hazy plains and hot sky*[9]*—Yesterday I heard
a man say that in France coal is $100 and $250 a ton—Last week I
got talked about for objecting to cards in the drugstore—Christmas
cards—Statue of Liberty—and a verse that ended with "Wipe Ger-
many off the map!"—amusing but not exactly what one wants to get
mixed up in—Really funny—They couldn't understand how or why
anyone would object for any but pro-German reasons—even faculty
folks got after me about it and when I explained they looked at me
sort of cross-eyed and said they hadn't thought about it that way—I
can't help wondering what they are thinking about*[10]*—*

Your letter this morning—I liked—Yesterday I was very much
depressed with the futility of everything—all morning I talked with
Mrs. Shirley—the lady downstairs—She is great in a way—she is
waking up—and she is such a wonder physically. Some way—this
morning though ahead looks more uncertain than anything I have
ever looked ahead at—I feel more sure of myself than I ever have.
Good-morning to you—I have much to do. Fatty Stafford across
the street is acting president and asked me to talk in chapel in the
morning. I will if I have any voice. I haven't much yet.

*I may go to Waco for Christmas—I really don't want to—I'm so
tired and it makes me feel and think so hard—Costs a lot of self and a
lot of money. Seventy-five dollars looks big—It depends on how much
I am urged. I can't afford it in anyway. When I was there the brother
insisted that I must come again—I don't know—It depends on him—it
would be to please him—not myself* [. . .]

O'Keeffe to Stieglitz, December 19?, 1917, Canyon, Texas

My lips are greased and I'm in bed—Rouge is the only thing I know of that helps the chap—It's only nine—but I feel so near a headache I'm in bed anyway—much against my own will and desires—My throat is bad again—And I feel like a wreck—but the inside of me feels like a mad whirlwind—I can just see my one little star twinkling in the deep blueness out my window [fig. 11][11]—it will travel out of sight in a minute—This morning I got up just as daylight was coming[12]—It was great—The first thing I thought was—GOSH—didn't God have his nerve with him when he painted those swipes across the sky—I envied him—the size of it—and the daring—The early mornings are tremendous—I'm still talking in chapel and it's about to wear me out but I'm having a great time—Yesterday the faculty liked it—they all talked about it to me—most of them—I should say—and I heard that a lot of them talked about it in class—Today the students got terribly excited and the faculty didn't say a word—It's great—I don't know what will happen tomorrow—and I care less—I feel like slinging brick bats and I have the chance to—so I'm slinging—I'm telling them a few things they don't like to hear and it's giving me a good time—One of the students said—It feels as though you are just up there talking to us—it doesn't seem like a speech the way it does when the others talk—and you don't look mad about it—you laugh sometimes—And a lot of them told me they could hardly get to work afterward—they were so excited they felt as though they had to get up and do something—Still the faculty didn't say a word—It's amusing—Wouldn't it be a joke if they fired me—I'd laugh—Goodnight—So tired and limp feeling in my head—

O'Keeffe to Stieglitz, December 28, 1917, Canyon, Texas

Friday morning—It was 10:30 before I went for the mail this morning—The *Camera Works*—I came home and looked at them just a little—Do you want me to tell you the way they make me feel—They make me feel as though there isn't any place for me anywhere at all in the world—I believe if they had come at the beginning of

vacation it would have been—go to New York—the only thing to do [. . .] Then it flashed through my mind that school begins Monday—and goes on straight till sometime in May and I wondered how I could stand it—

The way people are living nowadays isn't living—It hardly seems existing—shutting their minds and eyes—I am just beginning to realize a little what your seeing means—I seem to feel myself so far from all the folks about me—so far in thought—feeling—everything— that—why—I just hardly can't understand it—How did I get where I am—why are they so queer—How did I ever get so far away from them—They all think they are nice good religious folks too—and I think them the most damnable heathens—I want to run away from them—out into the nothingness—and cry—It is a great time to be living—seeing the uprooting—twisting and turning and the way men and women respond—the way they all run brainless and heartless in a mob—it almost seems unbelievable—When I waked this morning I was thinking of it—Can I believe it—realize even a little what is happening—How long will it last—Will the little thirteen-year-old boy who brings my coal and kindling be going in a few years—Will Paul be going in another month[13]—Richard was up from camp Christmas[14]— I don't mind his being killed but I mind his killing—the smile is so sweet—I just love him—It's the older folks I cannot stand—The talk of men past thirty—The—women—Girls and boys and the ones who must fight are different—Christmas afternoon Richard and the girl he is engaged to came up to see me—talked awhile then went to ride— She was driving—Richard wanted to put his arm around me—so he did—it was so funny—I hadn't ridden with someone's arm around me like that since I rode with you—He would have liked me like Ted did last spring if I had let him—The brown face—color—very white teeth—and the smile—We all said such honest funny things—it was great—He is gone—

The Camera Works *look like life—and I don't see anything but death—even in the living folks—old dead ones hampering the young live ones—Even Ted—he isn't himself any more—the finest thing about him was his freedom—realness—Partly—maybe mostly— my fault—Engaged to Ruby[15]—Still—standing in front of me—he remarked—You know I just can't stand it to talk to you—it almost*

*drives me crazy—and after you are gone it's worse than while you are here. I stopped here and read—dinner—read again—*The New Republic*—I look at that pile of* Camera Works*—and wonder if I dare look at them—read them—or will it make me want too much to escape from what is here—from deadness to life—and the fear that life may be only a dream*[16]—

<center>*O'Keeffe to Stieglitz, postmarked*
December 29, 1917, Canyon, Texas</center>

[. . .] *My children—my second and third grades were great this morning—they are wonderful* [. . .] *David was in to see me today—a last year's Freshman—at home this year—farming—Father is in bad health. He had a garden next to mine in the spring—a wonderful boy—will be 21 in December—wants to come back next quarter— three weeks from now but so much to do for next year's crops—and War—I'll be back to see you all anyway—Told me he had been reading the Bible—tall—lean brown face—*

Leah is down[17]—Little Cooper and I had a great time last week[18]—handing out of opinions—and right after it two teachers came and asked me to work in their rooms—that she didn't make the work mean anything to the children—It was amusing—I have to laugh about it—I hate even to look at her—still I understand her so well that—it's like a machine I like—because of certain things in its make-up that are no fault of its own—but I hate what it produces—it doesn't produce anything that anybody would want—I hate it for using itself that way—She can't see at all—It's maddening—amusing—Her brain isn't made for teaching—she has no connection with the child at all—no feeling for it—But why talk about her. I think the President has a new Education man camping on my trail to see what it is all about—it's great—I'm glad to have him [. . .]

<center>*O'Keeffe to Elizabeth Stieglitz, January 1918,*
Canyon, Texas</center>

Your letters are nice—No nice isn't the word—They are wonderful— it would be great if you were here to talk to—would you get up and

leave the stupid maddening sort of folks—There is really no place to go to or would you stay and fight it out—Really nothing to do but stay—nothing really makes me move yet—You will laugh if I tell you what the last piece of excitement is over—it seems to be growing as the days go by—and it's really so funny—Some Christmas cards at the Drug Store that I asked the man not to sell—It's so funny—I have to laugh every time I think of it but it seems this whole town is talking about me—Not patriotic. One had a statue of liberty on it and a verse that ended with something to the effect that we wanted to wipe Germany off the map—I said it was utterly incongruous and pro-German propaganda—The others—some statue of liberty—and a verse with something about hating the Kaiser—Both entirely against what they all profess to believe as the principles of Christianity—and certainly not in keeping with any kind of Christmas spirit I ever heard of—The good Christians are up in arms—It happened three weeks ago and the gossip is beginning to have a great flavor—so fine that it's coming back to me—I was perfectly unconscious for a long time—it was just that I didn't want the students to buy cards like that—I never dreamed of folks talking—I don't care what they say about me—but it's amazing to see what is in their heads—that's what riles me so—

I've sat here a long time—a dog barking—the night very still—a train way off rumbling and humming I've heard it a long time [fig. 16]—I don't know whether it is coming or going—I guess it is coming—I don't seem to have anything else to say—except the only thing I had to say even in the beginning and haven't said yet—It is simply—that it looks as though the War is going to last a long time and I don't see how I'm going to be able to stand folks—It shows them up so queerly so rottenly—so pitifully—and so disgustingly—Sunday night—no Monday morning—When I turned out the light and lay down last night—I saw a star out the window—Laughed and slept—I wonder if the star was there before and I couldn't see it—

O'Keeffe to Alfred Stieglitz, postmarked
January 3, 1918, Canyon, Texas

[. . .] *Oh, I never felt so sick inside. I started to say—I wish someone would shoot me—I don't know—I don't want to live anymore.*

*That is a stupid thing to say. [. . .] Little Willie—the English Professor
I told you of was over this afternoon. I phoned him and he came
tearing over bare-headed—I wanted to ask him something. He stayed
a long time—The next draft will get him—he is not at all keen about
it—I feel as though we both almost burst talking. I'd—no I wouldn't
either—I was going to say I'd give anything if I didn't get so excited
over what I feel and think—It was funny—first talking on the porch
both sitting down—I got excited and got up and began talking with
hands and feet and all of me—we both laughed—it must have been
so funny to anyone looking on—he sat there cutting at the sole of
his shoe with his knife. I went upstairs to get a paper—flopped in a
chair when I came down and he began dancing around—walking the
floor—pawing the air—both of us raring at the War. He stopped at the
window—face red, eyes shining—"Look out here—I'm getting just as
excited as you are—You'll have me going full tilt in a minute." His
trying to reason with me about keeping quiet—and we would both
laugh. [. . .]*

A poor old lady phoned me to come and see her—Wanted to
sell me her dead daughter's paints—Gosh—I could hardly keep
from screaming [. . .] The daughter died years ago—I couldn't bear
to take them from her—she had them all done up in paper and
sewed up in a sack. I knew she wanted something and was very
proud so I had asked her to make me a knitting bag before she
got out the paints—I must think up something to keep her busy
for quite a while. I don't know—everything just seems terrible. I
wish you would carry me away—up into the snow—dark soft quiet
night—and let me sleep. And I don't ever want to wake up. [. . .]

A full day—My chapel talk and some other things have taken
fire—and a good blaze is going—I've been so riled—and thought
and felt so hard about it—Why—I can't begin to tell you how every-
thing I know and think and feel is tangled up in a knot—Everyone
I've said anything to about it—has been rather surprised at my
point of view—They always see it—but the amusing thing about
it is they always say "Yes—I see what you are driving at—you're
right—I hadn't thought it that way—but, Miss O'Keeffe, to save
your life—you can't drive that into the ordinary man's head—I
don't care how hard you try." Well—to make a long story short the

"ordinary man and woman" of our honorable village have stuck several different things together—my chapel talk—and various bits of information and they are just pawing the air—It is amusing—it's really the Devil too. I'm trying to calm down enough to talk to Mr. Cousins about it[19]—but I'm having a hard time to do it. I wanted to today and couldn't. I tell you—I'm mad enough to kill.—Shirley—downstairs—has helped me a lot—but it's really a snorting time we are all having—The Faculty are beginning to line up with me, I think—Thanks to Shirley, I guess—I don't know—The town however is wagging its poor tongue off—Isn't it disgusting to get in a mess like that.

My children were wonderful today—My first, second, and third graders—I am getting my children to paint even if I'm not painting—really wonderful—I wish you could see them—I have two Chinese lilies again—in a blue bowl—pure—white—clean—They and the children seem the only rest from the madness in the air—If I can't someway quiet down I don't see how I can keep on working.—Tonight I feel as tired as I did before vacation began. If I only could stop feeling and thinking—but my mind seems ravenous—I'm going like mad inside—and all sense and reason tells me I can't stand it—Still I can't stop—You know—I just can't understand Strand's being willing to let war—all that's happening get past him—and missing it—or wanting to miss it so long as it's a state that exists.[20] Yes—I can too understand—That is—I can and I can't—That bothers me too—It seems as though everything bothers me—do you suppose I'll—I don't know—I wonder what I'll do—will I ever be 54—I someway seem to feel that if I ever am 54 I'll be so different I'll hardly know it's me—I used to say I was going to live to be 93—but I'm thinking now—I won't—Just this one day of talking and work has made my throat as bad as it was before Christmas vacation began—Goodnight—It's only nine but I must have a bath and bed—Do you suppose I could stop feeling and thinking if I tried—it seems it would mean stopping living. Maybe I had better do that. I don't know.—

Wednesday night—Nine o'clock again and I feel almost dead—so tired—I must go to bed right away—Had a long talk with Mr. Cousins—Nice—He remarked—You think differently from other folks—You may be right—I'd not have you a bit different—but it's

going to be mighty hard for you to get along with folks—The ordinary run of men are just ordinary men and women and they don't think like you do and they are very apt to misunderstand you—more apt to than not—They don't think—and they don't want to think—We had a great talk. He thinks I'm queer—but he thinks too "You may be right"—it's funny. I like him, you know—but I'm so tired—please love me—a lot—Goodnight—I haven't decided yet—whether I want to trust *Camera Work* to these folks or not—I have so to think of folks looking at it that don't really love it like I do.

O'Keeffe to Stieglitz, postmarked January 8, 1918,
Canyon, Texas

[. . .] *Faculty meeting this afternoon—I've never seen or heard anything funnier—Faculty meetings are the most entertaining things that happen here—However—the others don't enjoy them like I do. I don't suppose anyone else has the particular sort of good time that I do—They mostly think it's stupid. You know—I am rather uncertain in my mind here—I may not last through till May—I'm going to try to last till after Summer School—Claudie will be back for Summer School to finish her work. But it wouldn't surprise me if I just packed up and left most any day—I feel less and less like a free white woman[21]—The old brothers felt as though—well—I just surprised them a bit lately—They either had to abandon their professed religion or side with me and it didn't exactly go with their unthinking crazy way of haranguing [. . .] about the war—and naturally—they didn't enjoy being jerked up—It was funny—worried me a lot—but it makes me laugh too—It's worth it—it all is but it's mighty ticklish ground to be walking on.—If I didn't like it here so much I wouldn't even bother to jolt them—but I like it—and—I wonder what I like—Isn't it queer that I like it here—like it so much—It isn't any particular person—except my children—The folks are really unimaginably stupid—hopelessly ordinary.*

Monday night—in bed—I've been to Amarillo—Lady Mac phoned me to come up yesterday[22]—Had a good time—it's like a moment's rest—the change. Leah made Dr. Mac get after my throat—He said after poking me around some that he didn't know enough about it and took me to another man—As a result my arm

is swelling up where he stuck it—He said—Rest—I explained that I couldn't—then he said—Don't say a word you don't have to—That made me laugh. But my throat is really very sore—Don't worry though—I'll be all right. Dr. Mac was not home for lunch—I didn't see him after the other man got through with me and talked to him—I'm to go up again next weekend. No more car-riding—He didn't want me to come home in a car this afternoon but I came anyway—Mouth and nose both to be covered when I'm out in the cold air—high shoes. [. . .] Dr. Mac said same as the other man in spite of the fact that he didn't know specially about throat—before he took me to the other man. Dr. Mac is nice.

O'Keeffe to Stieglitz, January 14, 1918,
Canyon, Texas, first letter from this date

[. . .] I'd like to have someone do all those tag-end things for me for about a year and maybe I'd catch up [. . .] I am seeing things again—not very distinctly yet but I like their untouchable color—wonder if I'll ever try to make them—they are lovely in my mind. [. . .] A letter from Claudie—Very funny—Country-life in the sticks isn't very comfortable in blizzard weather—Says she thinks she will stay down there next summer and farm—raise peanuts and water-melons—So funny.—I wonder. Or else she wants to go to Arizona. Said she slept under eight quilts—in her union suit—pajamas—sweater—and stocking cap one night—hot-water bottle too—still she likes it. Great sister—I've been to Amarillo—went on train and Leah brought me back in a closed car—Dr. Mac is sick—gone to hospital—more convenient than being sick at home—moved him out this afternoon—The other doctor read me another lecture—Scolded me for going out—then later said he didn't know that it mattered—might not be any worse than staying home alone—Told me doctoring wouldn't do me any good—no use to give me medicine—Still he gave me some—he is a funny old boy—said he would like to pick me up and put me down in a place where it was warm and sunny—and leave me alone—with only one prescrip-tion—Rest and don't talk—Medicine won't do you any good. He reared around and made a great time—As Leah said—made me

feel I'd die if a tree fell on me—Goodnight—I must go to bed—He said I'd feel better in a week or so—then he would come out with the rest talk again—You've got to do it—whether you want to or not—I laughed—Goodnight—I'm all tired—all over—Tired in my head—all of me—The tired in my head is bad.

O'Keeffe to Stieglitz, postmarked January 14, 1918,
second letter from this date

[. . .] *I coughed all night—My chest hurt so I didn't dare go to school—My voice is in such a bad fix too—I know I couldn't talk more than a few minutes without stopping completely. Thought a lot as I couldn't sleep. Remembering about Strand seemed to jolt me into liveness. My brother—packed and ready to move any day—has been since before Christmas—France next they think. It all seems so queer* [. . .] *No use to talk about Strand—I feel about him like about Hartley's canvases.*[23] *I want to kick my feet through it—jump on it with both feet—I'd take pleasure in tearing one up today—A fiendish kind of pleasure—I wonder if I would want to do that if there was only one Hartley canvas—When I think of them I seem to see millions of them. It's too bad I am not drafted instead of Strand—Exposure might kill me quickly—or it might improve me—And at heart—I believe I'm a murderer—I could kill, I believe—Maybe I couldn't—I don't know—I believe I occasionally want to* [. . .] *I would like to go to some country I've never seen—where it's warm and there are lots of flowers and birds—and where bright sunshine and sand are—and water—water that never ends—blue—sparkling—It seems I'd just as soon be there all alone—if it would always be daylight. Maybe I wouldn't mind the night if there would be a soft sleepy long-haired dog to curl up by*[24]*—My chest hurts so bad I could cry* [. . .]

O'Keeffe to Stieglitz, January 20, 1918, Canyon, Texas

Sunday morning—I am up and dressed. Mr. Cousins told the lady who is doing most things for me—and who saw him last night for me that he is coming to see me this morning so I am up and dressed—otherwise I would not be up—I guess I feel some better—anyway—I

haven't been coughing so much—I am sorry I've raised so much disturbance [. . .] It all made me decide though—that I'd stop work for a month—However—I think it would be a physical impossibility for me to do anything else. I guess I just didn't have energy enough to have the initiative to do it till I had to.—To get up and say you are going to quit when there isn't anyone anywhere around to do your work isn't as easy as it seems—He is going to try to get the girl who was here before me—She is married—living in Kansas— He likes her—so do I—the most life in the least bundle I've ever seen—So much for my job—

For myself—why I don't know—I don't seem to care—maybe I'll care in a few days. Leah is going to San Antonio for February—and wants me to go with her—I don't seem to care—Maybe I'll stay here—The lady who stews over me most—almost made me promise to go to Amarillo tomorrow if I feel able—to the sanitarium if I don't want to go to anyone's house—I've just about made up my mind to face the music and go—I've never been in a hospital—it scares me and I know they will come and haul me out [. . .] Mr. Cousins came—Wants me to rest a week and see if I can't go back to school for at least part-time [. . .] I just didn't much care one way or the other so agreed to do as he chooses. The excitement—or something—made my head ache—I got in bed right after he left and slept—like you sleep with a headache—all afternoon—Folks came when it was dark—Brought supper—I couldn't eat a bite—Feel as though I never want to eat again—I'm not going to see anybody anymore—They make me talk and make me tired—Have found a girl who will come and do the things I want done—Measles and all the pestersome diseases are flourishing and they don't want the children to get them downstairs [. . .]

O'Keeffe to Stieglitz, January 23, 1918, Canyon, Texas

[. . .] You see, I haven't even responded to the sunrise or the sunset or the bright shining day sky or the night sky—Other things have been taking so much of me there has been no energy—no vitality for others—I've often looked at things and wished I had the energy or life—whatever it is that makes you feel things enough

to create from them—but I haven't dared to give myself that way lately—There hasn't been enough of me—I can't even write about it—It makes my head ache—I went to sleep after your letters this morning—I feel better—but letter—breakfast—and then sleep again doesn't sound very frisky does it [. . .]

Leah came in about two—All up in the air—I had told them downstairs that she was the only person I wanted to see so they let her up—Leah is just like me only a little different—She had to come down to see about some of Dr. Mac's taxes at the court house here—He has a ranch twenty miles south—Anyway she said—"George—I just had to see you—I thought I'd go crazy if I didn't—ever since you didn't come up Saturday." And she sat on the table and kicked her heels and told me what she had been doing—falling from one scrape into another—And she said—"I'm coming back tomorrow with woolen stockings and robes and the car all shut in tight and you're going back with me and anyone that says you're not I'll just tell them to go to Hell—I'm engineering this." "Why" she said—"You've got to go—I want you around—I'm going crazy."—You would laugh at her. She is so funny—tall—slim—and such eyes—and the keenest tongue I ever saw???—She feels and thinks and does things—and goes like the wind—Things bothering her—she said "Why you know I just walked the floor and I don't often do that"—and then began tearing around through the things on my table for something to read—I gave her Schopenhauer—I wish you could see her—she is wonderful—She wears a man's coat and hat and then the most wonderful pair of women's feet kick out from under the skirts—long—slim—unusually good-looking feminine feet—And the eyes up top—People always think we are sisters—here and in Amarillo too[25]—it's so funny—She is food demonstrator for three counties here and burns up so much good gasoline tearing over them—Dr. Mac furnishes the car—the counties the gasoline—Don't exactly know why I'm writing so much about her today—Except that the first time we met—nothing had to be explained—it was as though we had always known all about one another—Guess this is enough for today—No I don't cough so bad but I don't enjoy what I do at it—Don't worry—I'm quite Irish—and quite tough [. . .]

O'Keeffe to Stieglitz, postmarked January 23, 1918,
Canyon, Texas

*Monday night—The youngsters raised such a time this afternoon that
I got really waked up—Their noise bothered me so I read for about an
hour to keep from minding them. They were only playing [. . .] in spite
of my asking folks not to come to see me—and asking them not to let
them in—three got past and came up. Little Cooper was one of them—
I was simply amazed—She hardly exists in my mind at all—so funny
for her to come to see me—a picture of her small baby nephew—a let-
ter from France—her knitting—what should she send Jack to read—
handles for a new knitting bag—story about a fire just over—You
never saw such a flurry—made my head hurt. [. . .] It's queer to think
I've been stretched out here for three days now—not even wanting
to turn over. I'm feeling better though. My interest in things—and it
isn't so hard to write. It's great too—to think I can stay in a room a
whole week by myself—and to have made up my mind to stay longer
if I want to—Goodnight—The Age of Reason came yesterday—Some-
way—just the word <u>Reason</u> makes me think I won't read it for a while.
I can't tell—may read it tomorrow—but—I don't think so. Strand has
come to my mind often. Why can't I have just a little of the strength he
has. And the soldier that swung easily along down the street in front
of me Friday morning—The wind didn't blow him and it didn't blow
me—It's amusing to be so good for nothing. [. . .]*

O'Keeffe to Stieglitz, January 31, 1918, Canyon, Texas

It's night again—and I want to write big but only have a few sheets
of paper and may not get to town to get any for some time so I
guess I had better write little—I said it was gosh darned cold—
Shirley says it's damn cold—My throat bothered me—I'd like to
be buried way out on the plains somewhere till I feel better [. . .] A
talk with Mr. Cousins—not much encouragement about that Spring
Quarter off—He thinks I'll be all right by then—it's three weeks
off—He is a nice little man—And you know I just couldn't tell him
that what I want even more than a beautifully working throat is to
feel free for just a little while.

O'Keeffe to Stieglitz, postmarked January 31, 1918, Canyon, Texas

I came home yesterday intending to go to school today—Slept about 12 hours last night. Went to school this afternoon—one class—couldn't stay any longer—came home and lay down—my head ached so—so tired and sick at my stomach too—goodness knows what it is that makes a woman feel like that—I got up now to warm my feet—thinking it might help—I believe it has—I hate so to undress—I felt so much better up at Dr. Mac's—He thought I might have the grippe[26]—but I don't believe it has any name—I was just sick and I don't seem to be able to get over it—The other man almost killed me mopping out my throat—It's better but I don't know—I want to go to school and I just don't see how I can. I feel like Nothing—Nowhere—Never—Do you know what that feels like? [. . .] I am feeling better today. Went to class this A.M. No more today. I've given up my Training School work. I'd rather give up the other [. . .] I feel on the edge of something—as though something must happen. This morning while at school I went in to tell Mr. Cousins that I want the spring quarter off [. . .] I feel I might just as well tell him I am not coming back anymore—It feels that way. Isn't it funny—and I haven't an idea of what I am going to do—where to go or anything. [. . .] I think my brother would think my work very astonishingly queer—but he can't help that—neither can I. I wish he would want me to go to Cuba[27]—I think I'd like to go [. . .] Isn't this war-time an absurd time for a person to just sit down and say they are going to quit work—Really—it all seems too funny—It makes me laugh—and I don't care [. . .] In bed over 12 hours again—it's three now and I'm so tired I ache all over.

Friday morning—Yes—feeling better—going to get up in a little while. I've decided it's too perfectly disgusting to be sick—and there is absolutely no excuse for anyone being sick in bed—I'm going to get up. [. . .] I would like to go East—but it's too expensive just to please myself that way [. . .] Probably more than half the trouble with me is lack of real human folks—I hate to go out and see the faces—mostly masks—and I feel what's behind the masks and it has grown to be almost unbearable. [. . .] If I go anywhere—I ought to go wherever it's warm [. . .] Friday afternoon—I got up

at noon—there was an impossible dust storm—air all yellow for about an hour—Now it's clear—a strong west wind—good prospects of a norther—but you can never tell. I'm feeling lots better [. . .] You feel much more civilized—up and dressed—it's great. Haven't coughed so much yesterday and today and sometimes I can talk—Just in from supper [. . .] The good brethren and sisters would be horrified if they knew me like you do—I can't be human here. I can't even wear the kind of clothes I want to. Why I feel as though I can't even think what I want to. [. . .]

O'Keeffe to Stieglitz, February 4, 1918, Canyon, Texas

Just back from Amarillo again and a most uncanny feeling that I must write you now because my arm aches so—another hypodermic of some sort of serum[28]—I can hardly move it—and I'm going to bed and I don't know—I just don't feel like getting up again soon—Dr. Mac got me to go specially to his office—and told me I just must be careful and a lot of not encouraging things—The other man got him to think—He says the serum will make me sick but to take it anyway—dangerous not to—

Wednesday night—started this Monday—I haven't been up till tonight—I got up and went to supper—queer feeling in my head and slow walking—Surely have been laid out—the darned stuff gives me an awful headache and makes me deathly sick at my stomach—and the worst of it is that as soon as I feel pretty well again I have to have another dose—So tomorrow morning I'll have another—pleasant to think about—But you know—I don't much care anymore—don't care much about anything—don't care if it makes me sick—don't care if it doesn't—The Van Gogh letters came Monday[29]—I have read them—not the introduction—in between sleeping and waking—read mostly to forget how sick I felt—then would go to sleep—reading makes me so tired—but I enjoyed it—enjoyed it very much [. . .] Such a wonderful letter from the sister last week—Hardly anyone but you could imagine how pleased—that's not the right word either—I am with the way she is growing.—It is wonderful. I had two of Wright's *Creative Will*—she helped herself to one without telling me and writes that

she is having a wonderful time reading it—late at night and early in the morning when it's quiet.[30] She says it doesn't seem new at all—that it's just like talking to me only he uses different words—I had to laugh—Wright probably wouldn't feel flattered—Anyway it's a great discovery to her—"More truth in it than you dare believe" she says. She almost scares me. I don't know what she will turn into and her interests separate her more and more from people—She said remarkable things in that letter—the saving thing is I guess that the things she sees give her great pleasure—Aloneness—is more fun than folks—She loves the country down there[31]—Shadows of the trees on the bare ground in the night—moonlight—and the sky—My little girl is queer.—No not queer. Leah took the thing I painted last week up to show Billie Mac when she brought me down Monday. She thought it wonderful and wondered what Billie would say—she was to leave yesterday for the south [. . .]

O'Keeffe to Stieglitz, February 8, 1918, Canyon, Texas

Friday—1:30—Isn't everything funny—The day out is a yellow Hell of tearing biting cold wind—fairly blinding with dust—why it's mad—It's wonderful too—I like it—I'm glad it is that way—it's tremendous—still it is laughable—It's like some crazy folks I've seen[32] [. . .] had an awful fear of them—I'm just as afraid to go out into this weather as I used to be of crazy folks—It affects me about the same way—feeling as I do. I went in a cab this morning and came back in it—it wasn't so bad when I went out [. . .] Yesterday I went to school—and I've come to the conclusion that I just simply can't go anymore—no two ways about it—That makes me laugh too—and I couldn't sleep for thinking what I would do about it—It doesn't worry me (I know that's a bad word) like it would most anyone else—I don't much care—only I wonder what I'll do [. . .] I know by the way I feel that it is pretty apt to take at least two or three months to make me human again—I've tried to think I was mistaken but I'm not I guess—Needles in my throat you know—it's way down—you can't see it—and the rest of me just no good—Today it even hurts to whisper. It is amusing—The people I know in San Antonio are a variety I don't seem to want to see right now [. . .]

My brother from the Waco camp was on the boat that was sunk off the coast of Ireland[33]—As far as I can tell from the papers he didn't go down—I knew he wouldn't as soon as I heard it yesterday and thought a minute—then this morning saw that his division seems to be safe—Amusing—I envy him—He is so funny I wish I could see him—He took my hand over the table down at Waco one night and remarked with his funny laugh—You know—you are I are lucky— There is a check for a hundred and fifty over there in my drawer from the other brother[34]—More when I want it—That's amusing too because I have no desire to cash it—What's the use—As usual— the things you said about the War today were almost exactly what I had been thinking—This morning almost forgot to finish lacing my shoe—a high tan boot—and I hate tan shoes—sitting here pulling on the strings—thinking about the War—I rather like those shoes—only they are tan and too wide—couldn't get them narrow—Of course that doesn't seem to leave much in their favor—still I'm fond of them—

I've been boiling for several days—Mrs. Reeves picked up Van Gogh's Letters *from my table[35]—turned over pages—remarked quickly and dropped it as though it had burned her— "Ugh—it's trans- lated from the German"—I have to laugh about it and at the same time I feel as though she is too stupid to speak to—Isn't it funny— What is the use in petting and coddling yourself into living a long time among folks like that—Funny—Why it's the funniest thing to do that I can imagine—Being any sicker among them would be worse though—they look so much uglier inside when you are sick—even when they are being nice to you.—Yes? You like the little girl— it's only a little girl—I never felt before so much as though I don't belong anywhere—Wish I could talk to you.—Don't bother about me though—Why don't you live where it's warm in the winter—Wish you could see this day—*

O'Keeffe to Stieglitz, postmarked February 12, 1918, Canyon, Texas

[. . .] I feel too tired to live—Sunday morning—I thought I was read- ing but Will—a big colored man—came in—poked the fire—said I'd freeze to death if he didn't come and fix me up—and now he is

playing the victrola out in the sitting-room[36]—and I can't read—Billie and Dr. Mac have gone to church—Will entertained me most of yesterday afternoon—I on the couch in the sitting-room—under a livid red quilt—a big open fire—it's a long room—one and all windows—mahogany that looks like black walnut because the walls are yellowish tan and deep cream—wonder why I thought so much about you stretched out there all afternoon—half asleep except for Will—his teeth the whitest thing in the room—his face and head the blackest—it was funny—really great—he wants me to stay here—he likes me around, he says—so ridiculous—I like the black folks—it seems like home.—Dr. Mac advises me again to San Antonio—the other doctor has given up in despair—I've just about decided to go next week—I'm not coughing any more but my throat seems worse—Muscles just contracted when he treated it yesterday—half strangled me [. . .] Yesterday when I came in here and took off my hat—for the first time I noticed what I looked like—a colorless pale dragged-out look—I hadn't noticed before—the figure looked so lacking in vitality—I unexpectedly saw the full length in the strong afternoon sun—slim little upper part—full skirt accentuated it I guess [. . .]

Yesterday afternoon went to the country to one of the most famous ranches in this part of Texas—Hermosa or The Devil's Kitchen[37]—It was warm—cloudy—the sun in spots like wonderful gold on the plains—<u>wonderful</u> [. . .] I—why when I go to talk I'm not sure I can walk straight to the place I want to go—Something is certainly queerly wrong with me. Dr. Mac says go South—lower altitude—and warm—He says San Antonio so I go—I think I'll go Thursday—I seem to get—He says go immediately—No use talking about it. You think my letters sound better—it really does make me laugh because I am so very sick. [. . .] Why—yes—I'm afraid—but what good does it do [. . .] Don't be surprised if I don't write—I'll be busy winding things up and getting away.

Commentary

In this chapter, O'Keeffe found a new vitality and inspiration, especially after visiting her brother Alexis at the training camp in Waco,

Texas. She wrote several times that she felt she had been awakened by her visit to something powerful, some new purpose: "a coming out of the fog," where "the soldier mind is a revelation to me." She then turned this awakening into action and began speaking out on how education needed to change to serve young people, how it should provide guidance on real human needs, desires, and emotions. She aimed to help students not just get degrees or certificates but discover the "livingness" of life. She lambasted the older generations, the "old dead ones," for their exploitation of the young "live" people through the war. She declared several times that she planned to stay in Canyon, even "for the rest of [her] life." She compared herself now not to "fast-burning wood" or an exploding firecracker that sparks and dies out rapidly, but to things with more lasting and destructive force: a "tornado," a soldier "on the warpath," and a "ravenous" madwoman. She continued to use metaphors of violence to capture her passion and frustration: "I'm mad enough to kill," she wrote; or "I believe I'm a murderer." She also described how speaking out had put her on "ticklish ground" with the townspeople, but that the faculty, her landlord and colleague Douglas Shirley, and her supervisor Robert Cousins had all fallen "in line" with her and supported her strength and efforts. She felt that she was getting through to people and described how students responded to her public presentations— "it feels as though you are just up there talking to us—it doesn't seem like a speech the way it does when the others talk." She had determined that it was indeed "worth it" to stay and fight. We see her gift for activist public speaking, something her biographers rarely credit her for. She viewed this moment in her life as a "great time to be living."

Then, suddenly, she found herself terribly sick, physically weak with a flu-like illness that gave her no choice but to slow down, be silent, and ultimately leave Canyon. Again, she began to doubt that she would live much longer, believing she would never reach Stieglitz's age of fifty-four. She was often filled with envy for the soldiers and their adventures. She regretted that she could not be drafted into the army so that she could be killed quickly. "I wish someone would just shoot me," she wrote. She realized that "the

War was going to last a long time" and feared that life itself "may only be a dream." She stopped caring about things, feeling things, and having opinions about them, finding herself "too tired" for it all: "I don't care about much anymore—don't care much about anything," she wrote. "What's the use?" "I don't see anything but death," she sadly stated. Finally, feeling truly ill and exhausted, she wished to be "buried" alone "way out on the plains."

What we see throughout her time in Texas, but especially in this chapter, is a woman whose personality was often in disarray. O'Keeffe showed many tendencies toward dramatic mood swings between elation and dejection, certainty and utter confusion; toward narcissism in the constant insistence on her own "specialness" and the contrasting stupidity and ordinariness of others; and toward depression with her perpetual talk of death and dying, killing and murder. While her letters reveal that she was indeed physically sick between November 1917 and February 1918, they disclose an unhealthy mental state as well. What must be noted, though, is how the war exacerbated these tendencies. As she pointed out, the war made the townsfolk even more "rotten." It made her feel increasingly isolated from her peers, while it also inspired her to a kind of revolutionary zeal for change.

[6]

San Antonio and Waring

"COUNTRY LIFE . . . IS WONDERFUL"

O'Keeffe to Stieglitz, February 14, 1918,
en route from Canyon to San Antonio, Texas

You will laugh—I'm on my way—The tall lean man who mops my throat out could hardly believe his ears today when I told him I had quit work and was on the way to San Antonio—Dr. Mac says—You don't need to go to any doctor if you will take your own hypos—he showed me how—The change and rest and warmth is what you need—What doctors can do for you doesn't amount to anything— My arm is almost too sore to move tonight from where he stuck me this afternoon—This is the filthiest railroad station I ever saw—it's nearly 9:30—train late—half-lighted—straggling—listless moving crowd like late train crowds are—I don't seem to care if the train is late—Time is nothing now—It's great—seven—eight—nine—no hour means anything—Tomorrow—if I miss connections it doesn't matter—Think of it—time is nothing—it doesn't matter—I haven't anything to matter—General Delivery—San Antonio is the only address I know—I wish you were here—This dismal droopy-looking crowd—smoky room—No hurry—only I'm tired—I want to go to bed—Goodnight—

One o'clock Friday noon—Here again—This is such a very undesirable place that I like it—Just got in—had some food—train five hours late so I missed connections—This is right across the street from the station—The prunes are good—have to wait till 8:50 tonight— Richard met me[1]—he is in camp here—His pass only lasted till 11:30 so he had to go back to camp and get another—Late trains are a bit inconvenient—It seems as though no time has passed since I sat at this very desk and wrote you before—Funny—It's hazy out—blue

haze—in Canyon we hardly ever have anything but yellow dust haze [. . .] It seems so funny to be coming down here again and so odd to be going to San Antonio—I always wanted to go—and now that I have to go don't care anything about it—I just can't imagine getting there but I suppose I will [. . .] It's nice to be alone—no one to talk to—Richard says I don't look sick—I guess—Well—to myself I look like the devil—Maybe it's because I see myself not dressed— However it doesn't matter—I don't care what I look like—General Delivery—San Antonio—I'll send you a scrap I wrote last night if I can find it—Soldiers again—they don't interest me greatly now—I don't know why—.

O'Keeffe to Stieglitz, February 18, 1918, San Antonio, Texas

I hardly know what to say—I feel in another world [. . .] I arrived Saturday morning—and I'm so glad I'm here and not in Canyon— Still it all seems so funny and unbelievable—It has rained ever since I've been here—not real rain—the air has just been wet and the mistiness is wonderful—I've never seen such a motley mixed-up town and every time I go down the street I meet someone I know—the most unheard-of—unexpected people—Leah brought the mail this afternoon—about 1:30—with it the telegrams and I got right up and tore out to answer them—I had been lying down all morning—just won't stay in bed—

We went to the bank and while we stood in line I turned round and there was Frank Day—Lieutenant Day—one of our Canyon army boys[2]—He almost stood on his head—it was great to see how excited he was—and changed though still the same—And just as we were bidding him goodbye—he is leaving for Austin tonight—Leah turned round and saw Willard Austin—the man of last spring with the yellow car[3]—it was too funny.

After that I wanted to tell Leah not to look anyone else straight in the face for fear we might recognize them—Spent rest of the afternoon with him—Food and *The Garden of Allah*[4]—A summer-school student waylaid me—A girl I knew years ago in Chicago— and another who roomed in the same apartment I did in New York at one time. And I don't care particularly about meeting folks I

know. I am feeling better—rather stupid today and tired because I had a new dose of serum yesterday—but I can talk better than in a long time—it's great—I'll feel better in a little while I know—As far as being taken care of—I hardly know how to behave—I am staying with Sibyl Browne—a South Carolina girl I knew at Columbia[5]—and she is too good to be true—The sort of person I call a nice sweet lovely girl—thinks of doing things for you that you would never even think of wanting done—Almost too comfortable feeling to be true—it's great—it doesn't seem natural—I haven't even felt like writing—Being lazy is great—between them all they think they have time filled up for me till Friday—Well—maybe they have and maybe they haven't—You don't need to be alarmed about me—Leah says she is going to write you—I'll be all right here in a little while—She is going back in about ten days and will ask Dr. Mac—I'd lots rather you wouldn't ask him about me—things up there at Canyon had just about driven me crazy I guess—If I don't get lots better in a little while I will do something else—but—I wanted to go East and he said—no—it's too cold—He said El Paso—California—or San Antonio—and here I am. I must go to bed. Goodnight [. . .] You see—up there at Canyon it was so hard not to go to work and—I don't know—the whole thing almost ran me crazy—

Next morning—Tuesday—Raining still—not enough to see—you just can feel it misty on your face—I'll be all right if folks just leave me alone—and—well—I'm going to be left alone anyway—There isn't much the matter with me except what I told you before—See Dr. Mac said my throat might turn into TB if I wasn't careful[6]—said it had fine chances to—if I wasn't careful—But I really feel so much better and I've only been here three days—He said TB or pneumonia—and he rubbed it in so hard—that's why I came down here as he said—It's warm here in spite of rain—The city like a fairy city last night—looking out into the mist.

O'Keeffe to Stieglitz, February 25, 1918, San Antonio, Texas

Monday morning—Been to breakfast and the post office—your letter about the roll and one from Strand—Gray sky this morning—Sibyl slept with me and got up early and left—It's funny—I'm

afraid to sleep alone—Isn't that ridiculous [. . .] Yesterday morning ran away from me—Sibyl was here—In the afternoon we went out to Hot Wells again[7]—Leah's wish—Leah and I had dinner with her father[8]—He is remarkable—eighty his next birthday and more alive physically and mentally than most people ever are—He is wonderful—it was a perfect spring day like in Virginia—only maybe softer and warmer—really almost unbelievable—and the night—if possible—it was more wonderful than the day—quiet—moonlight—and this quaint funny town—and the remarkable old man—who has lived and is old—and is young and—at first said little—but as time went on seemed to take more and more pleasure in us—Leah was sick—a terrible cold—fever a hundred and two—the woman at the baths told her—but you can't stop her—She is so wonderful—and not strong—and won't give up—Maybe she wouldn't be so wonderful if she were different—I suppose she would not be—The sun is out—very pale through the mist—No—the building I see over there is bright yellow against the gray sky—pale gray sky [. . .] I want to make more nudes as soon as I feel like working—wanted to for some time—some time before I left Canyon—I'm feeling better—yes really—but I don't seem to have a feeling of push—I have to have to work—One thing that is great is that there are so many things I want to do—paint I mean—Things look so wonderful to me—You know—I didn't care—No that's not the way to say it—I just couldn't leave that stuff around Canyon—and I hadn't energy to do it up right myself—the nudes specially couldn't be left [fig. 4][9] [. . .] I must go out—can't miss the sun. It's almost impossible to stay in here—I'd like to live out [. . .]

O'Keeffe to Stieglitz, March 6, 1918, San Antonio, Texas

[. . .] You know Willard has a wife—somewhere—I don't know where—Evidently not known here because I have been taken for his wife till it's funny—and he has a son finishing high school this year—here—I haven't seen him but he told me about him—Both bother him a lot—I didn't ask questions and he didn't tell me—It almost seems that this is the first sunny afternoon since I've been

here that I've been left alone—I like it—I'm tired—am tilted back in a white chair in the side lawn—I say <u>in</u> because it's fenced—nice trees—spreading fat-looking fig trees—gray—with a few leaves just out—and some other taller trees—very soft and feathery[10]—It's almost hot—just right here in the shade but I don't want to go out in the sun—and it's so wonderfully quiet [. . .] I wish you could see the funny little Mexican man who does things around here—queer brown and black face—blue shirt—oyster trousers—red handker-chief in his pocket and red tobacco bag[11]—He has a creepy kind of movement—We can't talk much but we have a great smiling acquaintance—He just crept around—he is very little—and told me I have a great place to sit here and that it's pretty hot—I agreed and told him I didn't know he could talk so much—that he had fooled me and he just laughed and laughed—twisted up his face and shoulders—He is great—Birds sound so nice—Your speaking of cold seems—oh so far away and impossible—

Wright[12]—he will have to go to war or do something about it, won't he—I don't want him to go to war—It seems like—why it seems outrageous—Seems to me he should be moving.—Why doesn't he get busy and learn to speak Spanish right away—There isn't going to be any place for some of us to live for a while—or is it ever—

Leah and I have just about decided to farm—decided it would be least objectionable—I don't believe I could stand Canyon any-more—They say and do and stand for so many things I can't be roped in for—I can't begin to tell you what a relief it has been to get away—Running around with their eyes shut and suspicious of anyone who doesn't run with them—Leah tells me I'd be crazy to go back—she is returning the tenth—She can't stand the work and the climate up there—Dr. Mac told her she had to come right back here—It's almost a misfortune that Leah and I ever met because when we get together the wheels in our heads go so fast we turn over most anything [. . .] My Mexican just crept by with a broom and a red handle—Must go—I have more to say but it doesn't come to me because I just thought of something I must do for Sibyl—I sleep alone now—I'm not afraid anymore—

O'Keeffe to Stieglitz, March 14, 1918, San Antonio, Texas

[. . .] Then—oh more folks and they wanted me to go to the country for supper—I wouldn't—it seemed colder and I am bent on fixing this throat if possible—and coughing again makes me mad—So I wouldn't risk it—and I didn't want to go anyway—So they got their stuff and all came up to my room for supper—it was very funny— I'm glad they are gone—Leah comes in the morning—I will surely be glad to see her—Lucy wants me to go out to the ranch tomorrow too[13]—Well—I said I didn't know—I'm not planning [. . .] A new idea has sort of grown around in my head the past few days—since I painted last [. . .] I work in a queer sort of unconscious way—more feeling than brain—I seem to throw my brain away sometimes— Maybe I haven't any [. . .] I can paint things I feel and do not understand when I can't formulate them into words [. . .] My idea was— some colors I put together—The thing they are in is bad—but as colors they talk—I feel like saying I found some new colors—and finding them saying something I hadn't been able to say before is like feeling something I have never felt before [. . .]

O'Keeffe to Stieglitz, March 21, 1918, San Antonio, Texas

[. . .] The place we went to camp was the farm. It is a funny little house[14]—no one lived in it for two years—We camped in the front yard for the night—between two lilac bushes—In the back yard under a tree to eat—We really had a wonderful time [. . .] Leah and I have been planning to farm for quite a while—half in fun but as we both had to come down here and quit work—why not in reality—It is really amusing—everyone has promised donations—the most remarkable kind of donations—A thorough-bred Jersey cow—two goats—one pig—one bedroom set—two small rag rugs—We had a Reo car but Dr. Mac said Leah mustn't run it and I can't and don't want to so we had to give that up—I think Brack is going to invest in a kitchen stove today before he goes up[15]—he is fond of biscuits it seems—And Mr. Harris wants to visit us but won't come unless he has a bed so I guess he will bring another bed along—We also have one table—already—and a waffle iron among the donations

to come—The farm—well we just decided we were going to have
it—Borrow the money—a thousand dollars—and get it and go to
it—Willard offered to back us to get it[16]—so did some other folks—
We don't know how we are going to pay for it but we are—

I don't want to go back to Canyon—it seems terrible to think
of—I really can't think of anything else I can do and be left alone—
When Leah was back in Amarillo—Watkins asked her[17]—what
business I have going on a farm—what do I know about it—Leah
laughed and told him I didn't know anything—didn't need to when
she knew enough for two—I didn't tell you about it before because I
didn't know whether I really wanted to do it or not—but I am begin-
ning to think there isn't anything else I'd rather do right now—It's
beautiful up there now—plums and pink Judas trees blooming—
everything young green—sleep out under the stars—planning to
live out in the open together—house only for rain—Billie Mac says
she will paper it[18]—I wonder if you think I have lost my mind—Just
being out that little made [me] almost feel like a human being—
Makes me crazy to go up and live out—Must go—Oh—I almost
forgot—The sister writes that she found she had to have a horse
so she bought one—isn't that a joke—

O'Keeffe to Stieglitz, April 6, 1918, Waring, Texas

It's Saturday afternoon—I don't know what time—We have no
timepiece running—Willard brought us out last night and he and
Brack went to San Antonio this morning—Both had to get back to
town—and we forgot to set a watch before they went—It's great
not even to know the time—If I could cut my hair off it seems I
would be quite happy—I've been lying here wondering if I dare—I
don't know—but it seems to be the most civilized thing about me
and I'd like to get rid of it—I wish you were here to talk to—We had
such a time yesterday I'd like to tell about it—We lunched with Mr.
Harris—Then Willard came for us and we did our shopping—Just
as we were ready to start for the country—Willard made me per-
fectly furious—I don't get angry—maybe I should say <u>crazy</u> like
that very often but when I do I almost lose my mind—It was ter-
rible—Leah had a terrible time patching it up—I didn't want to ride

in his car even—Oh, it was awful—it was also very absurd—however—Leah fixed things so we at last started between three and four—It is about forty miles up here—

About twenty miles out of town a storm broke—The clouds have been marvelous—wild green and blue and dirty yellow rolling over the dark green and blue hills—it was like Willard's and my falling out—Really great right at that time—It rained so hard we had to stop and just sit there all shut in while everything that the heavens can send down tore around us—Leah and I in the red blankets—We had food along and ate supper—Finally it cleared but streams were so swollen that we couldn't get past—the hardest rain in over two years they say—We were on a strip of road about a mile long—near a little store—Leon Springs Camp[19]—with about five or six other cars—they were all full of soldiers—and streams at either end of the mile strip of road—swollen so that nothing could pass—It was very funny—a wonderful sunset—a fire—a long dark bridge—three or four hours we had to wait—and it was so funny to see how the different folks took it—An ambulance was stuck in one stream—It was great—Then the ride in the dark—I forgot to tell you that while we waited in the storm—I was afraid—it was while we were still driving—before it got so bad we had to stop—Willard knew I was scared—I don't remember exactly how or exactly why—but I knew he felt abused—I was on the back seat alone and I leaned forward—scrambled over the spading fork and box of all kinds of things and kissed him—I know it gave him a large surprise and I debated for some time—but I wanted to—so I did [. . .]

O'Keeffe to Stieglitz, April 17, 1918, Waring, Texas

[. . .] My brain works differently from the instinctive feelings I have for many things—It's the same thing in life that I've known in art for a long time—When Leah was in town night before last—we lay flat on our backs—My right arm through her left one—talking—for a long time—When we were ready to go to sleep we noticed for the first time how characteristic the position was and both laughed—We wouldn't put our arms round one another—Just linking together seems to fit—Still—tonight—I've been thinking very

much about us—Life has been so different to us—still seems to have made very much the same thing out of us—No that's not what I mean—We are alike and yet not—The difference seems to be—race[20]—breeding—traditions—Still—she is one of the very very few who understands [. . .]

They asked me to talk at one of the high schools next Wednesday—Do I want to—Maybe I'll say something I ought not—Still— I have a lot of things on my mind that I want to say—My throat seems to be feeling pretty good—I was rather discouraged a week or so ago—but it's better now—In fact I'm as fat as I ever am— Can do as much as the average person—running around and that sort of thing—in a day and not mind it—I ought to be thinking of going to work—Am I going to hoe beans or misinform the young and unprotected—I don't seem to think I ought to go back for the summer—I could stand the work—could be doing it now for that matter—but the misfitness of it would wear me out in just a little while again—

Still—you say Strand is going to war—I'm glad! Isn't that funny to say and to feel—No—not funny—it's incongruous for—I seem to want to fit him into the machine and all the time feel that it's a physical impossibility to fit myself in—Everybody seems to be having a hard time to fit these days—that is—everyone who can think a little— Lucy is disturbed because she doesn't want to buy Liberty Bonds—I finished yesterday with her—afternoon and evening—poking around old houses and queer corners of San Antonio—in a Ford—Just riding in the Ford is an adventure—She drives it so queerly it is like riding a horse that you can't get in motion with—it's between a gallop and a trot—and snorts and puffs and gets hot and she dodges around queer alleys and corners and across streams—all but climbs trees—And every five minutes you marvel at your charmed life—Nothing but a charmed life could survive Lucy's driving—When the engine stops— and it frequently does—you just wait till someone comes along who looks as though he might not mind cranking it—She is so absent-minded she stops it without intending to—Well—her brother and sister went over with the Ford Peace Party[21]—They are peace folks and don't want to buy Liberty Bonds—one of the oldest families here and wealthy—The brother will be drafted—he just married—Needless to

*say it's a rather disturbing situation—one brother is in France—the
mother has bought bonds—and Lucy isn't looking forward to either
buying or refusing—Really it's a great time to be living—to see how
folks behave—*

*I wonder if it would be very foolish of me if I got a notion that I had
to go to New York and talk to you about things [. . .] I asked you why
you don't come out here[22]—It's a wonderful place—I wonder why
everyone doesn't live here—Still—it would be very foolish for you
to come—I don't know why—I just heard a wonderful bird-call—so
sweet in the stillness—Then too—the talk with Sam yesterday—an
old friend of Leah's—I think the army will get him soon—He wants
to argue about it and we won't argue—we just see he is going—He is
thirty-one—very Irish—It's queer—the different ways it gets different
folks [. . .]*

O'Keeffe to Stieglitz, April 30, 1918, Waring, Texas

[. . .] It had rained—the sky was a deep cloudy brilliant blue in the
east—Somehow making trees and bushes and hills and dirt at [the]
side of the road stand out warm and brilliantly against the blue-
ness—a queer deep blueness—The color was wonderful—Color
doesn't often thrill me—but I walked up the road—it's up hill—then
level—then up again to a wonderful view of valley and mountains
as you look back[23]—your letters in my hand—the first one open—
I not reading because the color of the world just seemed to go
through me and through me—I saw colors I had never seen before
[. . .] I'm getting to want to see you so bad I'm afraid I'll have to be
moving up that way [. . .] I've gardened and cooked and cleaned up
and sewed—and walked to town and back—In fact I've worked as
hard as I could all day—wanted to do it all—Leah didn't get up till
suppertime—I wouldn't let her—She laughed at me when I was too
tired to garden anymore and sat down and sewed [. . .] And you
know—I was laughing at myself—I remember days at 291[24]—many
men—or maybe just a few—standing about—the best way I can
express it is worrying over their souls—and I laughed to myself as
I went out with a grubbing hoe to get rid of some brush I'm waging
war on—What good use I could make of a lot of those long stand

around fellows if I could just get them to work a week—and how different the world would look to them in a week if they got out and dug and scratched around—A week wouldn't really be long enough—A month would be a short while [. . .]

O'Keeffe to Stieglitz, May 11, 1918, San Antonio, Texas

Friday night—more likely Saturday morning—I hear roosters crowing—foolishly drank coffee for supper and I can't sleep—Wrote the sister a long letter [. . .] Had two talks today—A long one with Mrs. Maury this morning—Five daughters and a son—son younger—a lieutenant—in Washington State holding down a camp of German-born American soldiers—rather—helping to hold it down—I made a remark about how age—weathering—improved her service flag—then my mind wandering on about flags I remarked that I thought the Russian colors so much nicer than ours—Then the circus began—Judith is in bad anyway because her husband has ideas[25]—And she is so afraid I'll get her in worse I guess—She finally hauled me off—but it wasn't dangerous at all as far as I could see—It's amusing to see what fear those girls have of her—I'm really curious—Judith thought she was getting ready to eat me and I didn't feel it at all—Judith said she didn't want to risk it—It was funny [. . .] An invitation to talk at another high school today but I didn't go—No more such stunts—

O'Keeffe to Stieglitz, May 21, 1918, Waring, Texas

[. . .] You can't imagine anything funnier than the combination of Leah, Strand, and myself—He is the most helpless, slow, unseeing creature I ever saw—Gosh—it's funny—He moves so slowly that we can hardly realize it's true—Really—country life—tending to all your own wants is wonderful for showing folks up—Leah and I just look at one another in amazement at times—I guess we are spoiled [. . .] I am almost afraid that you might spoil me like you seem to have spoiled Strand—if I let you—Only—I am both fortunate and unfortunate in being a woman—Some of the things they say make me feel like a fine blooded cow—My work—Gosh—folks are funny—I am trying to keep them from worrying you—Last night

after I had gone to bed—Leah lay across the foot of it—Strand across the corner—my head on him—his arm around me—I half asleep—He said my arm was very smooth—I wished he were someone I would let feel all of me—But I never could let him [. . .] I have written Mr. Cousins that I'll not return to Canyon this summer[26]—In a way maybe that is preferable to this—It never seemed that my painting was so important—or important at all—It was just something I wanted to do—had to do usually [. . .]

O'Keeffe to Stieglitz, May 25, 1918, Waring, Texas

Greetings—Your telegram last night—I guess Strand thinks me a hard-hearted wretch for—just going on after I read it—Laughing and talking—I had gotten up to make corn muffins for supper—in my kimono—because I wanted them—He didn't know what was in it and I didn't tell him—Talking seems to have become next thing to impossible—You are such a perfect god to him—I have to laugh—It seems to me secrets aren't necessary—Why not tell anybody anything—It ought to be possible to talk to anybody about anything—Leah and I do—He has made things three cornered though—So I said nothing till he and Lucy went to walk and Leah came and got in bed with me—He is improving though—I told him yesterday morning that he might just as well go home—That or something did him a lot of good—You see—Leah and I <u>move</u>—he wonders that we never rest—We are in the habit of doing things for ourselves and for others too—He has done very little even for himself [. . .] Leah remarked that she would like to get hold of his mother and tell her what she thinks of her for raising anything like that—Really—you can't begin to imagine how amazingly amusing and aggravating it has been—Then too it is largely my fault—I was too nice to him—it inflated his ego to such an extent that it made me contrary—So there you have it all [. . .]

I have set the end of the month as my day to be free—Leah's nephew is coming then so she won't be alone and I am going—I don't know where—I'm just going—I won't be bothered <u>anymore</u>. The Dutchman business bothers me[27]—I'm just going away [. . .] I don't look sick—Nothing hurts—It's just that moving seems to

be next thing to impossible—Maybe I'm only lazy [. . .] I feel a bit bad about what I write you because in a little while I'll be up stewing around the house—laughing—talking—I only send you the inside—

O'Keeffe to Stieglitz, May 29, 1918, Waring, Texas

[. . .] I think I have decided to go to New York—Am beginning to think I have to—

O'Keeffe to Stieglitz, June 3, 1918,
San Antonio, Texas [telegram]

Starting for New York tonight. Just told Leah goodbye. If I had let anybody or anything get in my way I wouldn't be going. It has to be this way. I don't know why. I don't know anything. Think I see straight yet see nothing. O'Keeffe.

Commentary

In this final chapter, O'Keeffe arrived in San Antonio, where she discovered more of a metropolitan urban space than Canyon or Amarillo, which she called a "motley mixed-up town" and wondered why "everyone doesn't live here." She found rest and relief, especially in the ability to stay away from "work" or teaching, which she said was impossible to do in Canyon. As in the Panhandle, she discovered natural landscapes and colors in South Texas that she "had never seen before," such as "wild green and blue and dirty yellow rolling over the dark green and blue hills," or different trees from the "scrubby" cedars of the arid Palo Duro Canyon, including the lush and floral fig, plum, and "Judas" trees. She began to want to paint again and during this time produced numerous watercolors in response to the places and people she saw. She also found the comfort of a family life with Leah Harris and her father, Mose, her brother Brack, and her sister Billie Mac, as well as friends such as Don Willard Austin, Sibyl Browne, and Lucy (whose last name remains unknown). Though O'Keeffe said

she desired solitude, she also seemed to thrive within this strong social support network. Still, the war made its presence known: she got stuck in the rain with cars full of soldiers from a nearby military camp; she learned that Lucy's family were pacifists who had joined Henry Ford's famous Peace Expedition in 1915–1916 and refused to buy war bonds but still had a son in France; she made offensive comments about another family's American flag, comparing it to the Russian flag, which she admired, a phrase that would not have been taken lightly during the very years of the Communist Revolution in Russia. And she talked about how the army would "get" her friends soon. Indeed, she was struck by "the different ways [the war] gets different folks," immersing itself into people's lives. She found relaxation in the chores of farming, seeing herself "waging war" on the bushes on Harris's land, and we see here her affinity for rural living, or "living out" as she called it, which would later inspire her to reside at Ghost Ranch and in Abiquiu in New Mexico. She often thought about returning to Canyon and teaching again, asking herself whether she should "hoe beans or misinform young and unprotected people." But in the end, she did not go back to the Panhandle or to teaching.

Then, after making an abrupt but decisive choice, she suddenly left farm life and her adopted family in Texas to be with Stieglitz in New York.[28] This chapter also discloses the strange romantic triangle that went on between Stieglitz, Strand, and O'Keeffe. Set on luring O'Keeffe back to New York, Stieglitz bizarrely sent the young, attractive artist Strand to San Antonio to retrieve her. Strand lived with O'Keeffe and Harris in Texas for months, spending intimate moments with O'Keeffe, as when the two lay together in bed, her head on him and his arm around her body. During this time, O'Keeffe continued to taunt Stieglitz with her descriptions of this intimacy, expressing that she wished she could "let [Strand] feel all of [her]." But she also mocked and insulted Strand in her letters to Stieglitz, describing how she would "[go] on" after reading Stieglitz's letters, "laughing and talking" until Strand thought her "a hard-hearted wretch." She wrote about how Strand was lazy and had an inflated ego, and how Harris wanted to "get hold of his mother" to tell her how poorly she had raised him. In O'Keeffe's

letters, we see very little of Strand convincing O'Keeffe to return to New York, and more of O'Keeffe suddenly coming to her own conclusion about leaving Texas and going to be with Stieglitz. And when she arrived in New York in early June 1918, she had turned a dramatic corner in her life. Though she couldn't have known it at the time, she would never again live in Texas, never again teach school for a living, never again speak publicly about education and war. And, until she moved permanently to New Mexico after Stieglitz's death in 1946, she would not live a life of her own control, where she could come and go as she wanted, paint when and what she wanted, and feel the freedom of independent agency over her own life that she so enjoyed in Texas.

Conclusion

This volume has focused on O'Keeffe's letters from Texas, demonstrating how, in these writings, her voice emerges as a powerful witness of her own life and of western America in a pivotal moment of its development, especially the turmoil-filled years of World War I. O'Keeffe's letters describe a time when rural life thrived alongside rising urbanization; when horse-powered vehicles and trains were still vitally important in conjunction with the new and exciting automobile; when young people could be alone and socialize in ways that threatened traditional values and gender roles; and when America geared up for and finally entered the war, making the Middle American homefront a complicated space for young men and women alike. O'Keeffe's letters address all this and much more. They are a pleasure to read and betray a wonderful sense of humor, a poignant exploration of grief and loss, and a poetic interpretation of space and place that is rivaled by very few. Her writings are sexy and even risqué when they tell of her romantic passions and her own body as a source of desire. They reveal the young O'Keeffe as a New Woman and a fighter for the future of the nation, a gifted teacher, mentor, and public speaker, a modernist who blended radical aesthetics with social activism. In this, her Texas letters represent one of the freshest perspectives on O'Keeffe as an artist whose biography has been studied and studied again. Through the lens of her Texas writings, we discover much more than simply O'Keeffe's life for its own sake. We find that O'Keeffe shares a voice of America, of history, and of hope.

Notes

Introduction

1. See, for instance, Kuh, *Artist's Voice*, 189; and Tomkins, "Profiles," 41–42.

2. Hereafter cited with the shorthand GOKW.

3. Counting the letters published in Sarah Greenough's *My Faraway One*, O'Keeffe wrote Stieglitz from Texas around ninety times, and there are many more letters in the Beinecke Library's Alfred Stieglitz/Georgia O'Keeffe Archive (hereafter ASGOA), with a good number of them being published first in this volume. O'Keeffe also wrote Paul Strand around seventeen times, Anita Pollitzer about twelve times, and Stieglitz's niece Elizabeth at least twice. So we are talking about more than two hundred letters penned from Texas. See Greenough, *My Faraway One*; Paul Strand, 1902–1976, AG 17, Center for Creative Photography, University of Arizona, Tucson, AZ; Peters, *Becoming O'Keeffe*, especially 183–92; Pollitzer, *Woman on Paper*, 145–61; and Giboire, *Lovingly, Georgia*.

4. Greenough, *My Faraway One*, 24–298.

5. See letters dated (postmarked) December 12, December 21, 1916; February 16, postmarked April 13, October 1, 1917.

6. In contrast to the conclusions of some biographers, O'Keeffe could not have been suffering from the Spanish flu at this time. See, for instance, Lisle, *Portrait of an Artist*, 83–84; Robinson, *Georgia O'Keeffe*, 192–94; Hogrefe, *Georgia O'Keeffe*, 95; Carlson and Becker, *Georgia O'Keeffe in Texas*, 22, 59, 62; and Scott, *Georgia O'Keeffe*, 26. The first flu cases occurred in the summer of 1918, and O'Keeffe's sickness occurred from November 1917 to the spring of 1918. On the deadly influenza of 1918 to 1919 as related to WWI, see Keene, *World War I*, 20, 165–68.

7. See especially Pollitzer, *Woman on Paper*.

8. O'Keeffe, *Georgia O'Keeffe*, text across from plate 2.

9. "Miss O'Keeffe is a graduate of the Art Institute of Chicago, completing her work at Pratt and as a member of the Art Students' League of New York City, under Mora, Chase, Nichols, and other artists" ("General Information about Our Schools," *Amarillo Daily News*, August 15, 1912). Though she attended the Art Institute, she never graduated with a degree from there and never attended Pratt. We still do not know whether the Amarillo newspaper simply got the details wrong or whether someone

(O'Keeffe or someone else) provided false information. The former seems the most likely.

10. "Amarillo, Texas, was the cattle-shipping center for a large area of the Southwest. Trains ran east and west and north and south. For days we would see large herds of cattle with their clouds of dust being driven slowly across the plains toward the town." O'Keeffe, *Georgia O'Keeffe*, text across from plate 2.

11. On O'Keeffe seeing Sneed, see Pollitzer, *Woman on Paper*, 103. Sneed's murder of two men—Al Boyce Sr. and Al Boyce Jr., the latter having run away with Sneed's wife, Lena—and the subsequent trials became a national sensation in 1912, especially when Sneed was acquitted in court for both crimes. See Neal, *Vengeance Is Mine*.

12. On the documented facts of this phrase, see Neal, *Getting Away with Murder*.

13. On her request for a raise, see John F. Matthews, "The Influence of the Texas Panhandle on Georgia O'Keeffe," in Carlson and Becker, *Georgia O'Keeffe in Texas*, 82.

14. On how "art training and employment as art teachers and commercial artists" were "viable pursuits for middle class white women" in 1900s America, see Grasso, *Equal under the Sky*, 14, 74–87; and Prieto, *At Home in the Studio*.

15. Claudia O'Keeffe (1899–1984).

16. It should be noted that she was a department of only one faculty member. Departments at West Texas State Normal College (hereafter WTSN) at the time were nearly all a faculty of one. See Hill, *More Than Brick and Mortar*; and Kuhlman, *Always WT*.

17. O'Keeffe to Pollitzer, February 25, 1916.

18. O'Keeffe to Stieglitz, September 8, 1916.

19. On April 3, 1917, at the art gallery 291, Stieglitz opened the *Exhibition of Recent Work—Oils, Watercolors, Charcoal Drawings, Sculpture—By Georgia O'Keeffe of Canyon, Texas.* See Greenough, *My Faraway One*, 130; and Pollitzer, *Woman on Paper*, 154.

20. O'Keeffe to Stieglitz, August 26, 1916, Craggy, North Carolina, as reproduced in Greenough, *My Faraway One*, 23.

21. O'Keeffe to Stieglitz, September 8, 1916. See also O'Keeffe to Stieglitz, February 16, 1917, on the newness of WTSN.

22. O'Keeffe to Stieglitz, September 8, 1916. Numerous oral interviews conducted with O'Keeffe's Texas students in the 1970s and 1980s are now archived in the Panhandle-Plains Historical Museum Research Center (hereafter PPHMRC). These interviews describe O'Keeffe's strengths as a teacher and mentor.

23. Ted Reid (1895–1983) was born in the Texas Panhandle to a family of ranchers and farmers. He went to the University of Texas at Austin for a short time and then returned to WTSN in 1916. He said it was "so hot" in Austin that he got "sick to his stomach." And though he had originally shunned the idea of attending "the Normal School" because he did not want to be a teacher, he ultimately decided it was the better option for him. He was never a direct student of O'Keeffe's but met her while the two were working on set designs for the college theater programs. Reid was an involved student. In September 1916, he was elected vice president of the senior class at WTSN. On Reid, see especially the uncataloged Ted Reid Family Papers at West Texas A&M University; A. Kirk Knott, interview with Ted Reid, PPHMRC, April 26, 1978, CS 1970–19/10a (hereafter Reid interview); and Hill, *More Than Brick and Mortar*, 318. On Reid according to O'Keeffe, see letters from May 9, postmarked June 8, June 16, postmarked June 19, postmarked June 25, July 1, August 6, October 18, 1917.

24. O'Keeffe to Stieglitz, October 18, 1917.

25. Pollitzer, *Woman on Paper*, 158; O'Keeffe to Stieglitz, August 15, 1917, New Mexico.

26. O'Keeffe to Stieglitz, postmarked February 28, 1917. See also Von Lintel, "'Little Girl of the Texas Plains,'" 21–56.

27. "Parties of young ladies and gentlemen should be properly chaperoned at all times. Auto rides at night or out of town at any time by boys and girls, or by young ladies and gentlemen who are college students, are considered grossly improper—an unpardonable college impropriety." On this and other restrictive rules, see Lowes and Jones, *We'll Remember Thee*, 41–42.

28. O'Keeffe to Stieglitz, postmarked October 16, 1916; January 2, 1917.

29. Reid interview.

30. On women walking or hiking alone, see letters from October 9, October 26, October 31, postmarked December 12, 1916; postmarked April 13, April 29, June 11, October 1, 1917.

31. O'Keeffe to Stieglitz, October 1, 1917.

32. On O'Keeffe hitchhiking on farmers' wagons, see O'Keeffe to Stieglitz, postmarked March 14, 1917. On Claudia hitchhiking on a truck loaded with baled hay, see O'Keeffe to Stieglitz, December 21, 1916.

33. On Claudia driving a motorcycle, see O'Keeffe to Stieglitz, December 21, 1916. On women driving cars, see letters from May 3, December 28, 1917; January 23, April 17, 1918.

34. On women shooting guns, see O'Keeffe to Stieglitz, December 21, 1916; February 16, 1917. Claudia even tried to use O'Keeffe's paintbrushes

to clean her gun. See O'Keeffe to Stieglitz, January 10?, 1917. On Claudia O'Keeffe playing tennis or ice skating, see letters from October 26, December 21, 1916; postmarked March 15, 1917. On Claudia riding horses, see O'Keeffe to Stieglitz, February 4, 1917.

35. O'Keeffe to Stieglitz, December 21, 1916.

36. O'Keeffe to Stieglitz, March 21, 1918. Though O'Keeffe had lived on a farm in Sun Prairie, Wisconsin, as a young girl, she had not worked on a farm since then; Harris had been raised through her adulthood on working farms and ranches. She also knew how to protect herself when living in an isolated place alone; she apparently never went to bed without her pistol nearby. See Pollitzer, *Woman on Paper*, 161.

37. "Typically imaged alone with her paintings or in nature, she was almost never seen in the company of other women" (Grasso, *Equal under the Sky*, 16). O'Keeffe even shows proclivities for this rejection of other women and their needs in her Texas years. For instance, she hopes that Susie Ackerman, whom she saw as overfed and underexercised, with a "stupid" attitude on life, "gets what's coming to her" in a fight with her husband. See O'Keeffe to Stieglitz, November 20, 1917.

38. Grasso, *Equal under the Sky*, 68. Here she quotes O'Keeffe to Stieglitz, November 13, 1916. Grasso also writes: "O'Keeffe was unmarried, mobile, and an independent wage earner, a quintessential New Woman" (13).

39. Grasso, 4, 6.

40. O'Keeffe to Stieglitz, September 20; October 9, 1916. On women, the West, and its particular gendered experiences, see especially Grauer, *Madonnas of the Prairie*; Von Lintel and Roos, "Expanding Abstract Expressionism," 52–79; and GOKW.

41. O'Keeffe to Stieglitz, postmarked October 16, 1916.

42. O'Keeffe to Stieglitz, postmarked October 16, 1916.

43. O'Keeffe to Stieglitz, June 29, 1917.

44. O'Keeffe to Stieglitz, November 13, 1916.

45. Her show opened on April 3, and war was declared on April 6. On Gallery 291, see especially Greenough, *Modern Art and America*.

46. On this, see Greenough, *My Faraway One*, 148.

47. Greenough, *My Faraway One*, 149; Pollitzer, *Woman on Paper*, 156.

48. Stieglitz to O'Keeffe, June 1, 1917, as reproduced in Greenough, *My Faraway One*, 151.

49. O'Keeffe to Strand, November 15, 1917.

50. On O'Keeffe's pacifism, see, for instance, Lisle, *Portrait of an Artist*, 82–84; Robinson, *Georgia O'Keeffe*, 193; Carlson and Becker, *Georgia O'Keeffe*

in Texas, 21–22; Kuhlman, *Always WT*, 84–87; Stoker, *Georgia O'Keeffe in Canyon*, 22; Eldredge, *Georgia O'Keeffe*, 31; Constantino, *Georgia O'Keeffe*, 23; Griffin, *Georgia O'Keeffe*, 31; and Scott, *Georgia O'Keeffe*, 69.

51. Stieglitz's supposed pacifism deserves its own careful study. He, like O'Keeffe, was conflicted in his attitude toward the war but from a much different perspective.

52. Other contenders for this title include the Dallas-based Frank Reaugh. See Grauer, *Rounded Up in Glory*.

53. Kandinsky, *Art of Spiritual Harmony*. O'Keeffe's letter to Stieglitz on January 14, 1918, stated that she had read this book by Kandinsky "or something like that" and remembered "it was blue in color" and that she had "lent it to a friend." See also Greenough, *My Faraway One*, 1, 235; and Scott, *Georgia O'Keeffe*, 65, 73.

54. *Art Institute of Chicago*, 254. In another interesting connection, Stieglitz sent Eddy's book *Cubists and Post-Impressionism* (1914) to O'Keeffe in Canyon. See O'Keeffe to Stieglitz, November 27, 1916, as reproduced in Greenough, *My Faraway One*, 82.

55. *Blast* was published in only two editions: July 1914, right before the war began in August; and July 1915. The poet Ezra Pound, whose work was included in *Blast*, called the original pink cover the "great MAGENTA cover'd opusculus." On Vorticism, see Wees, *Vorticism and the English Avant-Garde*; Cork, *Vorticism and Abstract Art*; Farrington, *Wyndham Lewis*; and www.vorticism.co.uk. On Futurism, see especially Poggi, *Inventing Futurism*; and Perloff, *Futurist Moment*.

56. In O'Keeffe to Stieglitz, postmarked April 13, 1917, she writes "American Art News calls me a 'Futurist.'" Though she doesn't seem to like this label, the connection is worth noting here.

57. O'Keeffe to Stieglitz, July 1, July 13, 1917.

58. O'Keeffe's public lectures, held at "Faculty Circle" or during Chapel Hour at WTSN, began in January 1917. For instance, at this first lecture, she spoke on modern art and Cubism. However, after April 1917, her lectures became even more vehement and she used violent and warlike language to describe them in her letters. See O'Keeffe to Stieglitz, December 7, December 10, 1917; January 2, 1918.

59. O'Keeffe to Strand, November 15, 1917.

60. O'Keeffe to Stieglitz, December 7, 1917. See also O'Keeffe to Stieglitz, December 19?, 1917.

61. See Marinetti, "Foundation and Manifesto of Futurism," *Le Figaro*, February 20, 1909, reproduced in Herschel B. Chipp, *Theories of Modern Art*, 284–89.

62. On the incredible attrition of soldiers during WWI, see Eksteins, *Rites of Spring*, 143–55; and Keene, *World War I*, 12, 20.

63. Boccioni was wounded on the battlefield in 1915 and then died while convalescing; Sant'Elia was killed in the Battle of Monfalcone in 1916. Vorticists such as Henri Gaudier-Brzeska were also killed in the war. Likewise, the German Expressionist artist Franz Marc was killed in 1916 during the Battle of Verdun, while the Cubist Georges Braque served in the French army in 1915 and suffered a head trauma that required trepanation. According to Keene, "By the time America entered the war there were few remaining illusions about the horror of industrialized warfare." *World War I*, 2.

64. On the profound connections between art and war during the WWI era, which reached even into letters of soldiers from the frontlines and therefore defined a particularly modern consciousness, see Eksteins, *Rites of Spring*, especially 93–94, 208–23.

65. See Marinetti, "Foundation and Manifesto"; and Lewis, "Vorticist Manifesto."

66. O'Keeffe to Stieglitz, April 24, 1917. On the ways women contributed to the war, primarily on the home front but also on the battlefields of Europe, see Keene, *World War I*, 113–20.

67. On Alexis O'Keeffe (1892–1930), see especially O'Keeffe to Stieglitz, November 13, 1916; and O'Keeffe to Strand, June 3, 1917.

68. "On 5 June 1917, 10 million men between the ages of 21 and 30 registered amid patriotic festivals throughout the nation. Ship horns, church bells, and factory whistles rang out in cities and towns to announce the start of registration, and many families accompanied their sons, husbands, and brothers to the designated registration sites. Officials had focused so much attention on potential resistance to the draft that they were unprepared, yet pleasantly surprised, to discover that complaints instead came from men who had to wait for hours in long lines to complete the registration process. In some areas, men camped out overnight to be the first to register from their neighborhoods, with much shoving, pushing, and occasional fistfights in the morning over who would receive this honor." Keene, *World War I*, 35.

69. O'Keeffe to Stieglitz, February 8, 1918.

70. O'Keeffe to Strand, November 15, 1917.

71. Fifteen percent of the US male population served in the military between April 1917 and the armistice in November 1918, which added up to an army of over 4 million men, 2 million of whom were transported to Europe, and 1 million of whom saw combat on the Western Front in Europe. Of the total 14 million deaths in the war (with British military losses at 900,000; French at 1.3 million; German at 1.6 million; and Russian at 1.7

million), American military casualties reached, in six months of battle, 53,402 men. However, this totaled an average of 820 American losses per day, which was between the daily average total losses of France (at 900) and Britain (at 457). See Keene, *World War I*, 1–2, 11, 25.

72. About windmills and homes against the horizon, O'Keeffe wrote: "Sat on the end of the porch—quiet—just a little wind in the little locusts—windmills—very fine and lace-like—and the line of little houses against a quiet cloudless sunset—all so quiet." See O'Keeffe to Stieglitz, September 26, 1916, as reproduced in Greenough, *My Faraway One*, 35. On windmills, see also O'Keeffe to Stieglitz, July 1, July 13, 1917.

73. On O'Keeffe and cattle country, see letters from September 20, November 4, November 30, postmarked December 12, 1916; March 11, postmarked April 13, October 1, October 18, 1917.

74. O'Keeffe to Stieglitz, May 1, 1917.

75. So Reid could have, at this point in May, been hoping to receive official permission to avoid the draft because of his ranch work. On the draft for WWI, called "selective service," and the ability of skilled agricultural workers to get deferment from fighting, see Keene, *World War I*, 34–36; Kennedy, *Over Here*, 148; and Nall, "Agricultural History of the Texas Panhandle," 119–21.

76. O'Keeffe to Stieglitz, May 9, 1917. "River Guard" probably meant National Guard.

77. Reid joined the Air Service within the US Army Signal Corps, serving for fourteen months during the war, between 1917 and 1919. The US Army Air Service officially became its own warfare division in 1920, then the US Army Air Corps during WWII, and finally the US Air Force in 1947. "I wasn't about to be drafted," he said, so he made his application to the Signal Corps. In September 1918, Reid married his hometown girlfriend Ruby Fowler, who had been a student of O'Keeffe's in Texas. See Reid interview. During the war, Reid was never deployed overseas, largely because of his severe color blindness; but he worked stateside for the Signal Corps assembling JN-4D planes, or "Jennies," which he test piloted and used to develop his aviation skills. After the war, he served in the Army Air Corps Reserves as a flight instructor and then in WWII as a captain, again teaching flight school. Jan Minton, Reid's granddaughter, shared these details with me in an interview on July 8, 2018, as well as an anecdote about the only time Reid said he "got high" from the "banana glue" used to glue the balsawood Jennies together.

78. "When the cattle arrived they were put in pens near the station, separated from their calves and sometimes kept there for two or three days.

The lowing of cattle was loud and sad—particularly haunting at night [. . .] The cattle in the pens lowing for their calves day and night was a sound that has always haunted me. It had a regular rhythmic beat like the old Penitente songs, repeating the same rhythms over and over all through the day and night. It was loud and raw under the stars in that wide empty country." O'Keeffe, *Georgia O'Keeffe*, text accompanying plates 2 and 3.

79. O'Keeffe to Stieglitz, April 19, 1917. As Keene explains, "The composition of [the] draft boards put the local professional elite firmly in control of deciding the fate of each community's lower and working classes." In other words, WWI in America was seen as "a rich man's war, poor man's fight." *World War I*, 36–37.

80. O'Keeffe to Stieglitz, April 24, 1917.

81. See, for instance, Carlson, *Empire Builder in the Texas Panhandle*.

82. It is worth comparing O'Keeffe's remarks not only to the writings of Marinetti that celebrated the motorcar as more beautiful than the Nike of Samothrace, but also to the words of Kaiser Wilhelm II of Germany in his 1906 speech when he heralded "the century of the motorcar." The symbolic and cultural importance of the car for modern consciousness in the war era cannot be overstated. However, the distinction that O'Keeffe made between car drivers and fighting soldiers had its exceptions: Reid, for instance, was driving his parents' car on his family farm by 1908 when he was around thirteen years old, and he often drove O'Keeffe around the region before he left for the war as a soldier. See Eksteins, *Rites of Spring*, 88; and Reid interview.

83. O'Keeffe to Stieglitz, December 28, 1917.

84. O'Keeffe to Stieglitz, December 28, 1917; Marinetti, "Foundations and Manifesto."

85. See, for instance, Lisle, *Portrait of an Artist*, 83; Robinson, *Georgia O'Keeffe*, 190–94; Eldredge, *Georgia O'Keeffe*, 31; Hogrefe, *Georgia O'Keeffe*, 89; and Flores, *Caprock Canyonlands*, 128.

86. O'Keeffe to Stieglitz, April 19, 1917.

87. O'Keeffe to Stieglitz, postmarked January 8, 1918.

88. Regarding this policy, where young men received credit and degrees for graduation early if they enlisted, see Reid interview. Reid related that O'Keeffe had told him in 1917 to wait out the summer and finish his credits at the college before enlisting. "The war will still be going on when the summer's over," she apparently told him. "Stay here and get your work done, then go in." Reid said he would have done so anyway but he sincerely appreciated her advice at the time.

89. Eksteins, *Rites of Spring*, 228–29. See also Fussell, "Enemy to the Rear," in *The Great War*, 90–98.

90. Eksteins, *Rites of Spring*, 229.

91. See Lisle, *Portrait of an Artist*; Robinson, *Georgia O'Keeffe*; Constantino, *Georgia O'Keeffe*; and Griffin, *Georgia O'Keeffe*; as well as Frazier, *Georgia O'Keeffe*; Benke, *Georgia O'Keeffe*; and Drohojowska-Philp, *Full Bloom*.

92. O'Keeffe to Stieglitz, October 18, 1917.

93. O'Keeffe to Stieglitz, December 28, 1917.

94. O'Keeffe to Stieglitz, February 18, 1918.

95. O'Keeffe to Stieglitz, December 14, 1917.

96. O'Keeffe to Stieglitz, October 29, 1917. See also O'Keeffe to Stieglitz, February 8, 1918, when she writes that she craved adventure enough to "envy" her brother's close escape from death.

97. O'Keeffe to Strand, October 30, 1917.

98. O'Keeffe to Stieglitz, postmarked January 14, 1918.

99. O'Keeffe to Stieglitz, December 14, 1917.

100. O'Keeffe to Stieglitz, postmarked December 19, 1916. On her struggles with chasing designs, see also O'Keeffe to Stieglitz, postmarked June 26, 1917, where she writes: "The sunset I saw last night—Anything to get the feeling of the sky-line—No, I didn't get it." See also letters from October 9, November 13, December 21, 1916; postmarked March 14, postmarked March 27, postmarked April 24, June 14, June 16, postmarked June 22, postmarked October 5, 1917; March 14, 1918.

101. O'Keeffe to Stieglitz, postmarked March 26, 1917; GOKW, plates 8, 10, 13, 18, 41, 42, 45; CR, 199–206.

102. Russell, *Why Men Fight*. The lack of mentions of war in O'Keeffe's letters prior to April 6, 1917, and then a sudden preoccupation with the topic after that date, is not surprising. As Keene explains, "During the period of neutrality, the United States made few preparations for war and consequently the declaration of war initiated a frenzied effort to raise, train, equip, and transport a mass army capable of fighting on the Western Front." *World War I*, 29.

103. She wrote to Pollitzer in October 1916 about landscapes painted "out where the canyon begins" and described them as "slits in nothingness" that are "not very easy to paint." See Pollitzer, *Woman on Paper*, 147; and Giboire, *Lovingly, Georgia*, 207. She mentions and draws the X shape at the center of this composition in O'Keeffe to Stieglitz, postmarked March 26, 1917, putting the date of the painting somewhere around that date. See figure 19 in this volume.

104. O'Keeffe to Stieglitz, September 3, 1916.

105. O'Keeffe mentions the color red many times in her letters. See,

for instance, O'Keeffe to Stieglitz, September 20, November 4, postmarked December 12, 1916; postmarked March 26, postmarked March 27, May 3, July 13, 1917.

106. O'Keeffe to Stieglitz, July 13, 1917. She continued: "One of the funniest things is that I haven't made a single one that begins to compare in nakedness with the feeling of nakedness in a landscape." In addition to figure 4 in this volume, see also GOKW, plates 1, 6, 9, 16, 22, 23, 29, 33, 39; and CR, 176–88.

107. O'Keeffe to Stieglitz, October 18, 1917.

108. Reid interview.

109. O'Keeffe wrote several letters about her opinions of Nietzsche. See letters on February 4, postmarked February 28, postmarked March 11, postmarked March 15, 1917. On Nietzsche's impact and the surprising diversity of his readership in early twentieth-century America, see Ratner-Rosenhagen, *American Nietzsche*.

110. O'Keeffe to Elizabeth Stieglitz, January 1918.

111. O'Keeffe to Stieglitz, April 29, 1917. Another German American was arrested in Canyon around that time for owning a picture of the Kaiser. See also O'Keeffe to Stieglitz, February 8, 1918, when her friend Mrs. Reeves discovered that O'Keeffe's translation of van Gogh's letters was from German and she "dropped it as though it had burned her," behavior O'Keeffe found "stupid."

112. O'Keeffe to Stieglitz, April 24, 1917.

113. O'Keeffe to Stieglitz, December 2, 1917. On life in the American training camps, including the meeting facilities that were provided for family members to visit the soldiers, as well as on the training of officers, see Keene, *World War I*, 40–49, 85; and Faulkner, *School of Hard Knocks*.

114. O'Keeffe to Stieglitz, February 8, 1918. His ship was the *Tuscania*, which was struck by German U-boat torpedoes on February 5, 1918, resulting in the death of 150 soldiers. British soldiers and the rest of the Anchor Fleet fought valiantly to save the remaining men. See Scott, *Georgia O'Keeffe*, 69–70. On the "extremely stormy winter" of 1917 and 1918 and its effects on ships transporting US soldiers to Europe, see Keene, *World War I*, 124–25.

115. "Their younger sister Catherine remembered that he took a full year to recuperate, but his health was broken and he died in January 1930 at the untimely age of 38." Scott, *Georgia O'Keeffe*, 70.

116. O'Keeffe to Stieglitz, December 2, 1917.

117. O'Keeffe to Stieglitz, December 2, 1917.

118. On Hassam's paintings and the context of art and the war in New York City, see Fort, *Flag Paintings of Childe Hassam*.

119. On Church's painting, see Burke, "Frederic Edwin Church," 39–46; and Newberry Library, "Home Front: Daily Life in the Civil War North; Our Banner in the Sky," http://publications.newberry.org/digitalexhibitions/exhibits/show/homefront/introduction/introbanner.

120. As Kennedy notes, "It is easy to forget how vivid the Civil War seemed to Americans in the World War I era." See Kennedy, *Over Here*, 178.

121. For O'Keeffe's descriptions of trains, see letters from November 30, postmarked December 19, 1916; April 29, November 20, 1917; and O'Keeffe to Elizabeth Stieglitz, January 1918. In addition to figure 16 in this volume, see also GOKW, plate 3.

122. O'Keeffe to Stieglitz, April 19, 1917.

123. On Pershing and the independence of the American military, see Keene, *World War I*, 11–12. Exceptions to this include the regiments called the "Harlem Hellfighters" and the "Harlem Rattlers," which were African American troops under French command and among the first US soldiers to fight in the war.

124. Tomkins, "Profiles," 42–43.

125. On this painting and its gendered, nationalist, and Christian symbolism, see Griffin, *Georgia O'Keeffe*, 99–100.

126. O'Keeffe to Strand, November 12, 1917, as reproduced in Peters, *Becoming O'Keeffe*, 188.

127. O'Keeffe to Stieglitz, October 1, 1917.

128. O'Keeffe to Stieglitz, October 29, 1917.

129. O'Keeffe to Stieglitz, June 14, 1917.

130. O'Keeffe to Stieglitz, April 24, 1917.

131. O'Keeffe to Stieglitz, postmarked January 31, 1918. Indeed, she used such phrases at least ten times in letters written after the declaration of war in April 1917.

Chapter 1

1. Pollitzer, *Woman on Paper*, 126; Giboire, *Lovingly, Georgia*, 123.

2. O'Keeffe is haggling with Robert Bartow Cousins (1861–1932), founding president of WTSN. On Cousins and his ability to recruit excellent faculty members to the isolated Texas Panhandle, see especially Hill, *More Than Brick and Mortar*, 10–17. On Cousins according to O'Keeffe, see letters from October 26, 1916; February 16, October 1, 1917; postmarked January 3, January 20, January 31, postmarked January 31, 1918.

3. When O'Keeffe sold her charcoal version of this train in Canyon to Jacob Dewald, a friend of Stieglitz's, in 1917, the work was given the name *Train at Night in the Desert*. But when the watercolor version was acquired

at the Amarillo Museum of Art after O'Keeffe's death, it included a reference adhered to the frame giving the title *Train Coming In, Canyon, TX*. I use this title, rather than the one in the catalogue raisonné, with permission from the Georgia O'Keeffe Museum and the Amarillo Museum of Art. See CR, 128–30.

4. Here she refers to Arthur Wesley Dow as "Pa Dow," whose methods course at Columbia University Teachers College she was required to take before starting at WTSN.

5. This telegram was from Cousins at WTSN. "T. C." is Columbia University Teachers College.

6. Here we learn that she was paid $1,800 per year at WTSN.

7. O'Keeffe painted several pictures of the houses in Canyon. In addition to figure 3 in this volume, see GOKW, plate 40 (*Morning Sky with Houses*, 1916); CR, 127.

8. The "lake" here is Lake George. On Stieglitz's family home at Lake George and the time O'Keeffe spent there, see Coe, Owens, and Robertson, *Modern Nature*.

9. See also GOKW, plates 2 (*Starlight Night*, 1917), 7 (*Light Coming on the Plains No. II*, 1917), 12 (*Sunrise*, 1916), 17 (*Light Coming on the Plains No. I*, 1917), 21 (*Sunrise and Little Clouds No. II*, 1916), 31 (*Morning Sky*, 1916), 41 (*Evening Star No. I*, 1917), and 46 (*Light Coming on the Plains No. III*, 1917); CR, 131–32, 134, 199, 207, 209–11.

10. She is referring to her time living and working in Amarillo, between 1912 and 1914.

11. On the fire of the original Old Main at WTSN in 1914, see Hill, *More Than Brick and Mortar*, viii, 54–58; and Kuhlman, *Always WT*, 30–32.

12. This swimming pool was in the basement of the only building on campus at the time, called "Old Main," which was also the location of O'Keeffe's office and classroom. It was the first college-owned indoor swimming pool in Texas. See Hill, *More Than Brick and Mortar*, 295. O'Keeffe mentions this pool again in letters to Stieglitz postmarked June 22, 1917, and June 29, 1917.

13. Claudia O'Keeffe.

14. Here she refers to Palo Duro Canyon. See figure 12 in this book, as well as GOKW, plates 24, 47–50; CR, 135–60.

15. See GOKW, plate 37 (*Canyon with Crows*, 1917); CR, 197.

16. She describes riding in a car here, when she uses the word "rode."

17. Susie Ackerman. On Susie Ackerman according to O'Keeffe, see letters from November 13, 1916; January 2, 1917.

18. September 15, 1916, was Canyon Day at the Panhandle State Fair, and WTSN observed a holiday where classes went together from the Santa

Fe depot in Canyon to the fairgrounds in Amarillo. It is likely that O'Keeffe attended the fair during this organized visit for the college. See Hill, *More Than Brick and Mortar*, 317.

19. J. F. McGregor was her miner friend from Alaska. He was secretary-treasurer of the Panhandle State Fair in 1916 and president of the Amarillo Real Estate Exchange, and he had been treasurer of Potter County in 1914, when O'Keeffe lived in Amarillo. See Greenough, *My Faraway One*, 32n71.

20. For these "rivers" as they appear in her art, see GOKW, plate 5 (*Hill, Stream, and Moon*, 1916–17); CR, 162.

21. Charles C. Ackerman, her landlord at the time. On Ackerman according to O'Keeffe, see also O'Keeffe to Stieglitz, September 24, 1916.

22. It is interesting that O'Keeffe paints numerous sunrises, according to her titles, but very few sunsets at this time. For her sunrises, see GOKW, plates 7, 12, 17, 20, 21, 31, 40, 46; CR, 127, 131–34, 175, 209–11. However, her *Evening Star* series likely represents her views of Texas sunsets. See figure 11 in this volume, as well as GOKW, plates 8, 10, 13, 18, 41, 42, 45; CR, 199–206.

23. According to Greenough, this trial concerned the case of Oscar I. Smith shooting and killing Claude Powell, while the man "shot" was Sam Reynolds, a crime for which his wife, Florence, was found guilty. See Greenough, *My Faraway One*, 33n74. On the "frontier justice" of the Texas Panhandle, which lasted past the early frontier days and into the twentieth century, see Neal, *Getting Away with Murder*.

24. On O'Keeffe and her progressive way of dressing, including wearing a "kimono," see Corn, *Georgia O'Keeffe*.

25. The WTSN Training School was a "practice school" for the student-teachers to work with students in nine grade levels; in 1917–1918, for instance, 270 students attended the school. See Hill, *More Than Brick and Mortar*, 258–70; and Kuhlman, *Always WT*, 91–96.

26. She is referring here to a "norther," a strong cold wind from the north that occurs mainly in fall and winter on the High Plains.

27. Ralph Ackerman, her landlords' son, who was high school-age at the time.

28. Possibly GOKW, plate 51; CR, 166.

29. Joseph Abner Hill (1877–1973) was head of the history department in 1916–1917, and when Robert Cousins left the position, Hill became the second president of WTSN in 1918. J. A. Hill Memorial Chapel on the college campus was dedicated in 1950. See especially Hill, *More Than Brick and Mortar*.

30. GOKW, plates 24, 37; CR, 197, 198.

31. WTSN students and faculty were required to go to a daily chapel

hour, where each person had an assigned seat so absences could be noted. The hour began with a hymn, a prayer, and a reading from biblical scripture. Then the audience would hear a presentation that could include lectures on spiritual and moral topics, but also cultural topics such as music and art. As Kuhlman notes, many colleges in America at the time included a compulsory chapel hour, and it was only in the 1920s that this practice was widely contested. Kuhlman also demonstrates that O'Keeffe was not the only one at WTSN trying to get out of her chapel hour; students complained in the school newspapers, and some even schemed to get someone to sit in their chair so they could skip without consequences. See Kuhlman, *Always WT*, 53–54.

32. Robert Bartow Cousins, as in n. 2, chap. 1.

33. Presumably Benjamin Alvis Stafford, the head of the Latin department, whom O'Keeffe always referred to as "fat" (Hill, *More Than Brick and Mortar*, 42). On Stafford according to O'Keeffe, see letters from November 4, November 13, 1916; postmarked October 5, December 7, December 14, 1917.

34. On the long wool coats that O'Keeffe wore in Texas, see GOKW, figures 2 and 24, where photographs from the Georgia O'Keeffe Research Center collection are reproduced.

35. On O'Keeffe's copy of Wolfgang von Goethe's *Faust: A Tragedy*, translated by Bayard Taylor (1912–13), which included handwritten notes from Stieglitz and sketches by O'Keeffe, see Tori Duggan, "It's A Sketch!," Georgia O'Keeffe Museum, April 26, 2016, https://www.okeeffemuseum.org/its-a-sketch/.

36. GOKW, plate 2; CR, 207.

37. On O'Keeffe and the pockets in her clothing, which were apparently a novelty to the people of Canyon, see letters from March 11, postmarked March 15, postmarked March 27, 1917.

38. *Seven Arts* was a short-lived radical periodical that ended in 1917. See Kennedy, *Over Here*, 51. O'Keeffe mentions reading this periodical again in O'Keeffe to Stieglitz, February 4, 1917, as reproduced in Greenough, *My Faraway One*, 104.

39. GOKW, plate 2; CR, 207.

40. She refers here to a production of Israel Zangwill's *The Melting Pot: Drama in Four Acts* (1914), performed in Amarillo. See Greenough, *My Faraway One*, 56n127.

41. Claudia O'Keeffe.

42. GOKW, plate 2; CR, 207.

43. She refers here to the paintings of Marsden Hartley (1877–1943), another artist in Stieglitz's 291 circle.

44. Stafford (see n. 33, chap. 1), was the head of the Latin department,

whereas J. W. Reid was head of the physics and chemistry department. See Hill, *More Than Brick and Mortar*, 40–43.

45. Here she refers to painting sets for the WTSN theater department.

46. These *Courses of Study* were the curriculum guides for WTSN.

47. Claudia O'Keeffe.

48. Alexis O'Keeffe (see n. 67, introduction).

49. The head of the English department was Horace Wilson Morelock. See Hill, *More Than Brick and Mortar*, 38–39. On President Cousins, History (Hill), and Chemistry (Reid), see n. 2, n. 29, and n. 44, chap. 1, respectively.

50. The presidential campaign between the Republican candidate Charles Evans Hughes and the Democrat Woodrow Wilson was, according to David M. Kennedy, "particularly bitter, revealing the depth of the divisions in American society." Wilson exploited the issue of "100 percent American-ism" regarding the forced assimilation of millions of immigrants living in the United States, as well as the slogan "He Kept Us Out of War," and won by a very narrow margin. See Kennedy, *Over Here*, 12.

51. This could possibly be a description of her first encounter with Ted Reid. (On Reid, see n. 23 and n. 77, introduction).

52. GOKW, plates 3, 19; CR, 129–30.

53. On her works that respond to Palo Duro Canyon, see n. 14, chap. 1.

54. Possibly GOKW, plate 12; CR, 131.

55. On her works with these straight and stark horizons, see GOKW, plates 2, 7, 12, 17, 21, 31, 46; CR, 131–32, 134, 207–11.

56. On her works with clouds and either sunrises or sunsets, see GOKW, plates 20, 21, 31, 40; CR, 127, 133–34.

57. See n. 55, chap. 1.

58. She likely refers to her *Evening Star* series; see n. 22, chap. 1.

59. See n. 52, chap. 1.

60. Possibly Ferdinand Paul Guenther (d. 1925), who was a professor of geography and modern languages. The daughter that O'Keeffe mentions was likely Margaret Guenther, who is recorded as having performed as a singer at a WTSN recital in late 1918. See Hill, *More Than Brick and Mortar*, 34–35, 319. O'Keeffe's observations on this woman's German nationality highlight how many German Americans were living in the American West in the WWI era. Many would be severely mistreated once America entered the war, espe-cially in Middle America. For instance, after April 1917, German-language studies were banned from many US schools, while instructors of German were seen as "traitors." At least in Iowa, the speaking of German was banned on streetcars, in public places, and over the telephone. See Kennedy, *Over Here*, 54–55, 68. See also n. 111, introduction.

Chapter 2

1. Susie Ackerman, as in n. 17, chap. 1.

2. She refers here to Rector Llano Lester (1887–1975). He was Yale edu-cated and was the Randall County prosecuting attorney. He was the son of L. T. Lester, who was the president of the First National Bank in Canyon and an early contributing founder of WTSN. See Hill, *More Than Brick and Mortar*, 16; and Greenough, *My Faraway One*, 757.

3. She refers to her talk on Cubism for the Faculty Circle. See her earlier letter from November 13, 1916.

4. WTSN was the first college in Texas to offer a twelve-week summer school. See Hill, *More Than Brick and Mortar*, 295. In O'Keeffe to Stieglitz, postmarked September 18, 1917, ASGOA, O'Keeffe describes how the sum-mer school had more than twice as many students as in fall session. Working teachers used the summer to take courses at WTSN.

5. This statement is one of a number of O'Keeffe's comments regarding race in her Texas letters. In another instance, in O'Keeffe to Stieglitz, post-marked December 26, 1916, ASGOA, she described how she "scolded" her sister "royally" for not picking up her things in their rented room. O'Keeffe continued: "Niggers don't grow on bushes here—and I can't stand things out of place and I've been picking up for two ever since she has been here." See also O'Keeffe to Stieglitz, postmarked March 26, 1917, third letter from that date, ASGOA, where she talked about a writing entitled "Nigger" and how it was "great" and made her "laugh all over." She wrote: "It's so like the black things. They are so queer [. . .] A really idiotic nigger sometimes says or does things that for a moment makes you wonder is it he or I that's the fool." These statements must be understood in the context of their time; WTSN, for example, was established in 1910 as a school only for "the education of white teachers." Strict racial segregation was the standard in Texas in the 1910s, and only in the 1950s were black students allowed to attend WTSN. See Hill, *More Than Brick and Mortar*, 14, 47. For O'Keeffe's other letters dealing with race, see O'Keeffe to Stieglitz, January 5, 1918, as reproduced in Greenough, *My Faraway One*, 232, and February 12, 1918. For a study on the Stieglitz circle artists and race, see Kroiz, *Creative Composites*.

6. This statement appears to foreshadow her future decision, in late spring 1918, to leave her teaching career and move to New York to focus on her art with the financial support of Stieglitz.

7. Lloyd Green "Lanky" Allen was head of the mathematics department and developed WTSN's "course of study," or curriculum. See Hill, *More Than Brick and Mortar*, 34.

8. She refers here to the University of Virginia wanting her to come back and teach summer school again.

9. They were moving into the home of Dr. Douglas Alfred Shirley, professor of physics, head football coach, and later dean of WTSN. See Kuhlman, *Always WT*, 508. This home was at 500 Twentieth Avenue in Canyon; it was dedicated as a Texas Historic Landmark on October 13, 2018.

10. Don Willard Austin (1878–1953) was a married insurance salesman from Amarillo. See Greenough, *My Faraway One*, 104n223, 743. On Austin according to O'Keeffe, see letters from February 28, postmarked February 28, postmarked March 15, postmarked March 26, postmarked June 22, 1917; February 18, March 6, March 21, April 6, 1918.

11. There was a movie theater in Amarillo, but a "modern motion picture machine" was also installed in the WTSN auditorium in September 1916 and films were screened on Saturday nights. See Hill, *More Than Brick and Mortar*, 317.

12. There are rumors among Canyon locals that O'Keeffe had asked the Shirleys whether she could paint her room black. See Stoker, *Georgia O'Keeffe in Canyon*, 10. I have found no mention of this desire in O'Keeffe's extant letters.

13. On this wartime era and the desire for a unified consciousness and "correct" opinions in the United States, especially through public education, see Kennedy, *Over Here*, 46–47, 54–59.

14. Heyser is Fred Theodore Heyser (1894?–1963?), a senior at WTSN in 1917. See Greenough, *My Faraway One*, 113n246.

15. "Mattie B" is likely Mattie B. Hume, a junior at WTSN at the time. Greenough, *My Faraway One*, 112n243.

16. This is likely Mary Adaline Lamb, head of the Training School. Lamb was also one of the first women faculty members at WTSN to own a car. See Hill, *More Than Brick and Mortar*, 261; Lowes and Jones, *We'll Remember Thee*, 146.

17. Fred is Fred Theodore Heyser, as in n. 14, chap. 2.

18. On the rules regarding chaperones at all school activities, see Lowes and Jones, *We'll Remember Thee*, 41–42.

19. Davis is J. Lyman Davis (1897–1988?), a senior at WTSN in 1917. Greenough, *My Faraway One*, 128n277.

20. Beverly is likely Beverly B. Sportsman, a senior at WTSN. Greenough, *My Faraway One*, 113n247.

21. GOKW, plate 2; CR, 207.

22. On O'Keeffe's modern fashion, see Corn, *Georgia O'Keeffe*.

23. Here she refers to the Douglas Shirley house, as in n. 9, chap. 2.

24. B. A. Stafford, as in n. 33, chap. 1.

25. This yellow car was owned by Don Willard Austin, as in n. 10, chap. 2.

26. Oscar Seagle was a baritone singer popular at the time. He recorded numerous songs with Columbia Records.

27. The Country Club was the Palo Duro Club, which was founded around 1905, when local residents, including Tom Currie and Charles Wolflin, purchased the land in shares from the Santa Fe Railroad Company. The company sold off the land when it no longer needed it for railroad development. The new shareholders built cabins on the land and a shelter over the natural spring, making it a sort of resort or "club" for the owners. The plots are largely still owned today by descendants of the earliest owners. The land includes the most northwestern section of Palo Duro Canyon. On the Palo Duro Club, see Cornelia Wolflin Patton, oral interview with Al Kochka, March 24, 1986, Cs 1987 73/1, PPHMRC; and Pattilou Dawkins (grand-niece of Patton), interview with the author, April 9, 2014.

28. She spells kimono "kimona" here. That O'Keeffe was wearing an exotic, sexy garment in the conservative "Bible Belt," and spelling it this way, seems worth highlighting here. See also Corn, *Georgia O'Keeffe*.

29. Wright, *What Nietzsche Taught.* See also n. 109, introduction.

30. O'Keeffe never talks about painting flowers in her Texas years, but she often writes poetically and expressively about them at the time, perhaps foreshadowing her future interest in flowers as a such a key subject for her paintings, beginning in her Lake George years. See Coe, Owens, and Robertson, *Modern Nature*, as well as O'Keeffe's letter from April 19, 1917.

31. Thomas Viseno Reeves (1883–1979) and his wife, Luella (1890–1975). Reeves was Randall County district clerk. See Greenough, *My Faraway One*, 763. On Reeves according to O'Keeffe, see letters postmarked March 26, postmarked March 27, postmarked September 27, November 5, 1917; February 8, 1918.

32. GOKW, plate 5 (*Hill, Stream, and Moon*, 1916–17); CR, 162.

33. For her Palo Duro Canyon works, see n. 14, chap. 1.

34. Fred Heyser, as in n. 14, chap. 2.

35. GOKW, plate 5 (*Hill, Stream, and Moon*, 1916–17); CR, 162.

36. The Shirley children.

37. See n. 109, introduction, and n. 29, chap. 2.

38. On works by O'Keeffe that may have been used in teaching her "youngsters" at the Training School, or inspired by them, see *Yellow House* (1917) and *Chicken in Sunrise* (1917), CR, 174–75.

39. GOKW, plates 7, 17, 46; CR, 209–11.

40. On Lester, see n. 2, chap. 2.

41. Her *Red Landscape* (fig. 12) is painted on a wooden board, so this mention of getting lumber for painting on might help us date that landscape to mid-March 1917.

42. See her *Evening Star* series, as in n. 22, chap. 1.

43. Leah Harris (1888–1966) was a food demonstrator in West Texas. On Harris according to O'Keeffe, see letters postmarked March 26, postmarked April 13, April 19, April 24, May 3, postmarked June 22, November 5, postmarked December 29, 1917; January 14, postmarked January 20, January 23, February 4, February 18, February 25, March 6, March 14, March 21, April 6, April 17, April 30, May 21, May 25, June 3, 1918.

44. On Austin, see n. 10, chap. 2.

45. See n. 35, chap. 1.

46. GOKW, plate 5 (*Hill, Stream, and Moon*, 1916–17); CR, 162.

47. Wright, *What Nietzsche Taught*. See also n. 109, introduction.

48. See Lester, as in n. 2, chap. 2.

49. See n. 31, chap. 1.

50. On Davis, see n. 19, chap. 2.

51. The car belonged to Don Willard Austin, as in n. 10., chap. 2.

52. Beverly Sportsman, as in n. 20, chap. 2.

53. On Gallery 291 in New York, see n. 45, introduction.

54. Little Cooper is likely Ruth M. Cooper, a teacher at the Training School from 1916 to 1919. See Kuhlman, *Always WT*, 480. At one point, O'Keeffe was trying to set her up with Lester and a professor of English whose name is unknown. She writes: "Lester and a new English professor are the chief things looming up on the landscape—and I'm having a lot of fun trying to interest them in Little Cooper and another new Training School teacher—I seem to need nobody—nothing—want nothing myself unless maybe to see the others amused." O'Keeffe to Stieglitz, postmarked September 18, 1917, ASGOA.

55. Here she is referring to Ted Reid. On Reid, see n. 23 and n. 77, introduction.

56. Likely GOKW, plate 2; CR, 207, especially because she uses the words "starlight night" directly in this letter.

57. Likely the son of Douglas Shirley, her landlord.

58. W. H. Blaine was the head of the physical education department at WTSN. He also led an organization of the local Red Cross. See Hill, *More Than Brick and Mortar*, 61. In her letter to Stieglitz postmarked May 17, 1917, ASGOA, she mentions Blaine wanting her "to go with him for Red Cross supply work." It appears she never took him up on this invitation.

59. "Up on top of our house" refers to the O'Keeffe sisters climbing out of their dormer window in their rented room at the Shirley family home; see n. 9, chap. 2. This dormer opened onto the wide, shallowly slanted roof above the front porch. For photographs of this window taken by Claudia O'Keeffe of her sister out on the roof, see GOKW, figures 13–15.

60. Alexander Graham Bell invented the telephone in 1876, and it is noteworthy that by the 1910s, the largely rural Texas Panhandle had household telephone lines.

61. Russell, *Why Men Fight*. The book was written in response to the devastation of WWI, exploring such themes as liberty and militarism, individualism and patriotism. "Hauled me out the window" refers again to the roof of the Shirley house. For the photographs that Claudia took, see GOKW, figures 13–15.

62. On Beverly, see n. 20, chap. 2; on Davis, see n. 19, chap. 2; and on Fred, see n. 14, chap. 2.

63. On Little Cooper, see n. 51, chap. 2.

64. On Harris, see n. 43, chap. 2. This "red drawing" is most likely one of her *Evening Star* series paintings; see n. 22, chap. 1.

65. See Thomas and Luella Reeves, as in n. 31, chap. 2.

66. Likely Louise Shirley.

67. This letter is dated March 26, 1917, in Greenough, *My Faraway One*, but in ASGOA, it is dated from the postmark of March 27. Because there are three other letters dated March 26, I have kept the "postmarked March 27" designation for clarity.

68. See, for instance, GOKW, plate 41, *Evening Star No. 1* (1917); CR, 199.

69. Count Lev Nikolayevich Tolstoy (1828–1910) was a Russian writer best known for his novels *War and Peace* and *Anna Karenina*.

70. The "she" here is presumably Luella Reeves. Regarding Rodin, Stieglitz had sent O'Keeffe an issue of *Camera Work* featuring the art of sculptor Auguste Rodin.

71. Here she refers to an image by Rodin published in *Camera Work*.

72. She refers here to making sculptures. There are no extant sculptures from her Texas years.

73. Lyman is likely J. Lyman Davis, as in n. 19, chap. 2.

74. On this coat, see n. 34, chap. 1. On pockets, see n. 37, chap. 1.

Chapter 3

1. On her *Light Coming on the Plains* series, see GOKW, plates 7, 17, 46; CR, 209–11.

2. Leah Harris, as in n. 43, chap. 2.

3. On O'Keeffe's relationship to Futurism, see discussion in the introduction to this volume.

4. Kindred Marion Watkins was a married man who lived in Amarillo and was employed at the Connell Motor Company. See Greenough, *My Faraway One*, 136n294. On O'Keeffe's views of married men, see also O'Keeffe to Stieglitz, postmarked September 27, 1917, ASGOA, where she writes: "I've been riding [in a car with] Mr. Reeves—Mrs. Reeves is away—has been for two weeks—I don't know. I wish wives would stay at home." On Watkins according to O'Keeffe, see letters from April 24, April 29, May 3, May 6, postmarked June 8, September 20, October 18, November 20, 1917; March 21, 1918.

5. On Nietzsche, see n. 109, introduction. Jacob Dewald was a collector and supporter of Stieglitz's 291 circle; he purchased O'Keeffe's first artwork that she ever sold, the charcoal drawing *Train at Night in the Desert* (1917), for fifty dollars. On this purchase, see O'Keeffe to Stieglitz, postmarked June 8, 1917, ASGOA; Greenough, *My Faraway One*, 138n298; CR, 128.

6. In photographs of O'Keeffe in Texas, she wears white in addition to her staple color of black. For instance, see GOKW, figures 22, 23.

7. See "War Work," 17.

8. Buck W. Bolton was a junior at WTSN in 1917. See Greenough, *My Faraway One*, 139n301.

9. Ted Reid, as in n. 23 and n. 77, introduction.

10. Lester, as in n. 2, chap. 2.

11. Watkins, as in n. 4, chap. 3.

12. Dr. Mac is Robert Lee McMeans, a physician with a practice in Amarillo, who was married to Leah Harris's sister, Annette Harris McMeans, who was called "Billie Mac." See Greenough, *My Faraway One*, 145n310.

13. On these mesas out "where the Canyon begins," see CR, 195–96.

14. See her train images that correspond well to this written description, especially GOKW, plates 3, 19.

15. Henry William Geller (?–1918) worked at WTSN teaching agriculture between 1914 and 1918. His wife's name is unknown. Here O'Keeffe's description of the Gellers being "foreign" but having lived in the United States for "seventeen and twenty-two years" is noteworthy. Antiforeign and anti-immigration sentiments were acute in the nation at the time. Paranoia ran rampant that immigrants were "disloyal" and threatened the American

war effort, and mobs began using vigilante violence against immigrants, especially German-born Americans. For instance, Robert Prager was lynched near St. Louis, Missouri, and Frank Little was dragged behind a car in Butte, Montana, until his kneecaps were scraped off, and he was then hanged from a railroad trestle. Such incidents were particularly prevalent in Middle America and the West. It would seem that Mrs. Geller would have a good reason to be "nervous." See Kennedy, *Over Here*, 68, 73.

16. *The Masses*, published between 1911 and 1917 in New York City, was a "genteel anti-establishment publication that mixed political radicalism with literary and artistic avant-gardism," and it "presented eclectic political perspectives that spanned the socialist, Marxist, and anarchist spectrum and an artistic modernism that was not confined to European abstraction." During WWI, the US postmaster general (the Texan and anti-immigrant, antilabor, antipacifist Albert Sidney Burleson) targeted the journal for censorship. That O'Keeffe was reading this journal and receiving copies of it in the mail was at least daring, if not entirely radical at the time. See especially Kennedy, *Over Here*, 75; and Grasso, *Equal under the Sky*, 57–60. Grasso also sees O'Keeffe's reading of this periodical as an expression of her "feminist-modernist" sensibilities.

17. Of note is the aridity of the Texas Panhandle landscape, where annual rainfall is on average twenty inches per year, compared to the national average of thirty-nine inches. See http://usclimatedata.com.

18. Presumably officer training camp in Waco, Texas, where Alexis O'Keeffe was also stationed.

19. The Texas Panhandle is one of the few spots in the state that get snow, especially as late as May.

20. This letter was written just after O'Keeffe's trip back to New York to see her solo show at Stieglitz's Gallery 291. On her brother Alexis O'Keeffe, see n. 67, introduction. On her trip to New York, see Greenough, *My Faraway One*, 148–54.

21. She refers here to having left New York, Stieglitz, and his friends.

22. On these abstract human forms, see GOKW, plates 26, 30, 35; CR, 189–91. Paul Strand was the modernist photographer represented by Stieglitz at 291, whom O'Keeffe met in New York while she was there. On the friendship, romantic relationship, and artistic exchange between Strand and O'Keeffe, see especially Peters, *Becoming O'Keeffe*.

23. Robert Lincoln Marquis was head of the biology department at WTSN from 1910 to 1918. See Hill, *More Than Brick and Mortar*, 37–38. Hill writes: "At Canyon he quickly became a favorite with faculty, students, and townspeople. A charming personality in faultless attire, a learned man in his chosen field,

captivating public speaker, and 'nuts' on sanitation, he taught with a sense of mission; and no student dragged his feet on the way to Marquis' class." Again, O'Keeffe was in good company with quality educators at WTSN.

24. Presumably Mrs. Geller, as in O'Keeffe to Stieglitz, April 29, 1917.

25. See n. 9 and n. 59, chap. 2.

26. GOKW, plate 34; CR, 192–94.

27. Here she refers to <u>her</u> students from the Training School; see n. 25, chap. 1. In her letter to Stieglitz postmarked June 15, 1917, ASGOA, she writes: "My 68 has climbed past 70—must be near 80—I didn't count—No more room even for chairs and desks, let alone people, so I had to divide it up—My little folks are such fun."

28. Here she is clearly describing a cold front moving through, which in this area occurs first as high winds, followed by dropping temperatures.

29. On Cousins, see n. 2, chap. 1.

30. She refers to the watercolor paintings of John Marin (1870–1953) here, another artist in Stieglitz's 291 circle.

31. She refers to photographs that Stieglitz had taken of her when she was in New York in May 2017, which he sent to her in Canyon. See Greenough, *My Faraway One*, 150, 161n338.

32. This letter is dated June 28, 1917, in Greenough but is postmarked June 22 according to the original in the Stieglitz/O'Keeffe archive at the Beinecke Library.

33. GOKW, plates 26, 30, 35; CR, 189–91.

34. On this pool, see n. 12, chap. 1. Because "life drawing" classes with nude models were not permitted in the curriculum at WTSN, O'Keeffe sought models at the swimming pool for drawing practice, in addition to using her own nude body. It wasn't until a hundred years later that the university in Canyon permitted live nude models in its drawing classes.

35. On Austin, see n. 10, chap. 2.

36. Possibly CR, 241–42.

37. Here again she refers to her teaching at the Training School.

38. The professor of music was Virgie Kelley, a graduate of the New England Conservatory of Music. Like O'Keeffe, Kelley was East Coast trained, showing again that WTSN faculty included recruits from the top training schools in their fields. On Kelley, see Kuhlman, *Always WT*, 70. "Fisher" is William Murrell Fisher, who wrote "The Georgia O'Keeffe Drawings and Paintings at 291," *Camera Work* 49–50 (June 1917): 5. On Fisher's review, see also Scott, *Georgia O'Keeffe*, 67.

39. Presumably she is referring to Jennie C. Ritchie, assistant in English at WTSN. See Hill, *More Than Brick and Mortar*, 40–42.

40. See n. 45, introduction.

41. For these nudes, see also GOKW, plates 1, 4, 6, 9, 16, 22, 23, 29, 32, 33, 39; CR, 176–88.

42. GOKW, plate 23; CR, 178.

43. This "blond boy" has yet to be identified.

44. See n. 38, chap. 2.

45. See n. 41, chap. 3.

46. On O'Keeffe's use of cheap paper, especially newsprint, see Walsh, "Language of O'Keeffe's Materials"; and Walsh, "Paper Survey," 25–26.

47. Interestingly, Stieglitz never visited the West in his lifetime.

48. On the use of the term "queer" in current scholarship on gender and sexuality, see especially Seidman, Fischer, and Meeks, *Introducing the New Sexuality Studies*; Jagose, *Queer Theory*; and Wilchins, *Queer Theory, Gender Theory*.

49. See Grasso, as in the introduction to this volume.

Chapter 4

1. Morelock, as in n. 49, chap. 1.

2. Here we might see O'Keeffe's "disgust" for Watkins as part of an "antislacker" culture of the time. A "slacker" was a period term for men who dodged or avoided the draft. On slackers and "slacker raids" during WWI, see Kennedy, *Over Here*, 151, 165–66.

3. She had requested from Stieglitz a book on African sculpture, which she had lost, so she asked for another copy. On Strand, see n. 22, chap. 3.

4. On Cousins, see n. 2, chap. 1.

5. According to J. A. Hill, "In less than two weeks after the passage of the war resolution by Congress, ten College youth had joined the U.S. Army. And the exodus from the campus began. West Texas State almost became a girls' school in a matter of months." The play *Romeo and Juliet* was even produced with an all-woman cast at the college in early 1918. See Hill, *More Than Brick and Mortar*, 61, 319.

6. Marsden Hartley, as in n. 43, chap. 1.

7. Louise Shirley, the daughter of her landlord.

8. This could be R. A. Terrill and his wife. Terrill was the editor of the *Randall County News* and in 1909 served on the delegation that presented to the Texas state government the proposal from Canyon to secure WTSN in the town. In 1917, he held various positions at WTSN, including head of the Manual Training Department and building construction supervisor. See Kuhlman, *Always WT*, 10–11, 20.

9. On Little Cooper, see n. 51, chap. 2.

10. Again, a few works of O'Keeffe's from this time seem to have come out of her teaching young children. See n. 38, chap. 2.

11. On "Old Latin," see n. 33, chap. 1.

12. This "girl" was Ruby Fowler Reid (1896–1995). She married Ted Reid in September 1918.

13. W. H. Blaine, as in n. 58, chap. 2.

14. On Strand, see n. 22, chap. 3.

15. On Mr. and Mrs. Reeves, see n. 31, chap. 2.

16. It would seem Reid did not leave on this date, because in her letter on December 7, she repeated herself: "Ted met me at the station—bent on aviation."

17. She is talking about her landlords here, the Shirleys. See n. 9, chap. 2.

18. Buck Bolton, as in n. 8, chap. 3.

Chapter 5

1. This letter was written on Texas State Teachers Association letterhead, reminding us of O'Keeffe's professional service as an educator in Texas that reached beyond the local area of Canyon.

2. Alexis O'Keeffe.

3. She traveled with J. A. Hill and Mary Morgan Brown. See n. 29, chap. 1; and Greenough, *My Faraway One*, 217n446.

4. B. A. Stafford, as in n. 33, chap. 1.

5. Alon Bement was her teacher and colleague at the University of Virginia.

6. On Claudia deciding that she wanted to teach for a living, see O'Keeffe to Stieglitz, postmarked June 26, 1917, ASGOA. She got a teaching job in Spur, Texas.

7. This could be either Jessie E. Rambo, the head of the home economics department, or Martha T. Bell. See Hill, *More Than Brick and Mortar*, 61; and Greenough, *My Faraway One*, 220n448.

8. David M. Kennedy describes the "cloud of confusion" that surrounded US attitudes about WWI. Government institutions on national, state, and local levels supported a zero-tolerance policy of "disloyal utterances," resulting in arrests, imprisonments, and judicial cases that upheld the criminality of anything construed as antiwar statements or practices, especially under the Espionage Act of 1917. This included educational institutions, where "neither negative notes nor ambiguities were permissible." However, what was "permissible" and what was actually practiced diverged, and a variety of

attitudes toward the war persisted. O'Keeffe was not alone in her questioning and confusion. See Kennedy, *Over Here*, especially 20, 26, 56, 82.

9. GOKW, plates 7, 17, 46; CR, 209–11.

10. On the WTSN faculty and its supposed "complete and unreserved support to the government's war program," see Hill, *More Than Brick and Mortar*, 61. As Kennedy writes, "Americans went to war in 1917 not only against Germans in the fields of France but against each other at home." He continues, describing how educational institutions "had small patience with doubt-breeding complexities" and sought "a comforting measure of unblinking certainty." Therefore, the attitudes of "folks" in Canyon, as described by O'Keeffe, were not unusual but rather pervasive throughout the United States at the time (Kennedy, *Over Here*, 41, 58). This contrasts with several O'Keeffe biographers who characterized the Canyon citizens as incomparable "warmongers whose zeal seemingly had had no bounds," not as people showing common or typical behavior during the war. See, for instance, Hogrefe, *Georgia O'Keeffe*, 89.

11. See also GOKW, plates 8, 10, 13, 18, 25, 42, 45; CR, 199–206.

12. GOKW, 7, 17, 46; CR, 209–11.

13. She likely refers to Paul Bell here, not Paul Strand, whom she always called "Strand." On Bell, see her letter postmarked March 14, 1917.

14. Possibly Richard H. Harter, a former WTSN student. See Greenough, *My Faraway One*, 228n458.

15. Ruby Fowler, as in n. 12, chap. 4.

16. After Reid left for the war, O'Keeffe did not see him again until 1946, at the time of the opening for her retrospective at the Museum of Modern Art in New York. Reid was stationed within driving distance, at Valley Forge in Pennsylvania, so he borrowed a car and arrived at MoMA still wearing his military uniform. O'Keeffe introduced him to Pollitzer as "the boy from Texas." O'Keeffe also asked him why he had "dropped [her] like a hotcake in Canyon." Apparently, she felt that their relationship had ended suddenly and that she deserved an explanation. After seeing him, O'Keeffe wrote him two letters that noted how "good" it had been to see him. One read: "Seeing you has been very good. I must see you again to tell you how good." On these 1946 meetings, see O'Keeffe to Ted Reid, May 8 and May 10, 1946, Ted Reid Family Papers, as in n. 23, introduction. See also Pollitzer, *Woman on Paper*, 153–54.

17. Leah Harris.

18. On Little Cooper, see n. 51, chap. 2.

19. Robert Bartow Cousins, as in n. 2, chap. 1.

20. Strand served as an x-ray technician in the US Army Medical Corps out of Fort Snelling, Massachusetts, between 1918 and 1919. See timeline

from the finding aid for the Paul Strand Collection at the Center for Contemporary Photography, http://www.creativephotography.org/files/finding-aid-pdfs/ag17_strand.pdf.

21. On O'Keeffe and race, see n. 5, chap. 2.

22. Billie Mac, as in n. 12, chap. 3.

23. Marsden Hartley.

24. For photographs taken in Canyon of O'Keeffe petting and holding a small black dog—which probably belonged to her landlords' neighbor—see GOKW, figures 17–19.

25. For a photograph of O'Keeffe with a woman who might be Harris, see GOKW, figure 9.

26. "Grippe" was a French term for the flu at the time.

27. On her brother Francis O'Keeffe (1885–1959), who was living in Cuba, see O'Keeffe to Stieglitz, January 31, 1918, ASGOA. She surmises that he was employed variously "building bridges or govt. breakwater or railroad stations or raising sugar beets."

28. The development of vaccines by this time included only inoculations for smallpox (1796) and typhoid (1896), and researchers were still trying to isolate the microbes that caused the flu. Some "serums" were being administered by this date, as evidenced by O'Keeffe receiving them in Texas. But even during the Spanish flu outbreak later in 1918, vaccines were largely ineffective. It wasn't until the 1930s that flu viruses were isolated and identified, and the first commercial flu vaccines were not licensed in the United States until the 1940s. See, for instance, "The History of Vaccines: All Timelines Overview," College of Physicians of Philadelphia, https://www.historyofvaccines.org/timeline/all; and "The Medical and Scientific Conceptions of Influenza," Human Virology at Stanford, https://virus.stanford.edu/uda/fluscimed.html.

29. Van Gogh, *Letters of a Post-Impressionist*.

30. Wright, *Creative Will*.

31. Claudia was in Spur, Texas, which is about 160 miles southeast of Amarillo.

32. She is referencing having lived near an asylum when she was younger.

33. On this shipwreck, see n. 114, introduction.

34. Francis O'Keeffe, as in note 27, chap. 5.

35. Luella Reeves, as in n. 31, chap. 2.

36. Listening to records on a Victrola was something that entertained young people in Canyon. In a letter to Stieglitz postmarked March 18, 1917, ASGOA, O'Keeffe mentions her sister playing Harry Lauder's *Roamin' in the*

Gloamin' all afternoon finding it "most fun" until the workmen in their room were all singing and whistling it too. See also her letter postmarked March 15, 1917.

37. On the "Devil's Kitchen" in Palo Duro Canyon, see Hill, *More Than Brick and Mortar*, 51.

Chapter 6

1. Richard Harter, as in n. 14, chap. 5.

2. Frank Day was elected sophomore class president at WTSN in September 1916. See Hill, *More Than Brick and Mortar*, 318.

3. Don Willard Austin, as in n. 10, chap. 2.

4. This reference may correspond to a play based on a novel by British author Robert S. Hichens, which was first performed in London in 1909. See Hichens, *Garden of Allah*.

5. Sibyl Browne (1892–1979) was an artist, author, and teacher who lived in both South Carolina and San Antonio in the 1910s. She later studied with Diego Rivera, worked alongside her mother at a progressive private day school in San Antonio, and worked as an instructor at Columbia University Teachers College. See George, *Rosengren's Books*, 28; and Greenough, *My Faraway One*, 746.

6. On O'Keeffe's fear of tuberculosis, which her mother and several other family members died of, see the various biographies of O'Keeffe, including Lisle, *Portrait of an Artist*; Hogrefe, *Georgia O'Keeffe*; Robinson, *Georgia O'Keeffe*; and Drohojowska-Philp, *Full Bloom*.

7. On Hot Wells, Texas, a resort town in the 1910s that ceased to exist after the 1950s, see Martin Donell Kohout, "Hot Wells, TX," *Handbook of Texas Online*, Texas State Historical Association, accessed July 31, 2018, http://www.tshaonline.org/handbook/online/articles/HTH19.

8. Mose C. Harris (1843–1922) was a journalist and printer. He founded the *San Antonio Evening News* and was editor of the *Texas Republic*. See Greenough, *My Faraway One*, 754.

9. See also GOKW, plates 1, 4, 6, 9, 16, 22, 23, 29, 32, 33, 39; CR, 176–88.

10. O'Keeffe painted several pictures of trees in San Antonio. See GOKW, plates 38, 44; CR, 228, 232–33, 245–50.

11. O'Keeffe began painting figures again in San Antonio, largely Hispanic figures like this man she describes. See GOKW, plates 27, 36, 43; CR, 229, 235–39.

12. She refers here to Stanton MacDonald-Wright (1890–1973), an artist

in Stieglitz's 291 circle. See Greenough, *My Faraway One*, 758.

13. Lucy was a friend of Sibyl Browne's. See Greenough, *My Faraway One*, 267n526.

14. O'Keeffe painted several structures in San Antonio, one of which could be this farmhouse. See CR, 228, 230–31.

15. Brack is Thomas Brackenridge Harris, Leah Harris's brother. See Greenough, *My Faraway One*, 268n529.

16. At this time, women could not borrow money from a bank without a male sponsor or cosigner.

17. On Watkins, see n. 4, chap. 3.

18. Leah Harris's sister, as in n. 12, chap. 3.

19. The town of Leon Springs, and the nearby Camp Bullis and Camp Stanley that make up the Leon Springs Military Reservation, are just northwest of San Antonio. See especially the article "Leon Springs," City of San Antonio, https://www.sanantonio.gov/historic/historicsites/HistoricDistricts/LeonSprings.

20. Here O'Keeffe likely refers to the fact that Harris was Jewish. See Greenough, *My Faraway One*, 274n537.

21. Henry Ford organized a "Peace Expedition" to Europe to "call a conference of delegates from non-combatant countries during World War I." In the winter of 1915–1916, he transported a group of Americans to Norway, Sweden, and Holland to meet with fellow pacifists. See especially "Henry Ford Peace Expedition Collection, 1913–1924," Columbia University Libraries Archival Collections, MS 0441.

22. Again, Stieglitz interestingly never ventured out West, despite O'Keeffe's attempts to lure him.

23. Possibly CR, 246.

24. On 291, see n. 45, introduction.

25. According to Greenough, Judith Maury was a friend of O'Keeffe's from Virginia whose family lived in San Antonio. See *My Faraway One*, 285n557.

26. On Cousins, see n. 2, chap. 1.

27. The Dutchman was a neighbor at the farm who scared her and Harris, peering in their window at night. On this event, see O'Keeffe to Stieglitz, May 4, 1918, in Greenough, *My Faraway One*, 285.

28. Indeed, she seems to have cut off nearly all communication with her Texas connections after June 1918. The only person she stayed in contact with was Ted Reid, with whom she corresponded infrequently and visited a few times when she drove between New York and New Mexico after 1929. On her continuing relationship with Reid, see Ted Reid Family Papers at West Texas A&M University, as in n. 23, introduction.

Bibliography

Art Institute of Chicago: The Essential Guide. Chicago: Art Institute, 2013.

Benke, Britta. *Georgia O'Keeffe*. New York: Taschen, 2003.

Burke, Doreen Bogler. "Frederic Edwin Church and 'The Banner of Dawn.'" *American Art Journal* 14 (Spring 1982): 39–46.

Carlson, Paul H. *Empire Builder in the Texas Panhandle: William Henry Bush*. College Station: Texas A&M University Press, 2009.

Carlson, Paul H., and John T. Becker. *Georgia O'Keeffe in Texas: A Guide*. College Station, TX: State House Press, 2012.

Chipp, Herschel B. *Theories of Modern Art: A Source Book by Artists and Critics*. Berkeley: University of California Press, 1968. Reprint, 1996.

Coe, Erin B., Gwendolyn Owens, and Bruce Robertson. *Modern Nature: Georgia O'Keeffe and Lake George*. New York: Thames and Hudson, 2013.

Constantino, Maria. *Georgia O'Keeffe*. New York: Smithmark, 1994.

Cork, Richard. *Vorticism and Abstract Art in the First Machine Age*. 2 vols. Berkeley: University of California Press, 1976.

Corn, Wanda. *Georgia O'Keeffe: Living Modern*. New York: Prestel, 2017.

Cowart, Jack, and Juan Hamilton. *Georgia O'Keeffe: Art and Letters*. New York: New York Graphic Society, 1990.

Drohojowska-Philp, Hunter. *Full Bloom: The Art and Life of Georgia O'Keeffe*. New York: Norton, 2004.

Eksteins, Modris. *Rites of Spring: The Great War and the Birth of the Modern Age*. New York: Houghton Mifflin, 1989.

Eldredge, Charles C. *Georgia O'Keeffe: American and Modern*. New Haven, CT: Yale University Press, 1993.

Farrington, Jane. *Wyndham Lewis*. London: Lund Humphries, 1980.

Faulkner, Richard S. *The School of Hard Knocks: Combat Leadership in the American Expeditionary Forces*. College Station: Texas A&M University Press, 2012.

Flores, Dan. *Caprock Canyonlands*. College Station: Texas A&M University Press, 2010.

Fort, Ilene Susan. *The Flag Paintings of Childe Hassam*. New York: Harry N. Abrams, 1988.

Frazier, Nancy. *Georgia O'Keeffe*. New York: Knickerbocker, 1990.

Fussell, Paul. *The Great War and Modern Memory*. New York: Oxford University Press, 2013.

"General Information about Our Schools." *Amarillo Daily News*, August 15, 1912.

George, Mary Carolyn Hollers. *Rosengren's Books: An Oasis for the Mind and Spirit*. San Antonio: Wings Press, 2015.

Giboire, Clive, ed. *Lovingly, Georgia: The Complete Correspondence of Georgia O'Keeffe and Anita Pollitzer*. New York: Simon and Schuster, 1990.

Grasso, Laura M. *Equal under the Sky: Georgia O'Keeffe and Twentieth-Century Feminism*. Albuquerque: University of New Mexico Press, 2017.

Grauer, Michael R. *Madonnas of the Prairie: Depictions of Women in the American West*. Canyon, TX: Panhandle-Plains Historical Museum, 2014.

———. *Rounded Up in Glory: Frank Reaugh, Texas Renaissance Man*. Denton: University of North Texas Press, 2016.

Greenough, Sarah, ed. *My Faraway One: Selected Letters of Georgia O'Keeffe and Alfred Stieglitz*. Vol. 1, *1915–1933*. New Haven, CT: Yale University Press, 2011.

———, ed. *Modern Art and America: Alfred Stieglitz and His New York Galleries*. Washington, DC: National Gallery of Art, 2001.

Griffin, Randall. *Georgia O'Keeffe*. London: Phaidon, 2014.

Hichens, Robert S. *The Garden of Allah*. New York: Grosset and Dunlap, 1904.

Hill, J. A. *More Than Brick and Mortar: West Texas State College, 1909–1959*. Amarillo: West Texas State College Ex-Students Association, 1959.

Hogrefe, Jeffrey. *Georgia O'Keeffe: The Life of an American Legend*. New York: Bantam, 1992.

Jagose, Annamarie. *Queer Theory: An Introduction*. New York: New York University Press, 1997.

Kandinsky, Wassily. *The Art of Spiritual Harmony*. Introduction and translation by M. T. H. Sadler. London: Constable, 1914.

Keene, Jennifer D. *World War I: The American Soldier Experience*. Lincoln: University of Nebraska Press, 2006.

Kennedy, David M. *Over Here: The First World War and American Society*. New York: Oxford University Press, 2004.

Kroiz, Lauren. *Creative Composites: Modernism, Race, and the Stieglitz Circle*. Berkeley: University of California Press, 2012.

Kuh, Katherine. *The Artist's Voice: Talks with Seventeen Artists*. New York: Harper and Row, 1960.

Kuhlman, Marty. *Always WT: West Texas A&M University Centennial History*. Stillwater, OK: New Forums Press, 2010.

Lewis, Wyndam. "Vorticist Manifesto." *Blast* 1 (1914).

Lisle, Laurie. *Portrait of an Artist: A Biography of Georgia O'Keeffe*. Albuquerque: University of New Mexico Press, 1986.

Lowes, Ruth, and W. Mitchell Jones. *We'll Remember Thee: An Informal History of West Texas State University, the Early Years*. Canyon: West Texas State University Alumni Association, 1984.

Lynes, Barbara Buhler, ed. *Georgia O'Keeffe: Catalogue Raisonné*. 2 vols. Washington, DC: National Gallery of Art, 1999.

Marinetti, F. T. "The Foundation and Manifesto of Futurism." *Le Figaro*, February 20, 1909.

Matthews, John F. "The Influence of the Texas Panhandle on Georgia O'Keeffe." In *Georgia O'Keeffe in Texas: A Guide*, by Paul H. Carlson and John T. Becker, 73–99. College Station, TX: State House Press, 2012.

Nall, Garry Lynn. "Agricultural History of the Texas Panhandle, 1880–1965." PhD diss., University of Oklahoma, 1972.

Neal, Bill. *Getting Away with Murder on the Texas Frontier: Notorious Killings and Celebrated Trials*. Lubbock: Texas Tech University Press, 2009.

———. *Vengeance Is Mine: The Scandalous Love Triangle That Triggered the Boyce-Sneed Feud*. Denton: University of North Texas Press, 2011.

O'Keeffe, Georgia. *Georgia O'Keeffe*. New York: Viking, 1976.

Perloff, Marjorie. *The Futurist Moment: Avant-Garde, Avant Guerre, and the Language of Rupture*. Chicago: University of Chicago Press, 2003.

Peters, Sarah Whitaker. *Becoming O'Keeffe: The Early Years*. New York: Abbeville Press, 2001.

Poggi, Christine. *Inventing Futurism: The Art and Politics of Artificial Optimism*. Princeton, NJ: Princeton University Press, 2008.

Pollitzer, Anita. *A Woman on Paper: Georgia O'Keeffe*. New York: Simon and Schuster, 1988.

Prieto, Laura R. *At Home in the Studio: The Professionalization of Women Artists in America*. Cambridge, MA: Harvard University Press, 2001.

Ratner-Rosenhagen, Jennifer. *American Nietzsche: A History of an Icon and His Ideas*. Chicago: University of Chicago Press, 2011.

Robinson, Roxana. *Georgia O'Keeffe: A Life*. Lebanon, NH: University Press of New England, 1999.

Russell, Bertrand. *Why Men Fight: A Method of Abolishing the International Duel*. New York: Century, 1917.

Scott, Nancy J. *Georgia O'Keeffe*. London: Reaktion Books, 2015.

Seidman, Steven, Nancy L. Fischer, and Chet Meeks, eds. *Introducing the New Sexuality Studies*. 3rd ed. New York: Routledge, 2016.

Sinor, Jennifer. *Letters like the Day: On Reading Georgia O'Keeffe*. Albuquerque: University of New Mexico Press, 2017.

Stoker, Fred. *Georgia O'Keeffe in Canyon*. Canyon, TX: Self-published, 1990.

Tomkins, Calvin. "Profiles: The Rose in the Eye Looked Pretty Fine." *The New Yorker*, March 4, 1974, 41–42.

van Gogh, Vincent. *The Letters of a Post-Impressionist: Being the Familiar Correspondence of Vincent Van Gogh*. Translated by Anthony M. Ludovici. New York: Houghton Mifflin, 1913.

Von Lintel, Amy. *Georgia O'Keeffe: Watercolors, 1916–1918*. Santa Fe: Radius Books, 2016.

———. "'The Little Girl of the Texas Plains': Georgia O'Keeffe's Panhandle Years." *Panhandle-Plains Historical Review* 85 (2014): 21–56.

Von Lintel, Amy, and Bonnie Roos. "Expanding Abstract Expressionism: Elaine de Kooning, Action Painting, and the American West." *American Art* 32, no. 2 (Summer 2018): 52–79.

Walsh, Judith C. "The Language of O'Keeffe's Materials: Charcoal, Watercolor, Pastel." In *O'Keeffe on Paper*, edited by Ruth E. Fine and Barbara Buhler Lynes, 57–79. Washington, DC: National Gallery of Art, 2000.

———. "Paper Survey." In *Georgia O'Keeffe: Catalogue Raisonné*, by Barbara Buhler Lynes, 25–26. 2 vols. Washington, DC: National Gallery of Art, 1999.

"War Work." *Bulletin of the West Texas State Normal College* 16 (1918): 17.

Wees, William C. *Vorticism and the English Avant-Garde*. Manchester, UK: Manchester University Press, 1972.

Wilchins, Riki. *Queer Theory, Gender Theory*. New York: Magnus, 2014.

Wright, Willard Huntington. *The Creative Will: Studies in the Philosophy and the Syntax of Aesthetics*. New York: John Lane, 1916.

———. *What Nietzsche Taught*. New York: B. W. Huebsch, 1915.

Index

158; feeblemindedness, 27, 54,
123, 127, 130, 139; feeling unbal-
anced, 130; mood swings, 139,
158, 160; narcissism, 158
Mexico, Mexicans, 85, 126, 163
Middle America, 3, 8, 175
militarism, 32–33, 196n61
modernism, ix-x, 9–10, 13–15, 175,
198n16
modernity, 2, 9–10
money and finances, 3, 60, 72, 116,
139, 155, 165
moon and stars, 49, 51, 52, 55–57,
66, 76, 78, 88, 90–91, 99, 117, 125,
127, 143
moonlight, 55, 57, 65, 71, 73, 83, 99,
101, 113–114, 117, 124, 128–129,
154, 162
Morelock, Horace Wilson (Little
Willie), 62, 122, 144, 191n49
morning, letters about the, 140
motorcycles, 7, 66, 73, 179n33
mountains, 47, 119, 168
movies and movie theaters, 74, 90,
193n11
murder, 3, 27, 148, 157, 178n11,
189n23
Museum of Modern Art, 202n16
music, 53
My Faraway One (Greenough), 1–2

Negro Art, 123
neighbors, letters about the, 6,
24, 31, 49–50, 61, 64–65, 79–80,
132–133, 170
New Mexico, ix, 5, 118–119, 172,
205n28
New Woman, 7–8, 120, 175, 180n38
The New Republic, 142
New York: 53, art scene, xiii; GOK
glad she's not in, 60; GOK desir-
ing, 130, 138; education in, 177n9;
GOK living in, ix, 21, 26, 44–45,
73, 160, 205n28; moving back to,

171, 192n6; solo show in, 4, 8–9,
38, 198n20; visiting, 48, 87, 106,
112, 118, 141, 168, 198n22, 199n31;
wartime parades in, 32, 35
Nietzsche, 32, 73, 79, 82, 85, 97–98
night and stars, letters about the, 131
night colors, letters about the, 116
nonobjectivity, 10
nothingness, 43, 49, 55, 63, 65, 69, 74,
85, 99, 103, 106, 108, 114, 122–123,
185n103
nudes and nudity: 13–14, 14f, 31, 106,
112, 115, 117, 120, 162, 186n106,
199n34, 200n41; pink in, 13–14,
14f; red in, 31

O'Keeffe, Alexis, 16: 17f, 33, 35,
59, 105, 135, 139, 148, 155–156,
182n67, 198n18; shipwreck and,
33, 155, 186n114; death of, 35,
186n115
O'Keeffe, Catherine, 186n115
O'Keeffe, Claudia, 4, 6, 7, 48–49, 53,
55–56, 58–62, 64–67, 69, 72–74,
76–77, 82, 84, 87, 89, 90, 92,
97, 99–100, 106–109, 113–115,
124–125, 128–129, 131, 133,
137–138, 146–147, 153–154, 165,
180n36, 192n5, 196n59, 201n6
O'Keeffe, Francis, 152, 155, 203n27
O'Keeffe, Georgia (GOK): Amarillo
years, 2–3, 48, 188n10; as a
Futurist, 96, 181n56; as anti-
American, 32; as New York artist,
2, 5, 9; bad with words, on being,
68; being talked about, 102, 108,
143; busy-ness, 73, 75–76, 104,
115, 127, 170; cheap paper, use of,
56, 117, 200n46; children and art,
82, 116, 201n10; children, views
on, 81–82, 88–89, 90, 93, 109,
113, 116, 119, 124, 126, 131, 134,
141–142, 145–146, 151; contrari-
ness, 71, 86, 94; creative energy,